# A Short Guide to Writing about Art

# THE SHORT GUIDE SERIES
## Under the Editorship of
## Sylvan Barnet
## Marcia Stubbs

*A Short Guide to Writing about Art* by Sylvan Barnet
*A Short Guide to Writing about Literature* by Sylvan Barnet
*A Short Guide to Writing about Chemistry* by Herbert Beal and John Trimbur
*A Short Guide to Writing about Film* by Timothy Corrigan
*A Short Guide to Writing about Social Science* by Lee J. Cuba
*A Short Guide to Writing about History* by Richard Marius
*A Short Guide to Writing about Biology* by Jan A. Pechenik
*A Short Guide to Writing about Science* by David Porush

# A Short Guide to Writing about Art

## Fifth Edition

## SYLVAN BARNET
Tufts University

 LONGMAN

An imprint of Addison Wesley Longman, Inc.

New York • Reading, Massachusetts • Menlo Park, California • Harlow, England
Don Mills, Ontario • Sydney • Mexico City • Madrid • Amsterdam

Senior Editor: Patricia A. Rossi
Developmental Editor: Lynne Cattafi
Project Editor: Dora Rizzuto
Text and Cover Designer: Sandra Watanabe
Front Cover Art: *The Human Condition* by René Magritte.
   Copyright ARS, NY. Private collection. (Snark/Art Resource)
Back Cover Art: *Mountains and Sea* by Helen Frankenthaler,
   1952 Oil on canvas 7' 2 5/8" × 9' 9 1/4". National Gallery
   of Art, Washington, D.C. © Helen Frankenthaler.
Photo Researcher: Judy Feldman
Electronic Production Manager: Valerie A. Sawyer
Desktop Administrator: Jim Sullivan
Manufacturing Manager: Helene G. Landers
Electronic Page Makeup: BookMasters, Inc.
Printer and Binder: RR Donnelley & Sons Company
Cover Printer: The Lehigh Press, Inc.

For permission to use copyrighted material, grateful acknowledgment is made to the
copyright holders on p. 218, which is hereby made part of this copyright page.

**Library of Congress Cataloging-in-Publication Data**

Barnet, Sylvan.
   A short guide to writing about art / Sylvan Barnet. —5th ed.
      p.   cm.— (The short guide series)
   Includes bibliographic references and index.
   ISBN 0-673-52487-6
   1. Art criticism—Authorship.   I. Title
N7476.B37   1996
808'.0667—dc20                                    95-54667
                                                  CIP

ISBN 0-673-52487-6
   5678910–DOC–99

*To the memory of my brother, Howard*

# Contents

# Preface

*Another* book for the student of art to read? I can only echo William James's report of the unwed mother's defense: "It's such a *little* baby." The title and the table of contents adequately reveal the subject of this book; if the chapters themselves fail to please and instruct, and if the questions listed on the inside front cover do not help to produce better essays, no preface will avail.

Still, a few additional words may be useful. Everyone knows that students today do not write as well as they used to. Probably they never did, but it is a truth universally acknowledged (among English teachers) that the cure is *not* harder work from instructors in composition courses; rather, the only cure is a demand, on the part of the entire faculty, that students in all classes write decently. But instructors outside of departments of English understandably say that they lack the time—and perhaps the skill—to teach writing in addition to, say, art.

This book may offer a remedy. Students who read it—and it is short enough to be read in addition to whatever readings the instructor regularly requires—should be able to improve their essays (1) partly by studying the principles explained (e.g., on tone, paragraphing, and manuscript form), (2) partly by studying the short models throughout the book, and, perhaps most important of all, (3) partly by finding that it will help them to generate ideas. As Robert Frost said, writing is a matter of having ideas, and this book tries to help students to have ideas by suggesting questions they may ask themselves as they contemplate works of art.

*A Short Guide to Writing about Art* contains two sample essays by student writers, two essays by professors, and numerous model paragraphs by published scholars such as Rudolf Arnheim, Albert Elsen, Mary D. Garrard, Anne Hollander, and Leo Steinberg. These discussions, as well as the numerous questions that are suggested, should help students to understand the sorts of things one says, and the ways one says

them, when writing about art. After all, people *do* write about art, not only in the classroom but in learned journals, catalogs, and even in newspapers and magazines.

A few pages in Chapter 1 focus on *why* people write about art, but on this topic I would like to add one quotation. The late Harold Rosenberg said:

> The art critic is the collaborator of the artist in developing the culture of visual works as a resource of human sensibility. His basic function is to extend the artist's act into the realms of meaningful discourse.
>
> *Art on the Edge* (1975), p. 142

## A NOTE ON THE FIFTH EDITION

I have been in love with painting ever since I became conscious of it at the age of six. I drew some pictures which I thought fairly good when I was fifty, but really nothing I did before the age of seventy was of any value at all. At seventy-three I have at last caught every aspect of nature—birds, fish, animals, insects, trees, grasses, all. When I am eighty I shall have developed still further, and will really master the secrets of art at ninety. When I reach one hundred my art will be truly sublime, and my final goal will be attained around the age of one hundred and ten, when every line and dot I draw will be imbued with life.

Hokusai (1760–1849)

Probably all artists share Hokusai's feelings. And so do all writers of textbooks. Each edition of this book seemed satisfactory to me when I sent the manuscript to the publisher, but with the passing not of decades but of only a few months I detected inadequacies, and I wanted to say new things. This fifth edition, therefore, not only includes fifth thoughts about many topics discussed in the preceding editions but it also introduces new topics.

The emphasis is still twofold—on *seeing* and *saying,* or on helping students to get ideas about art and to present those ideas effectively in writing—but I have some new ideas about both of these familiar topics, as well as some ideas about new topics. For instance, in the pages concerned with generating ideas, the discussions of *interpretation* and *meaning* have been extensively revised, and there is new material on such matters as *deconstruction, indeterminacy, New Art History,* and *validity in the interpretation of art.* In the pages concerned with writing effectively, the material on *organizing, outlining, comparing,* and *evaluating* has

been amplified, and there is new material on *avoiding Eurocentric language* and on *writing with a computer*.

Much of this new material responds to relatively new trends in the study of art. The interests of earlier criticism and history in matters of style, authenticity, and quality, have in large measure been replaced by an interest in the political, economic, and social implications of art. In short, contemporary interest seems to have moved from the *text* to the *context*. Nevertheless, *A Short Guide* continues to give generous space to the formal analysis of art. (I have not yet been able to bring myself to replace the term *art* with *visual culture*, though I uneasily recall Andy Warhol's observation that in America most people think that Art is a man's name.)

## ACKNOWLEDGMENTS

I am glad to have this opportunity to thank James Cahill, Madeline Harrison Caviness, Robert Herbert, Naomi Miller, and Elizabeth de Sabato Swinton for showing me some of their examinations, topics for essays, and guidelines for writing papers. I have received invaluable help of another sort from those who read part or all of the manuscript, or who made suggestions while I was preparing this revised edition. The following people called my attention to omissions, excesses, infelicities, and obscurities: Jane Aaron, Mary Clare Altenhofen, Howard Barnet, Peter Barnet, Mark H. Beers, Morton Berman, William Burto, Ruth Butler, James Cahill, Charles Christensen, Fumiko Cranston, Joan Feinberg, Elizabeth ten Grotenhuis, Julius Held, Joseph Hutchinson, Eugene J. Johnson, Deborah Martin Kao, Laura Kaufman, Susan Kuretsky, Elizabeth Anne McCauley, Jody Maxmin, Lawrence Nees, Kenneth J. Procter, Jennifer Purtle, Patricia Rogers, John Rosenfield, James M. Saslow, John M. Schnorrenberg, Jack J. Spector, Marcia Stubbs, Ruth Thomas, Gary Tinterow, Stephen K. Urice, Jonathan Weinberg, and Tim Whalen. I have adopted many of their suggestions verbatim.

In addition, the generous contributions of Anne McCauley, James M. Saslow, Mark Beers, and Stephen K. Urice must be further specified: McCauley wrote the material on photography, Saslow on gay and lesbian art criticism, and Beers and Urice on writing with a computer. I am further indebted to Marcia Stubbs for letting me use some material that had appeared in a book we collaborated on, *Barnet and Stubbs's Practical Guide to Writing*.

I am also indebted to reviewers, whose comments helped me revise this edition: Margaret Fields Denton, University of Richmond; Joseph M. Hutchinson, Texas A & M University; Janice Mann, Wayne State University; Elizabeth Pilliod, Oregon State University; and Paul J. Zelanski, University of Connecticut. At Longman, Lynne Cattafi, Dora Rizzuto, and Patricia Rossi were always receptive, always encouraging, and always helpful.

SYLVAN BARNET

I saw the things which have been brought to the King from the new golden land: a sun all of gold a whole fathom broad, and a moon all of silver of the same size, also two rooms full of the armour of the people there, and all manner of wondrous weapons of theirs, harness and darts, wonderful shields, strange clothing, bedspreads, and all kinds of wonderful objects of various uses, much more beautiful to behold than prodigies. These things were all so precious that they have been valued at one hundred thousand gold florins. All the days of my life I have seen nothing that has gladdened my heart so much as these things, for I saw amongst them wonderful works of art, and I marvelled at the subtle *ingenia* of men in foreign lands. Indeed, I cannot express all that I thought there.

> Albrecht Dürer, in a journal entry of 27 August 1520, writing about Aztec treasures sent by Motecuhzoma to Cortés in 1519, and forwarded by Cortés to Charles V

Painting cannot equal mountains and water for the marvels of nature, but nature cannot equal painting for the marvels of brush and ink.

> Tung-Ch'i-chang (1555–1636)

What you see is what you see.

> Frank Stella, quoted in 1970

# 1

## Writing about Art

### WHAT IS ART?

Perhaps we can say that a work of art is anything that is said to be a work of art by people who ought to know. Who are these people? They are the men and women who teach in art departments, who write about art for newspapers and magazines and scholarly journals, who run museums, who call themselves art dealers, and so forth. Of course their ideas change over time. For instance, until a decade or two ago, such Native American objects as blankets, headdresses, beaded clothes, and horn spoons were found not in art museums but in ethnographic museums. Today curators of many art museums are eager to acquire and display such Native American objects.

And let's not forget the opinions of the people who consider themselves artists. If someone with an established reputation as a painter says of a postcard she has just written, "This is a work of art," well, we would probably have to be very cautious before we replied, "No it isn't." Art includes a great many things that do not at all resemble Impressionist paintings. For instance, there are *earthworks* or *Earth Art*, large sculptural forms made of earth and rocks. An example is Robert Smithson's *Spiral Jetty,* created in 1970. Smithson supervised the construction of a jetty—if a spiral can be regarded as a jetty—some 15 feet wide and 1,500 feet long, in Great Salt Lake, Utah (see p. 2). Because the water level has since risen, *Spiral Jetty* is now submerged, though the work still survives—under water, in a film Smithson made during the construction of the jetty, and in photographs taken before the water level rose. Is this combination of mud, rocks, and water art? Smithson said so, and the writers of books on recent art agree, since they include photographs of *Spiral Jetty.* When you think about it, Earth Art is not unprecedented; photographs of the Egyptian pyramids have for decades appeared in books of art.

Let's look briefly at a work produced in 1972 by a student in the Feminist Art Program at the California Institute of the Arts, and exhibited again at the Bronx Museum of the Arts in 1995. Two instructors and

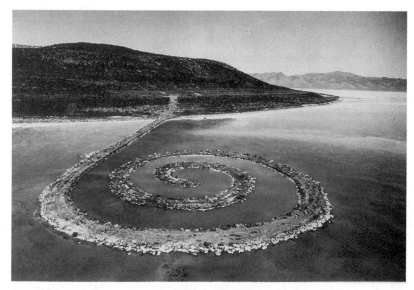

Robert Smithson, *Spiral Jetty,* 1970. (Estate of Robert Smithson; courtesy of John Weber Gallery; photograph by Gianfranco Gorgoni)

some twenty students in the class decided to take an abandoned house and turn it into a work of art, *Womanhouse.* Each participant took some part of the house—a room, a hallway, a closet—and transformed it in accord with her dreams and fantasies. The students were encouraged to make use of materials considered trivial and associated with women, such as dolls, cosmetics, sanitary napkins, and crocheted material. One student, Faith Wilding, constructed a rope web to which crochet was attached, thereby creating what she called (in 1972) *Web Room* or *Crocheted Environment* and (in the 1995 version) *Womb Room* (see p. 3). Traditionally, a work of art (say, a picture hanging on the wall or a statue standing on a pedestal) is set apart from the spectator, and is an object to be looked at from a relatively detached point of view. But *Womb Room* is a different sort of thing. It is an *installation*—a work that takes over or transforms a space, indoors or outdoors, and that usually gives the viewer a sense of being not only a spectator but also a participant in the work. With its nontraditional material—who ever heard of making a work of art out of rope and pieces of crochet?—its unusual form, and its suggestions of the womb, a nest, and primitive architecture, Wilding's installation would hardly have been regarded as art before, say, the mid-twentieth century.

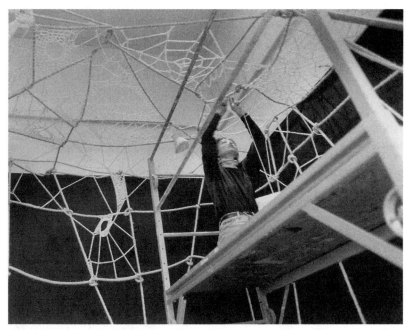

Faith Wilding crocheting the *Womb Room* installation (1995) at the Bronx Museum of the Arts. (© C. M. Hardt/NYT Pictures)

We have been talking about the idea that something is a work of art if its creator—whether a person or a culture—says it is art. But some cultures do not want some of their objects to be thought of as art. For example, although curators of American art museums have exhibited Zuni war god figures (or *Ahayu:da*), the Zuni consider such figures to be embodiments of sacred forces, not aesthetic objects, and therefore *un*suitable for exhibition. The proper place for these figures, the Zuni say, is in open-air hillside shrines.*

What sorts of things you will write about will depend partly on your instructor, partly on the assignment, partly on what the museums in your area call art, and partly on what you call art.

---

*See Steven Talbot, "Desecration and American Indian Religious Freedom," *Journal of Ethnic Studies* 12:4 (1985), 1–8; and T. J. Ferguson and B. Martza, "The Repatriation of Zuni *Ahayu:da*," *Museum Anthropology* 14:2 (1990), 7–15.

## WHY WRITE ABOUT ART?

We write about art in order to clarify and to account for our responses to works that interest or excite or frustrate us. In putting words on paper we have to take a second and a third look at what is in front of us and at what is within us. Picasso said, "To know what you want to draw, you have to begin drawing"; similarly, writing is a way of finding what you want to write, a way of learning. The last word is never said about complex thoughts and feelings—and works of art, as well as our responses to them, embody complex thoughts and feelings. But when we write about art we hope to make at least a little progress in the difficult but rewarding job of talking about our responses. As Arthur C. Danto says in the introduction to *Embodied Meanings* (1994), a collection of essays about art:

> Until one tries to write about it, the work of art remains a sort of aesthetic blur. . . . After seeing the work, write about it. You cannot be satisfied for very long in simply putting down what you felt. You have to go further" (p. 14).

When we write, we learn; we also hope to interest our reader by communicating our responses to material that for one reason or another is worth talking about.

But to respond sensitively to anything and then to communicate responses, we must have some understanding of the thing, and we must have some skill at converting responses into words. This book tries to help you deepen your understanding of art—what art does and the ways in which it does it—and it also tries to help you transform your responses into words that will let your reader share your perceptions, your enthusiasms, and even your doubts. This sharing is, in effect, teaching. Students often think that they are writing for the instructor, but this is a misconception; when you write, *you* are the teacher. An essay on art is an attempt to help someone to see the work as you see it.

## THE WRITER'S AUDIENCE

If you are not writing for the instructor, for whom are you writing? For yourself, of course, but also for an audience that you must imagine. All writers need to imagine some sort of audience—high school students or lawyers or readers of *Time* or professors of art history—and the needs of one imagined audience are not the same as the needs of another. That is,

writers must imagine their audience so that they can decide how much information to give and how much can be taken for granted. In general, think of your audience as your classmates. If you keep your classmates in mind as your audience, you will not write, "Leonardo da Vinci, a famous Italian painter," because such a remark offensively implies that the reader does not know Leonardo's nationality or trade. You might, however, write, "Leonardo da Vinci, a Florentine by birth," because it's your hunch that your classmates do *not* know that Leonardo was born in Florence, as opposed to Rome or Venice. And you *will* write, "John Butler Yeats, the expatriate Irish painter who lived in New York," because you are pretty sure that only specialists know about Yeats. Similarly, you will not explain that the Virgin Mary was the mother of Jesus, but you probably will explain that St. Anne was the mother of Mary.

## THE FUNCTION OF CRITICAL WRITING

In everyday language the most common meaning of criticism is "finding fault," and to be critical is to be censorious. But a critic can see excellences as well as faults. Because we turn to criticism with the hope that the critic has seen something we have missed, the most valuable criticism is not that which shakes its finger at faults but that which calls our attention to interesting matters going on in the work of art. In the following statement W. H. Auden suggests that criticism is most useful when it calls our attention to things worth attending to. He is talking about works of literature, but we can easily adapt his words to the visual arts.

What is the function of a critic? So far as I am concerned, he can do me one or more of the following services:

1. Introduce me to authors or works of which I was hitherto unaware.
2. Convince me that I have undervalued an author or a work because I had not read them carefully enough.
3. Show me relations between works of different ages and cultures which I could never have seen for myself because I do not know enough and never shall.
4. Give a "reading" of a work which increases my understanding of it.
5. Throw light upon the process of artistic "Making."
6. Throw light upon the relation of art to life, to science, economics, ethics, religion, etc.

*The Dyer's Hand* (1963), pp. 8–9

The emphasis on observing, showing, illuminating suggests that the function of critical writing is not very different from the common view of the function of literature or art. The novelist Joseph Conrad said that his aim was "before all, to make you *see*," and the painter Ben Shahn said that in his paintings he wanted to get right the difference between the way a cheap coat and an expensive coat hung.

Take Auden's second point, that a good critic can convince us—show us—that we have undervalued a work. Most readers can probably draw on their own experiences for confirmation. Still, an example may be useful. Rembrandt's self-portrait with his wife (see p. 7), now in Dresden, strikes many viewers as one of his least attractive pictures: the gaiety seems forced, the presentation a bit coarse and silly. Paul Zucker, for example, in *Styles in Painting,* finds it "over-hearty," and John Berger, in *Ways of Seeing,* says that "the painting as a whole remains an advertisement for the sitter's good fortune, prestige, and wealth. (In this case Rembrandt's own.) And like all such advertisements it is heartless." But some scholars have pointed out, first, that this picture may be a representation of the Prodigal Son, in Jesus's parable, behaving riotously, and, second, that it may be a profound representation of one aspect of Rembrandt's marriage. Here is Kenneth Clark on the subject:

> The part of jolly toper was not in his nature, and I agree with the theory that this is not intended as a portrait group at all, but as a representation of the Prodigal Son wasting his inheritance. A tally-board, faintly discernible on the left, shows that the scene is taking place in an inn. Nowhere else has Rembrandt made himself look so deboshed, and Saskia is enduring her ordeal with complete detachment—even a certain hauteur. But beyond the ostensible subject, the picture may express some psychological need in Rembrandt to reveal his discovery that he and his wife were two very different characters, and if she was going to insist on her higher social status, he would discover within himself a certain convivial coarseness.
>
> *An Introduction to Rembrandt* (1978), p. 73

After reading these words we may find that the appeal of the picture grows. Clark does not, of course, present an airtight case—one rarely can present such a case when writing about art—but notice that he does more than merely express an opinion or report a feeling. He offers evidence (the tally-board, and the observation that no other picture shows Rembrandt so "deboshed"), and the evidence is sufficiently strong to make us take another look at the picture. After looking again, we may come to feel that we have undervalued the picture.

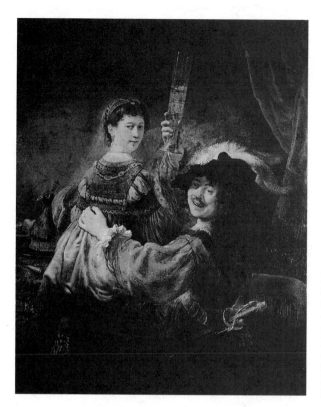

Rembrandt, *Self-Portrait with Saskia,* ca. 1635. Oil on canvas, 5′4″[TN]× 4′4″. (Art Resource, NY/Erich Lessing; Gemäldegalerie, Staatliche Kunstsammlungen, Dresden, Germany)

## A SAMPLE ESSAY

Kenneth Clark's comments, quoted a moment ago, come from one of his two books on Rembrandt. Clark's audience is not limited to art historians, but it is, of course, limited to the sort of person who might read a book about Rembrandt. The following essay on Jean-François Millet's *The Gleaners,* written by Robert Herbert, was originally a note in the catalog issued in conjunction with the art exposition at the Canadian World's Fair, Expo 67. Herbert's audience thus is somewhat wider and more general than Clark's. Given his audience, Herbert reasonably offers not a detailed study of one aspect of the painting, say, its composition; rather, he performs most of the services that on page 5 Auden says a critic can perform. In this brief essay, in fact, Herbert skillfully sets forth material that might have made half a dozen essays: Millet's life, the background of Millet's thought, Millet's political and social views, the composition of *The*

*Gleaners,* Millet's depiction of peasants, Millet's connection with later painters. But the aim is always to make us *see.* In *The Gleaners* Millet tried to show us certain things, and now Robert Herbert tries to show us—tries to make us see—what Millet was doing and how he did it.

**Robert Herbert**
## Millet's The Gleaners

Jean-François Millet, born of well-to-do Norman peasants, began his artistic training in Cherbourg. In 1837 he moved to Paris where he lived until 1849, except for a few extended visits to Normandy. With the sounds of the Revolution of 1848 still rumbling, he moved to Barbizon on the edge of the Forest of Fontainebleau, already noted as a resort of landscape painters, and there he spent the rest of his life. One of the major painters of what came to be called the Barbizon School, Millet began to celebrate the labors of the peasant, granting him a heroic dignity which expressed the aspirations of 1848. Millet's identification with the new social ideals was a result not of overtly radical views, but of his instinctive humanitarianism and his rediscovery in actual peasant life of the eternal rural world of the Bible and of Virgil, his favorite reading since youth. By elevating to a new prominence the life of the common people, the revolutionary era released the stimulus which enabled him to continue this essential pursuit of his art and of his life.

*The Gleaners,* exhibited in the Salon of 1857, presents the very poorest of the peasants who are fated to bend their backs to gather with clubbed fingers the wisps of overlooked grain. That they seem so entirely wedded to the soil results from the perfect harmony of Millet's fatalistic view of man with the images which he created by a careful disposition of lines, colors, and shapes. The three women are alone in the bronzed stubble of the foreground, far removed from the bustling activity of the harvesters in the distance, the riches of whose labors have left behind a few gleanings. Millet has weighted his figures ponderously downward, the busy harvest scene is literally above them, and the high horizon line which the taller woman's cap just touches emphasizes their earth-bound role, suggesting that the sky is a barrier which presses down upon them, and not a source of release.

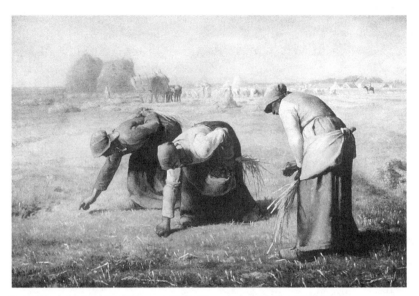

Jean-François Millet, *The Gleaners*, 1857. Oil on canvas, 32⅞" × 43¼". (Service Photographique de la Reunion des Musées Nationaux/The Musée d'Orsay, Paris)

The humility of primeval labor is shown, too, in the creation of primitive archetypes rather than of individuals. Introspection such as that seen in Velázquez's *Water Carrier of Seville*, in which the three men are distinct individuals, is denied by suppressing the gleaners' features, and where the precise, fingered gestures of La Tour's *Saint Jerome* bring his intellectual work toward his sensate mind, Millet gives his women clublike hands which reach away from their bent bodies toward the earth.

It was, paradoxically, the urban-industrial revolution in the nineteenth century which prompted a return to images of the preindustrial, ageless labors of man. For all their differences, both Degas and Van Gogh were to share these concerns later, and even Gauguin was to find in the fishermen of the South Seas that humble being, untainted by the modern city, who is given such memorable form in Millet's *Gleaners*.

In this essay there is, of course, **evaluation,** or judgment, as well as analysis of what is going on in the painting. First, Robert Herbert judges

Millet's picture as worth talking about. (Newspaper and magazine criticism is largely concerned with evaluation—think, for instance, of the film review, which exists chiefly to tell the viewer whether a film is worth seeing—but most academic criticism assumes the value of the works it discusses, and is chiefly analytic and interpretive.) Second, although Herbert explicitly praises some of the work's qualities (its "perfect harmony" and "memorable form"), most of his evaluation is implicit in and subordinate to the analysis of what he sees. (For the moment we can define **analysis** as the separation of the whole into its parts; the second chapter of this book is devoted to the topic.) The essayist sees things and calls them to our attention as worthy of note. He points out the earthbound nature of the women, the difference between their hands and those of Saint Jerome (in another picture that was in the exhibition), the influences of the Bible and of Virgil, and so forth. It is clear that he values the picture, and he states some of the reasons he values it; but he is not worried about whether Millet is a better artist than Velázquez, or whether this is Millet's best painting. He is content to help us see what is going on in the picture.

Or at least he seems to be content to help us see. In fact, of course, Herbert is advancing a **thesis,** an *argument*—in this case, that the picture celebrates the heroic dignity of the peasant. He tries to *persuade* us that what he sees is what is going on. And he sees with more than his eyes: Memories, emotions, his education, and value systems help him to see, and his skill as a writer helps him to persuade us of the accuracy of his report. If he wants to convince us and to hold our interest, he has to do more than offer random perceptions; he has to present his perceptions coherently.

It is not enough for writers to see things and to report to readers what they have seen. Writers have to present their material in an orderly fashion, so that readers can take it in, and can follow a developing argument. In short, writers must organize their material. Let's look for a moment at the **organization,** or plan, of Herbert's essay. In his effort to help us see what is going on, the author keeps his eye on his subject.

- The opening paragraph includes a few details (e.g., the fact that Millet was trained in Cherbourg) that are not strictly relevant to his main point (the vision embodied in the picture), but that must be included because the essay is not only a critical analysis of the picture but an informative headnote in a catalog of an exhibition of works by more than a hundred artists. Even in this preliminary biographical

paragraph the writer moves quickly to the details closely related to the main business: Millet's peasant origin, his early association with landscape painters, his humanitarianism, and his reading of the Bible and Virgil.

• The second paragraph takes a close look at some aspects of the picture (the women's hands, their position in the foreground, the harvesters above and behind them, the oppressive sky). Notice too that this paragraph calls attention to the social context: Herbert points out that the "poorest of the peasants" are apart "from the bustling activity of the harvesters in the distance."

• The third paragraph makes illuminating comparisons with two other paintings in the exhibition. (A good description—one that catches the individuality of a particular work—almost always makes use of comparison. On comparing, see pp. 86–153.)

• The last paragraph, like most good concluding paragraphs, while recapitulating the main point (the depiction of ageless labors), enlarges the vision by including references to Millet's younger contemporaries who shared his vision. Notice that this new material does not leave us looking forward to another paragraph but neatly opens up, or enriches, the matter and then turns it back to Millet. (For additional remarks on introductory and concluding paragraphs, see pp. 151–53.)

## A Note on Outlining

If Herbert prepared an outline to help him draft his essay, it may have looked something like this:

```
Biographical background
    Barbizon
    Millet's humanitarianism
The Gleaners
        The figures and the setting (poorest peas-
        ants apart from harvesters)
        Compare (contrast) with Velázquez and La
        Tour
Concluding paragraph
        Millet looks back, but anticipates later
        painters (Degas, van Gogh)
```

An outline—nothing elaborate, even just a few notations in a sequence that seems reasonable—can be a great help in drafting an essay.

If, however, you feel that you can't work from an outline, write a draft and *then* outline it. Why? An outline of your draft will let you easily

examine your organization. That is, when you brush aside the details and put down the chief point or basic idea of each paragraph, you will produce an outline that will help you see if you have set forth your ideas in a reasonable sequence. By studying this outline of your draft you may find, for instance, that your first point would be better used as your third point. (Outlining is discussed in more detail on pp. 83–85, 123, and 130–32.)

## WHAT IS AN INTERPRETATION—AND ARE ALL INTERPRETATIONS EQUALLY VALID?

### Interpretation and Interpretations

We can define **interpretation** as a setting forth of the meaning of a work of art, or, better, as the setting forth of one of the meanings of the work. This issue of *meaning* versus *meanings* deserves a brief explanation. Although some art historians still believe that a work of art has a single meaning—the meaning it had for the artist—most historians today hold that a work has several meanings: the meaning it had for the artist, the meaning(s) it had for its first audience, the meaning(s) it had for later audiences, and the meaning(s) it has for us today. Picasso offers a relevant comment:

> A picture is not thought out and settled beforehand. While it is being done it changes as one's thoughts change. And when it is finished, it still goes on changing, according to the state of mind of whoever is looking at it. A picture lives a life like a living creature, undergoing the changes imposed on us by our life from day to day. This is natural enough, as the picture lives only through the man who is looking at it.
>
> Conversation with Christian Zervos, 1935, reprinted in
> *Picasso on Art,* ed. Dore Ashton (1972), p. 8

Although viewers usually agree in identifying the subject matter of a work of art (the martyrdom of St. Catherine, a portrait of Napoleon, a bowl of apples), disputes about subject matter are not unknown. Earlier in the chapter, for example, we saw that one of Rembrandt's paintings can be identified as *Self-Portrait with Saskia* or as *The Prodigal Son;* similarly, later in Chapter 4 we will see that Rembrandt's painting of a man holding a knife has been variously identified as *The Butcher, The Assassin,* and *St. Bartholomew.* Of course an interpretation usually goes further than identifying the subject. Thus, as we saw earlier, Kenneth Clark interprets the picture with Saskia not only as an illustration of the story of

the Prodigal Son but also as Rembrandt's expression of an insight into his relationship with his wife. Similarly, an interpretation may begin by saying that Millet's picture shows poor women gleaning, and may go on to argue that it shows (or asserts, represents, or expresses) some sort of theme, such as the dignity of labor, or the oppression of the worker, or the bounty of nature, or whatever. Artists themselves sometimes offer interpretations of their works. For instance, writing of his *Night Café* (1888, Yale University Art Gallery), van Gogh in a letter (September 8, 1888) said:

> The room is blood-red and dark yellow with a green table in the middle; there are four lemon-yellow lamps with a glow of orange and green. Everywhere there is a clash and contrast of the most disparate reds and greens . . . in the empty, dreary room. . . . I have tried to express the idea that the café is a place where one can ruin oneself, run mad, or commit a crime. So I have tried to express, as it were, the powers of darkness. . . .

## Who Creates "Meaning"—Artist or Viewer?

Although van Gogh offered interpretations of some of his pictures, need we accept his interpretations as definitive? One can argue, perhaps, that the creator of an artwork may not be consciously aware of what he or she is including in the work, or that his or her views are by no means definitive, especially since artists—however independent they may think they are—participate in the ideological conflicts of their age. (In the terminology of modern critical theory, to accept the artist's statements about his or her intentions in the work is "to privilege intentionalism.") This idea that the creator of the work cannot comment definitively on it is especially associated with Roland Barthes (1915–80), author of "The Death of the Author," in *Image-Music-Text* (1977), and with Michel Foucault (1926–84), author of "What Is an Author?," in *The Foucault Reader* (1984). For instance, in "What Is an Author?" Foucault assumes that the concept of the author (we can say the artist) is a repressive invention designed to impede the free circulation of ideas. In Foucault's view, the work does not belong to the alleged maker; rather, it belongs—or ought to belong—to the *perceivers*, who of course interpret it variously, according to their historical, social, and psychological circumstances.

If one agrees that the beholders create the meaning (this view is called *Reception Theory*), one can easily dismiss the statements that artists make about the meaning of their work. For example, although Georgia O'Keeffe on several occasions insisted that her paintings of calla

lilies and of cannas were not symbolic of human sexual organs, we can (some theorists hold) ignore her comments. If *we* see O'Keeffe's lilies with their prominent stamens as phallic, and her cannas as vulval, that *is* their meaning—for us. One curator forcefully expresses this side of a highly debatable idea (although he is speaking of pictures, presumably he would extend his remarks to other kinds of artworks):

Pictures do not have meanings. They are given meanings, by people. Different people give them different meanings at different times. One cannot merely examine a painting and try to deduce its "meaning," for such a meaning does not exist. Meaning can only ever be the outcome of a particular set of historical circumstances, and since these circumstances change, a painting's meaning cannot remain a fixed constant.

Paul Taylor, "Looking and Overlooking," *Art History* 15 (1992), 108

Much can be said on behalf of this idea—and much can be said against it. On its behalf one can say, first, that we can never reconstruct the artist's intentions and sensations. Van Gogh's *Sunflowers*, or his portraits of his postman or of his physician, can never mean for us what they meant for van Gogh. Second, the boundaries of the artwork, it is said, are not finite. The work is not simply something "out there," made up of its own internal relationships, independent of a context (*decontextualized* is the term now used). Rather, the artwork is something whose internal relationships are supplemented by what is outside of it—in the case of van Gogh, by the artist's personal responses to flowers and to people, and by his responses to other pictures of flowers and people, and by our responses to all sorts of related paintings, and (to give still another example) by our understanding of van Gogh's place in the history of art. Because we now know something of his life and something of the posthumous history of his paintings, we cannot experience his work in the same way or ways that its original audience experienced it.

## The Relevance of Context

Similarly, we can look at ancient Greek sculptures or at Olmec sculptures in a museum—or at pictures of them in a book—but we cannot experience them as the Greeks or the Olmecs did, in their social and religious contexts. (Indeed, most of the Greek sculptures that we see today are missing limbs or heads and have lost their original color, so we aren't really looking at what the Greeks looked at.) We cannot even become mid-twentieth-century Americans contemplating American paintings

whose meaning in part was in their apparently revolutionary departure from European work. (Even those of the original viewers who are still living now see the works somewhat differently from the way they saw them originally.) Meaning, the argument goes, is indeterminate. Further, one can add that when a museum decontextualizes the work, or deprives it of its original context—for instance, by presenting on a white wall an African mask that once was worn by a dancer in an open place, or by presenting in a vitrine with pinpoint lighting a Japanese tea bowl that had once passed from hand to hand in a humble tea house—the museum thereby invites the perceivers to project their own conceptions onto the work. A well-intended liberal effort to present Chicano art in an art museum met with opposition from the radical left, which said that the proposed exhibition was an attempt to depoliticize the works and to appropriate them into bourgeois culture. In other words, it was argued that by being deprived of their storefront context, the works were drained of their political significance and were turned into art—mere aesthetic objects in a museum.

Much of what has been said about "white box" museum displays, with their implication that museums are repositories of timeless values that transcend cultural boundaries, also can be said about the illustrations of art objects in books. Here works of art are presented (at least for the most part) in an aesthetic context, rather than in a social context of, say, economic and political forces. Indeed, we have already seen that some non-Western objects—Zuni war god figures—are sometimes taken out of their cultural context and then are presented (by a sort of benevolent colonialism, it is said) as possessing a new value—artistic merit. In brief, some critics argue that to take a non-Western object out of its cultural context and to regard it as an independent work of art by discussing it in aesthetic terms is itself a Eurocentric (Western) assault on the other culture, a denial of that culture's unique identity.

Or conversely, it has been objected, that when a book or a museum takes a single art object and surrounds it with abundant information about the cultural context, the object is reduced to a mere cultural artifact—something lacking inherent value, something interesting only as part of a culture that is "the Other," remote and ultimately unknowable. Fifty years ago it was common for art historians to call attention to the aesthetic properties within a work, and for anthropologists to try to tell us "the meaning" of a work; today it is common for art historians to borrow ideas from a new breed of anthropologists, who tell us that we can

never grasp the meaning of an object from another culture, and that we can understand only what it means in *our* culture. That is, we study it to learn what the economic forces are that caused us to wrest the work from its place of origin, and what the psychological forces are that cause us to display it on our walls. The battle between, on the one hand, providing a detailed context (and thus perhaps suggesting that the work is alien, "Other"), and, on the other hand, decontextualizing (and thus slicing away meanings that the work possessed in its own culture) is still going on.

## Arguing an Interpretation

*Against* the idea that works of art have no inherent core of meaning, and that what viewers see depends on their class or gender or whatever, one can argue that competent artists shape their work so that their intentions or meanings are evident to competent viewers (perhaps after some historical research). Most people who write about art make this assumption, and indeed such a position strikes most people as being supported by common sense.

It should be mentioned, too, that even the most vigorous advocates of the idea that meaning is indeterminate do not believe that all discussions of art are equally significant. Rather, they usually agree that a discussion is offered against a background of ideas—shared by writer and reader—as to what constitutes an effective argument, an effective presentation of a thesis. (As we saw earlier, on p. 6, Kenneth Clark's thesis—or, because his thesis is tentative we can call it a hypothesis—is that Rembrandt's *Self-Portrait with Saskia* "may express some psychological need in Rembrandt to reveal his discovery that he and his wife were two very different characters." Similarly, as we noted on p. 10, Robert Herbert's thesis is that Millet's *The Gleaners* celebrates the heroic nature of the peasants.) Whatever the thesis, it must always be offered in an essay that is *coherent, plausible, and rhetorically effective.* This means that the writer cannot merely set down random expressions of feeling or even of unsupported opinions. To the contrary, the writer must convincingly *argue* a case—by pointing to evidence that causes the reader to say, in effect, "Yes, I see just what you mean, and what you say makes sense."

In reply to the claims that all interpretations are equally wrong or equally unprovable or both, perhaps one can say that some interpretations strike a reader as better than others because they are more inclusive; that is, because they account for more of the details of the work. The

less satisfactory interpretations of the supposed meaning(s) leave a reader pointing to some aspects of the work—to some parts of the whole—and saying, "Yes, but this explanation doesn't take account of . . ." or "This explanation is in part contradicted by. . . ."

We'll return to the problem of interpreting meaning when we consider the distinction between subject matter and content in Chapter 2 (pp. 25–28). But for now, we should keep in mind two things. The first is E. H. Gombrich's comment that to a person who has been waiting for a bus, every distant object looks like a bus. The second is the implication within this comment: After the initial mistake, the person recognizes the object for what it really is.

## WHEN WE LOOK, DO WE SEE A MASTERPIECE—OR OURSELVES?

Writing an essay of any kind ought not to be an activity that you doggedly engage in to please an instructor; rather, it ought to be a stimulating, if taxing, activity that educates you and your reader. The job is twofold—seeing and saying—because these two activities are inseparable. If you don't see clearly, you won't say anything interesting and convincing. In any case, if you don't write clearly, your reader won't see what you have seen, and perhaps you haven't seen it clearly either. What you say, in short, is a device for helping the reader *and yourself* to see clearly.

But what do we see? It is now widely acknowledged that when we look, we are not looking objectively with a disembodied or innocent eye. Inevitably a viewer is a person with a point of view (even if he or she is not aware of it)—for instance, the view of a white male, a Marxist, or a feminist. Our interpretations, far from being objective, are said to be conditioned by who we are, and who we are depends partly on the society we live in. Most people would probably agree with Nelson Goodman, who in *The Languages of Art* (1968), says that what the eye sees "is regulated by need and prejudice. It selects, rejects, organizes, discriminates, associates, classifies, analyzes, constructs. It does not so much mirror as take and make" (pp. 7–8). Some recent critics have pushed this idea even further: perceiving and interpreting are, it is said, a form of bricolage (from the French *bricole,* meaning "trifle")—a form of creating something new by assembling bits and pieces of whatever happens to be at hand or, in this case, to be in the viewer's mind.

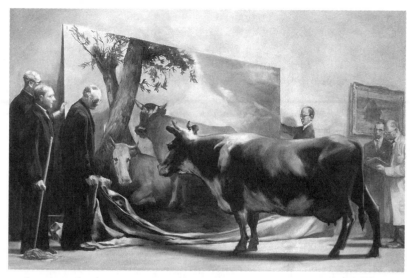

Mark Tansey, *The Innocent Eye Test*, 1981. Oil on canvas, 78″ × 120″. Tansey's cow is look-
ing at Tansey's version of a life-size painting, Paulus Potter's *The Young Bull* (1647), in
Mauritshuis, The Hague. To the right is one of Monet's paintings of grainstacks, another
motif the cow is expected to be interested in. Scientists—including the one at the left
equipped with a mop—will record the cow's response. (The Metropolitan Museum of Art,
promised gift of Charles Cowles, in honor of William S. Lieberman, 1988; courtesy of Curt
Marcus Gallery, New York)

These ideas have engendered distrust of the traditional concepts of
*meaning, genius,* and *masterpiece.* The arguments, offered by scholars
who belong to a school of thought called the *New Historicism,* run along
these lines: Works of art are not the embodiments of profound meanings
set forth by individual geniuses; rather, works of art are the embodiments
of the ideology of the age that produced them. Further, the meaning we
think we see in a work of art is something in large measure not inherent
in the work but (as Paul Taylor said on page 14) is created by the modern
perceiver. The old idea of a masterpiece—a work demonstrating a rare
degree of skill, embodying a profound meaning, and exerting a universal
appeal—thus is called into question. Theorists of the New Historicism
argue that to believe in masterpieces is to believe, wrongly, that a work of
art is the site of an individual artist's fixed, transcendent achievement,
whereas in fact (they argue) meaning is largely the representation of the
politics of the artist's age as interpreted by the politics of the viewer's age.

The idea of a universal appeal thus is said to be a myth created by a coterie (chiefly dead white males) that has succeeded in imposing its tastes and values on the rest of the world. According to these historians, the claim that, say, ancient Greece produced masterpieces of universal appeal, with the implication that all people *should* feel uplifted or enlightened or moved by such works, is looked at as the propaganda of European colonialism.

But the matter need not be put so bluntly, so crudely. We can hardly doubt that our perceptions are influenced by who we are, but we need not therefore speak dismissively of our perceptions or of the objects in front of us. True, talk about "universal appeal" is a bit highfalutin, but some works of art have so deeply interested so many people over so many years that we should hesitate before we dismiss these objects as nothing but the expression of the values of a particular class. Further, the work of one culture can be deeply exciting to people from another culture. We need only think, for instance, of the white response to the art of Africa (sculpture especially, but also such other forms as textiles, basketry, and wall paintings).

## EXPRESSING OPINIONS

The study of art is not a science, but neither is it the expression of random feelings loosely attached to works of art. You can—and must—come up with statements that seem true to the work itself, statements that almost seem self-evident (like Clark's words about Rembrandt) when the reader of the essay turns to look again at the object.

Of course works of art evoke emotions—not only nudes, but also, for example, the sprawled corpse of a rabbit in a still life by Chardin, or even the jagged edges or curved lines in a nonobjective painting. It is usually advisable, however, to reveal your feelings not by continually saying "I feel" and "this moves me," but by calling attention to qualities in the object that shape your feelings. Thus, if you are writing about Picasso's *Les Demoiselles d'Avignon* (see p. 20), instead of saying, "My first feeling is one of violence and unrest," it is better to call attention (as John Golding does, in *Cubism*) to "the savagery of the two figures at the right-hand side of the painting, which is accentuated by the lack of expression in the faces of the other figures." Golding does this in order to support his assertion that "the first impression made by the *Demoiselles* . . . is one of

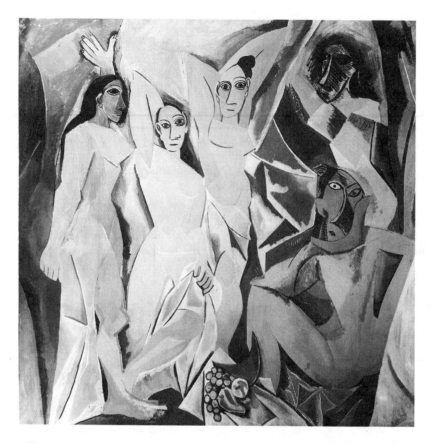

Pablo Picasso, *Les Demoiselles d'Avignon,* 1907. Oil on canvas, 8' × 7'8". (Collection, The Museum of Modern Art, New York. Acquired through the Lillie P. Bliss Bequest)

violence and unrest." The point, then, is not to repress or to disguise one's personal response but to account for it, and to suggest that it is not eccentric and private. Golding can safely assume that his response is tied to the object and that we share his initial response because he cites evidence that compels us to feel as he does—or at least evidence that explains why we feel this way. Here, as in most effective criticism, we get what has been called "persuasive description."

Understandably, instructors would rather be alerted to the evidence in the work of art than be informed about the writer's feelings, but to say that a writer does not keep repeating "I feel" is not to say that "I" cannot be used. Nothing is wrong with occasionally using "I," and noticeable

avoidances of it—"it is seen that," "this writer," "we," and the like—suggest an offensive sham modesty; still, too much talk of "I" can make a writer sound like an egomaniac.

Finally, it must be admitted that the preceding paragraph—indeed all of the preceding material—makes it sound as if writing about art is a decorous business. In fact, however, it is often a loud, contentious business, filled with strong statements about the decline of culture, revolution, pornography (or a liberating sexuality), the destruction of the skyline, fraud, new ways of seeing, and so forth. Examining the conflicting critical assumptions and methodologies will be part of your education, and if you find yourself puzzled you will also find yourself stimulated. An energetic conversation about art has been going on for a long time, and it is now your turn to say something.

# 2

---

# *Analysis*

## ANALYTIC THINKING: SEEING AND SAYING

An analysis is, literally, a separating into parts in order to understand the whole. You might, for example, analyze Michelangelo's marble statue *David* (see facing page) by considering:

- Its sources (in the Bible, in Hellenistic sculpture, in Donatello's bronze *David,* and in the political and social ideas of the age—e.g., David as a civic hero and David as the embodiment of Fortitude)
- Its material (marble lends itself to certain postures but not to others, and marble has an effect—in texture and color—that granite or bronze or wood does not have)
- Its pose (which gives it its outline, its masses, and its enclosed spaces or lack of them)
- Its facial expression
- Its nudity (a nude Adam is easily understandable, but why a nude David?)
- Its size (here, in this over-life-size figure, man as hero)
- Its original site (today it stands in the rotunda of the Academy of Fine Arts, but in 1504 it stood at the entrance to the Palazzo Vecchio—the town hall—where it embodied the principle of the citizen-warrior)

and anything else you think the sculpture consists of—or does not consist of, for Michelangelo, unlike his predecessor Donatello, does not include the head of the slain Goliath, and thus Michelangelo's image is not explicitly that of a conquering hero. Or you might confine your attention to any one of these elements.

Analysis, of course, is not a process used only in talking about art. It is commonly applied in thinking about almost any complex matter. Steffi Graf plays a deadly game of tennis. What makes it so good? How does her backhand contribute? What does her serve do to her opponents? The

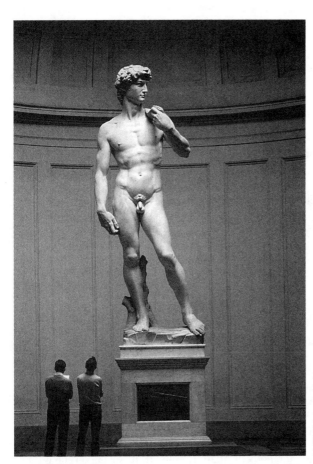

Michelangelo, *David*, 1501–1504. Marble, 13′5″. Accademia, Florence. (Photograph courtesy of H. W. Janson)

relevance of such questions is clear. Similarly, it makes sense, when you are writing about art, to try to see the components of the work.

Here is a very short analysis of one aspect of Michelangelo's painting, *The Creation of Adam* (1508–12), on the ceiling of the Sistine Chapel (see p. 24). The writer's *thesis*, or the point that underlies his analysis, is, first, that the lines of a pattern say something, communicate something to the viewer, and, second, that the viewer does not merely *see* the pattern but also experiences it, participates in it.

The "story" of Michelangelo's *Creation of Adam*, on the ceiling of the Sistine Chapel in Rome, is understood by every reader of the book of

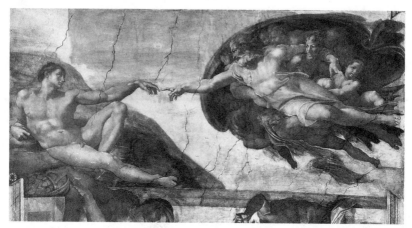

Michelangelo, *The Creation of Adam*, 1508–12. Fresco, 9′2″ × 18′8″. Sistine Chapel, Vatican City. (Art Resource, NY/Alinari; The Vatican Collection, Rome)

Genesis. But even the story is modified in a way that makes it more comprehensible and impressive to the eye. The Creator, instead of breathing a living soul into the body of clay—a motif not easily translatable into an expressive pattern—reaches out toward the arm of Adam as though an animating spark, leaping from fingertip to fingertip, were transmitted from the maker to the creature. The bridge of the arm visually connects two separate worlds: the self-contained compactness of the mantle that encloses God and is given forward motion by the diagonal of his body; and the incomplete, flat slice of the earth, whose passivity is expressed in the backward slant of its contour. There is passivity also in the concave curve over which the body of Adam is molded. It is lying on the ground and enabled partly to rise by the attractive power of the approaching creator. The desire and potential capacity to get up and walk are indicated as a subordinate theme in the left leg, which also serves as a support of Adam's arm, unable to maintain itself freely like the energy-charged arm of God.

Our analysis shows that the ultimate theme of the image, the idea of creation, is conveyed by what strikes the eye first and continues to organize the composition as we examine its details. The structural skeleton reveals the dynamic theme of the story. And since the pattern of transmitted, life-giving energy is not simply recorded by the sense of vision but presumably arouses in the mind a corresponding configuration of forces, the observer's reaction is more than a mere taking cognizance of an external object. The forces that characterize the meaning of the story

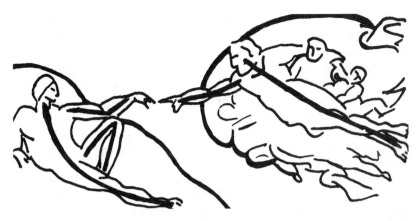

Rudolf Arnheim, diagram of Michelangelo's *Creation*. (Rudolf Arnheim, *Art and Visual Perception*, New Version [Berkeley and Los Angeles: University of California Press, 1974], pp. 458–60)

come alive in the observer and produce the kind of stirring participation that distinguishes artistic experience from the detached acceptance of information.

Rudolf Arnheim, *Art and Visual Perception* (1974), pp. 458–60

Notice that Arnheim does not discuss color, or the Renaissance background, or the place of the work in its site or in Michelangelo's development, though any or all of these are fit topics also. He has chosen to analyze the effect of only one element, but his paragraphs *are* an analysis, an attempt to record perceptions and to reflect on them.

## SUBJECT MATTER AND CONTENT

Before we go on to analyze some of the ways in which art communicates, we can take a moment to distinguish between the *subject matter* of a work and the *content* or *meaning*. (Later in this chapter, on pp. 77–78, we will see that the content or meaning is expressed through the *style* or *form,* but it is best to postpone discussion of those difficult terms for as long as possible.)

The study of artistic images and the cultural thoughts and attitudes that they reflect is called iconology (see pp. 115–20). Two pictures of the same subject matter—for instance, the Crucifixion—can express different meanings: One picture can show Christ's painful death (head

drooping to one side, eyes closed, brows and mouth contorted, arms pulled into a V by the weight of the body, body twisted into an S shape); the other can show Christ's conquest of death (eyes open, face composed, arms horizontal, body relatively straight and self-possessed). The subject matter in both is the same—the Crucifixion—but the meaning or content (painful death in one picture, the conquest of death in the other) is utterly different. (The image of Christ Triumphant was common in the twelfth and early thirteenth centuries; the Suffering Christ, emphasizing the mortal aspect of Jesus, was common in the later thirteenth and the fourteenth centuries.)

Or, to turn to another genre, if we look at some nineteenth-century landscapes we may see (aided by Barbara Novak's *Nature and Culture: American Landscape and Painting, 1825–1875*) that the *subject matter* of skies streaked with red and yellow embodies a *content* that can be described, at least roughly, as the grandeur of God. Perhaps Paul Klee was trying to turn our attention from subject matter to content when he said, "Art does not reproduce the visible; rather, it makes visible," or (in a somewhat freer translation), "Art does not reproduce what we see; rather, it makes us see."

The content, one might say, is the subject matter transformed or recreated or infused by intellect and feeling with meaning—in short, the content is a meaning made visible. This is what Henri Matisse was getting at when he said that drawing is "not an exercise of particular dexterity but above all a means of expressing intimate feelings and moods."

Even abstract and nonobjective works of art probably make visible the artist's inner experiences and thus have a subject matter that conveys a meaning. Consider Picasso's words:

> There is no abstract art. You must always start with something. Afterward you can remove all traces of reality. There is no danger then, anyway, because the idea of the object will have left an indelible mark. It is what started the artist off, excited his ideas, and stirred up his emotions. Ideas and emotions will in the end be prisoners in his work.
>
> *Picasso on Art,* ed. Dore Ashton (1972), p. 64

This seems thoroughly acceptable. Perhaps less acceptable at first, but certainly worth pondering, is Wassily Kandinsky's remark: "The impact of an acute triangle on a sphere generates as much emotional impact as the meeting of God and Adam in Michelangelo's *Creation.*" In this exaggeration Kandinsky touches on the truth that a painting conveys more than the objects that it represents. Still, lest we go too far in searching for a

content in or behind or under the subject matter, we should recall a story. In the 1920s the poet Paul Eluard was eloquently talking to Joan Miró about what Eluard took to be a solar symbol in one of Miró's paintings. After a decent interval Miró replied, "That's not a solar symbol. It is a potato."

The meaning or content of a work of art is not the opposite of form. To the contrary, the *form*—including such things as the size of the work, the kinds of brush strokes in a painting, and the surface texture of a sculpture—is part of the meaning. For example, a picture with short, choppy, angular lines will "say" something different from a picture with gentle curves, even though the subject matter (let's say a woman sitting at a table) is approximately the same. When Klee spoke of "going for a walk with a line," he had in mind a line's ability (so to speak) to move quickly or slowly, assertively or tentatively. Of course many of the words we use in talking about lines—or shapes or colors—are metaphoric. If, for instance, we say that a line is "agitated" or "nervous" or "tentative" or "bold" we are not implying that the line is literally alive and endowed with feelings. We are really talking about the way in which we perceive the line, or, more precisely, we are setting forth our inference about what the artist intended or in fact produced, but such talk is entirely legitimate.

Are the lines of a drawing thick or thin, broken or unbroken? A soft pencil drawing on pale gray paper will say something different from a pen drawing made with a relatively stiff reed nib on bright white paper; at the very least, the medium and the subdued contrast of the one are quieter than those of the other. Similarly, a painting with a rough surface built up with vigorous or agitated brush strokes will not say the same thing—and will not have the same meaning—as a painting with a smooth, polished surface that gives no evidence of the brush. If nothing else, the painting that gives evidence of brush strokes announces the presence of the painter, whereas the polished surface seems to eliminate the painter from the painting.

For obvious examples, compare a work by an Action painter of the late 1940s and the 1950s such as Jackson Pollock (as you can see from the illustration on p. 217, the marks on the canvas almost let us see the painter in the *act* of brushing or dribbling or spattering the pigment) with a work by a Pop artist such as Andy Warhol or Robert Indiana. Whereas Pollock executed apparently free, spontaneous, self-expressive, nonfigurative pictures, Pop artists tended to favor commonplace images (e.g., Warhol's Campbell's soup cans) and impersonal media such as the serigraph. Their works call to mind not the individual artist but anonymous

commercial art and the machine, and these commercial, mechanical associations are part of the meaning of the works. Such works express what Warhol said in 1968: "The reason I'm painting this way is because I want to be a machine."

In short, to get at the content or meanings of a work we have to interpret the subject matter, the material and the form (size, shape, texture, color, and the like), the sociohistoric content, and (if known) perhaps the artist's intentions. We also have to recognize, of course, that our own sociohistoric context—including our gender, economic background, political convictions, and so forth—will to some degree determine the meanings we see in a work. Nelson Goodman, you may recall from Chapter 1 (p. 17), says that because the perceiver's eye "is regulated by need and prejudice" the eye "does not so much mirror as take and make." And in our discussion (p. 14) of Paul Taylor's assertion that works of art do not have meanings, we encountered an extreme version of this position, the claim that all interpretations—all discussions of content—are misinterpretations. One also hears that no standards (e.g., common sense, or the artist's intention) can guide us in evaluating different interpretations.

## GETTING IDEAS:
## ASKING QUESTIONS TO GET ANSWERS

The painter Ad Reinhardt once said that "Looking is not as simple as it looks." What are some of the basic things to look for in trying to acquire an understanding of the languages of art; that is, in trying to understand what a work of art expresses? Matisse has a comment on how all of the parts of a work contribute to the whole: "Expression, to my way of thinking, does not consist of the passion mirrored upon a human face or betrayed by a violent gesture. The whole arrangement of my picture is expressive. The place occupied by figures or objects, the empty spaces around them, the proportions, everything plays a part."

### Basic Questions

One can begin a discussion of the complex business of expression in the arts almost anywhere, but let's begin with some questions that can be asked of almost any work of art—whether a painting or a drawing or a sculpture or even a building.

**What is my first response to the work?** Later you may modify or even reject this response, but begin by trying to study it. Jot down your

responses—even your free associations. Do you find the work puzzling, boring, pretty, ugly, offensive, sexy, or what? The act of jotting down a response may help you to deepen the response, or to move beyond it to a different response.

**When and where was the work made?** Does it reveal the qualities that your textbook attributes to the culture? (Don't assume that it does; works of art have a way of eluding easy generalizations.)

**Where would the work originally have been seen?** Perhaps in a church or a palace, or a bourgeois home, or (if the work is an African mask) worn by a costumed dancer, but surely not in a museum (unless it is a contemporary work) or in a textbook. For Picasso, "The picture-hook is the ruination of a painting. . . . As soon as [a painting] is bought and hung on a wall, it takes on quite a different significance, and the painting is done for." If the work is now part of an exhibition in a museum, how does the museum's presentation of the work affect your response?

**What purpose did the work serve?** To stimulate devotion? To impress the viewer with the owner's power? To enhance family pride? To teach? To delight? Does the work present a likeness, or express a feeling, or illustrate a mystery?

**In what condition has the work survived?** Is it exactly as it left the artist's hands, or has it been damaged, repaired, or in some way altered? What evidence of change can be seen?

**What is the *title*? Does it help to illuminate the work?** Sometimes it is useful to ask yourself, "What would I call the work?" Picasso called one of his early self-portraits *Yo Picasso* (i.e., "I Picasso"), rather than, say, *Portrait of the Artist,* and indeed his title goes well with the depicted self-confidence. Charles Demuth called his picture of a grain elevator in his hometown of Lancaster, Pennsylvania, *My Egypt,* a title that nicely evokes both the grandeur of the object (the silo shafts and their cap resemble an Egyptian temple) and a sense of irony (Demuth, longing to be in New York or Paris, was "in exile" in Lancaster). The painting by René Magritte that is on the cover of this book may at first puzzle a viewer and then, a moment later, may strike the viewer as a clever joke, an ingenious reworking of the old idea that a framed picture gives us the illusion that we are looking through a window at some aspect of reality. Magritte's painting may even force us to think about a classic question, What is the relation between art and external nature? When we learn that its title is *The Human Condition,* however, we probably begin to direct our thoughts along somewhat different lines. For instance, the real may not be "out there," or not entirely out there. Rather, reality is at least partly inside—within the room, according to the painting, which is to say

that we construct our own reality; the world is out there, and yet the only world we really know is the one we conceive within us. Further, the title may lead us to conclude that (at least for Magritte) "the human condition" is the condition of being unsure of what is real and what is illusory. Note, however, that many titles were not given to the work by the artist, and some titles are positively misleading. Rembrandt's *Night Watch* was given that name at the end of the eighteenth century, when the painting had darkened; it is really a daytime scene. And we have already noticed, on page 6, that one's response to a Rembrandt painting may differ, depending on whether it is titled *Self-Portrait with Saskia* or *The Prodigal Son.*

When you ask yourself such basic questions, answers (at least tentative answers) will come to mind. In the language of today's critical theory, by means of "directed looking" you will be able to "decode" (i.e., understand) "visual statements." In short, you will have some ideas, material that you will draw on and will shape when you are called on to write. (Robert Frost was overstating only slightly when he said, "All there is to writing is having ideas.") Following are some additional questions to ask, first on drawing and painting, then on sculpture, architecture, and photography.

## Drawing and Painting

What is the **subject matter?** *Who* or *what* can we identify in the picture? What (if anything) is happening?

If the picture is a **figure painting,** what is the relation of the viewer's (and the artist's) **gaze** to the gaze of the figure(s)? It has been argued, for instance, that in his pictures of his family and friends, Degas gives his subjects a level stare, effectively placing them on the same social level as the viewer; in his pictures of working women (laundresses, dancers), he adopts a high viewpoint, literally looking down on his subjects; in his pictures of prostitutes, he looks either from below or from above, as a spy or a voyeur might do.

If more than one figure is shown, what is the relation of the figures to each other?

If there is only one figure, is it related to the viewer, perhaps by the gaze or by a gesture? If the figure seems posed, do you agree with those theoreticians who say that posing is a subordination of the self to the gaze of another, and the offering of the self (perhaps provocatively or shamefully) to the viewer?

Baudelaire said that a **portrait** is "a model complicated by an artist." The old idea was that a good portrait revealed not only the face but also the inner character of the figure. The face was said to be the index of the mind; thus, for instance, an accurate portrait of King X showed his cruelty (it was written all over his face), and accurate portraits of Pope Y and of Lady Z showed, respectively, the pope's piety (or worldliness, or whatever) and the lady's tenderness (or arrogance, or whatever). It usually turned out, however, that the art historians who saw such traits in particular portraits already knew what traits to expect. When the portrait was of an unidentified sitter, the commentaries varied widely.

It is now widely held that a portrait is not simply a representation of a face that reveals the inner character; a portrait is also a presentation or a construction created by the artist *and* the sitter. Sitters and artists both (so to speak) offer interpretations.

How are their interpretations conveyed? Consider such matters as these:

- How much of the figure does the artist show, and how much of the available space does the artist cause the figure to occupy? What effects are thus gained?

- What do the clothing, furnishings, accessories (swords, dogs, clocks, and so forth), background, angle of the head or posture of the head and body, and facial expression contribute to our sense of the figure's personality (intense, cool, inviting)? Is the sitter portrayed in a studio setting or in his or her own surroundings?

- Does the picture advertise the sitter's *political* importance, or does it advertise the sitter's *personal* superiority? A related way of thinking is this: Does the image present a strong sense of a social class (as is usual in portraits by Frans Hals) or a strong sense of an independent inner life (as is usual in portraits by Rembrandt)?

- If frontal, does the figure seem to face us in a godlike way, as if observing everything before it? If three-quarter, does it suggest motion, a figure engaged in the social world? If profile, is the emphasis decorative or psychological? (Generally speaking, a frontal or, especially, a three-quarter view lends itself to the rendering of a dynamic personality, perhaps even interacting in an imagined social context, whereas a profile does not—or if a profile does reveal a personality it is that of an aloof, almost unnaturally self-possessed sitter.)

- If the picture is a double portrait, does the artist reveal what it is that ties the two figures together? Do the figures look at each other? If not, what is implied by the lack of eye contact?

It is sometimes said that every portrait is a self-portrait; does this portrait seem to reveal the artist in some way? Does the portrait, in fact, reveal anything at all? Looking at John Singer Sargent's portrait entitled *General Sir Ian Hamilton*, the critic Roger Fry said, "I cannot see the man for the likeness." Sargent, by the way, said that he saw an animal in every sitter. (For a student's discussion of two portraits by John Singleton Copley, see pp. 96–103 in Chapter 3. For a professional art historian's discussion of Anthony Van Dyck's portrait of Charles I, see pp. 147–49 in Chapter 6.)

If the picture is a **still life** (the plural is *still lifes*, not *still lives*), does it suggest opulence, or, in contrast, does it suggest humble domesticity and the benefits of moderation? Does it imply transience, perhaps by a clock or a burnt-out candle, or even merely by the perishable nature of the objects (food, flowers) displayed? Other common symbols of *vanitas* (Latin for "emptiness," particularly the emptiness of earthly possessions and accomplishments) are an overturned cup or bowl and a skull. If the picture shows a piece of bread and a glass of wine flanking a vase of flowers, can the bread and wine perhaps be eucharistic symbols, the picture as a whole representing life everlasting achieved through grace? Is there a contrast (and a consequent evocation of *pathos*) between the inertness and sprawl of a dead animal and its vibrant color or texture? Does the work perhaps even suggest, as some of Chardin's pictures of dead rabbits do, something close to a reminder of the Crucifixion? Or is all of this allegorizing irrelevant?

In a **landscape**, what is the relation between human beings and nature? Are the figures at ease in nature (e.g., aristocrats lounging complacently beneath the mighty oaks that symbolize their ancient power and grandeur), or are they dwarfed by it? Are they earth-bound, beneath the horizon, or (because the viewpoint is low) do they stand out against the horizon and perhaps seem in touch with the heavens, or at least with open air?

More generally, what does the landscape say about the society for which it was created? Does it reveal an aristocrat's view of industrious peasants toiling happily in an ordered society? Do the natural objects in the landscape (e.g., billowy clouds, or dark clouds, or gnarled trees, or airy trees) somehow reflect the emotions of the figures? Even if the landscape, like many seventeenth-century Dutch paintings, seems highly realistic, is it also expressive of political or spiritual forces?

In short, a representation of nature is not just an objective presentation of earth, rocks, greenery, water, and sky. The artist also presents what is now called a "social construction" of nature—for instance, nature as a

place made hospitable by the wisdom of the landowners, or nature as an endangered part of our heritage, or nature as a world that we have lost, or nature as a place where the weary soul can find rest and nourishment. Does the origin of the picture help us to interpret it? For instance, a Chinese landscape may bear an inscription explaining that the picture was a farewell gift to an official who was setting out for a remote post. In this case, the figures in the foreground (clear and detailed) may represent the present, and the misty depths may represent the uncertainty of the future. Or a Chinese landscape may have an inscription informing us that it shows someone's retirement villa. In this case the stream, the wall, and the screen of trees that separate the viewer from the cottage help to suggest the purity of the retiree's mind.

Are the **contour lines** (outlines of shapes) strong and hard, isolating each object? Or are they irregular, indistinct, fusing the objects or figures with the surrounding space? Do the lines seem (e.g., in an Asian ink painting) calligraphic—that is, of varied thicknesses that suggest liveliness or vitality, or are the lines uniform and suggestive of painstaking care?

What does the **medium** (the substance on which the artist acted) contribute? For a drawing made with a wet medium (e.g., ink applied with a pen, or washes applied with a brush), what does the degree of absorbency of the paper contribute? Are the lines of uniform width, or do they sometimes swell and sometimes diminish, either abruptly or gradually? (Quills and steel pens are more flexible than reed pens.) For a drawing made with a dry medium (e.g., silverpoint, charcoal, chalk, or pencil), what does the smoothness or roughness of the paper contribute? (When crayon is rubbed over textured paper, bits of paper show through, suffusing the dark with light, giving vibrancy.) In any case, a drawing executed with a dry medium, such as graphite, will differ from a drawing executed with a wet medium, where the motion of the instrument must be interrupted in order to replenish the ink or paint.

If the work is a painting, is it in tempera (pigment dissolved in egg, the chief medium of European painting into the late fifteenth century), which usually has a somewhat flat, dry appearance? Because the brush strokes do not fuse, tempera tends to produce forms with sharp edges—or, we might say, because it emphasizes contours it tends to produce colored drawings. Or is the painting done with oil paint, which (because the brush strokes fuse) is better suited than tempera to give an effect of muted light and blurred edges? Thin layers of translucent colored oil glazes can be applied so that light passing through these layers reflects from the opaque ground colors, producing a soft, radiant effect; or oil

paint can be put on heavily (*impasto*), giving a rich, juicy appearance. Impasto can be applied so thickly that it stands out from the surface and catches the light. Oil paint, which lends itself to uneven, gestural, bravura handling, is thus sometimes considered more painterly than tempera, or, to reverse the matter, tempera is sometimes considered to lend itself to a more linear treatment.

Chinese, Korean, and Japanese ink painting, too, illustrates the contribution of the media. A painting on silk is usually very different from a painting on paper. Because raw silk absorbs ink and pigments, thereby diluting the strength of the line and the color, silk is usually sized (covered with a glaze or filler) to make it less absorbent, indeed, slick. If the brush moves rapidly on the sized surface, it may leave a broken line, so painters working on silk usually proceed slowly, meticulously creating the image. Painters who want spontaneous, dynamic, or blurred brushwork usually paint not on silk but on paper.

*Caution:* Reproductions in books usually fail to convey the texture of brush strokes. If you must work from reproductions, try to find a book that includes details (small parts of the picture), preferably enlarged.

Is the **color** (if any) imitative of appearances, or expressive, or both? (Why is the flesh of the Buddha gold? Why did Picasso use white, grays, and blacks for *Guernica*, when in fact the Spaniards bombarded the Basque town on a sunny day?) How are the colors related—for example, by bold contrasts or by gradual transitions?

The material value of a pigment—that is to say, its cost—may itself be expressive. For instance, Velázquez's lavish use of expensive ultramarine blue in his *Coronation of the Virgin* in itself signifies the importance of the subject. Ultramarine—"beyond the sea"—made of imported ground lapis lazuli, was more expensive than gold; its costliness is one reason why, like gold, it was used for some holy figures in medieval religious paintings, whereas common earth pigments were used for nondivine figures.

Vincent van Gogh, speaking of his own work, said he sought "to express the feelings of two lovers by a marriage of two complementary colors, their mixture and their oppositions, the mysterious vibrations of tones in each other's proximity . . . to express the thought behind a brow by the radiance of a bright tone against a dark ground." As this quotation may indicate, comments on the expressive value of color often seem highly subjective and perhaps unconvincing. One scholar, commenting on the yellowish green liquid in a bulbous bottle at the right of Manet's *Bar aux Folies-Bergère*, suggests that the color of the drink—probably

absinthe—is oppressive. A later scholar points out that the distinctive shape of the bottle indicates that the drink is crème de menthe, not absinthe, and therefore he finds the color not at all disturbing.

*Caution:* It is often said that *warm colors* (red, yellow, orange) come forward and produce a sense of excitement, whereas *cool colors* (blue, green) recede and have a calming effect, but experiments have proved inconclusive; the response to color—despite clichés about seeing red or feeling blue—is highly personal, highly cultural, highly varied. Still, a few things can be said, or at least a few terms can be defined. *Hue* gives the color its name—red, orange, yellow, green, blue, violet. *Value* (also called *lightness* or *darkness, brightness* or *intensity*) refers to relative lightness or darkness of a hue. When white is added, the value becomes "higher"; when black is added, the value becomes "lower." The highest value is white; the lowest is black. *Saturation* (also called *hue intensity*) is the strength of a hue—one red is redder than another; one yellow is paler than another. A vivid hue is of high saturation; a pale hue is of low saturation. But note that much in a color's appearance depends on context. Juxtaposed against green, red will appear redder than if juxtaposed against orange. A gray patch surrounded by white will seem darker than gray surrounded by black.

When we are armed with these terms, we can say, for example, that in his South Seas paintings Paul Gauguin used *complementary colors* (orange and blue, yellow and violet, red and green, i.e., hues that when mixed absorb almost all white light, producing a blackish hue) at their highest values, but it is harder to say what this adds up to. (Gauguin himself said that his use of complementary colors was "analogous to Oriental chants sung in a shrill voice," but one may question whether the analogy is helpful.)

For several reasons our nerve may fail when we try to talk about the effect of color. For example:

- Light and moisture cause some pigments to change over the years.
- The colors of a medieval altarpiece illuminated by flickering candlelight or by light entering from the yellowish translucent (not transparent) glass or colored glass of a church cannot have been perceived as the colors that we perceive in a museum, and, similarly, a painting by van Gogh done in bright daylight cannot have looked to van Gogh as it looks to us on a museum wall.

The moral? Be cautious in talking about the effect of color. Keep in mind the remark of the contemporary painter Frank Stella: "Structural

analysis is a matter of describing the way the picture is organized. Color analysis would seem to be saying what you think the color does. And it seems to me that you are more likely to get an area of common agreement in the former."

What is the effect of **light** in the picture? Does it produce sharp contrasts, brightly illuminating some parts and throwing others into darkness, or does it, by means of gentle gradations, unify most or all of the parts? Does the light seem theatrical or natural, disturbing or comforting? Is light used to create symbolic highlights?

Do the objects or figures share the **space** evenly, or does one overpower another, taking most of the space or the light? What is the focus of the composition? The **composition**—the ordering of the parts into a whole by line, color, and shape—is sometimes grasped at an initial glance and at other times only after close study. Is the composition symmetrical (and perhaps therefore monumental, or quiet, or rigid and oppressive)? Is it diagonally recessive (and perhaps therefore dramatic or even melodramatic)?

Are figures harmoniously related, perhaps by a similar stance or shared action, or are they opposed, perhaps by diagonals thrusting at each other? Speaking generally, **diagonals** may suggest motion or animation or instability, except when they form a triangle resting on its base, which is a highly stable form. **Horizontal lines** suggest tranquility or stability—think of plains, or of reclining figures. **Vertical lines**—tree trunks thrusting straight up, or people standing, or upright lances as in Velázquez's *Surrender of Breda*—may suggest a more vigorous stability. **Circular lines** are often associated with motion and sometimes—perhaps especially by men—with the female body and with fertility. It is even likely that Picasso's *Still-Life on a Pedestal Table*, with its rounded forms, is, as he is reported to have called it, a "clandestine" portrait of one of his mistresses. These simple formulas, however, must be applied cautiously, for they are not always appropriate. Probably it is fair to say, nevertheless, that when a *context* is established—for instance, by means of the title of a picture—these lines may be perceived to bear these suggestions if the suggestions are appropriate.

*Caution:* The sequence of eye movements with which we look at a picture has little to do with the compositional pattern. That is, the eye does not move in a circle when it perceives a circular pattern. The mind, not the eye, makes the relationships. It is therefore inadvisable to say things like "The eye follows the arrow and arrives finally at the target."

Does the artist convey **depth**; that is, **recession in space**? If so, how? If not, why not? (Sometimes space is flattened—e.g., to convey a

sense of otherworldliness or eternity.) Among the chief ways of indicating depth are the following:

1. *Overlapping* (the nearer object overlaps the farther object)
2. *Foreshortening* (as in the recruiting poster, *I Want You,* where Uncle Sam's index finger, pointing at the viewer, is represented chiefly by its tip, and, indeed, the forearm is represented chiefly by a cuff and an elbow)
3. *Contour hatching* (lines or brush strokes that follow the shape of the object depicted, as though a net were placed tightly over the object)
4. *Shading* or *modeling* (representation of body shadows)
5. Representation of *cast shadows*
6. *Relative position from the ground line* (objects higher in the picture are conceived of as further away than those lower)
7. *Perspective* (parallel lines seem to converge in the distance, and a distant object will appear smaller than a near object of the same size.* Some cultures, however, use a principle of *hierarchic scale.* In such a system a king, for instance, is depicted as bigger than a slave not because he is nearer but because he is more important; similarly, the Virgin in a nativity scene may be larger than the shepherds even though she is behind them.)
8. *Aerial* or *atmospheric perspective* (remote objects may seem—depending on the atmospheric conditions—slightly more bluish than similar near objects, and they may appear less intense in color and less sharply defined than nearer objects. Note too that aerial perspective does *not* have anything to do with a bird's-eye view.)

Does the picture present a series of planes, each parallel to the picture surface, or does it, through some of the means just enumerated, present an uninterrupted extension of one plane into depth?

What is the effect of the **shape** and **size** of the work? Because, for example, most still lifes use a horizontal format, perhaps thereby suggesting restfulness, a vertical still life may seem relatively towering and mon-

---

*In the Renaissance, perspective was used chiefly to create a coherent space and to locate objects within that space, but later artists have sometimes made perspective expressive. Giorgio de Chirico, for example, often gives a distorted perspective that unnerves the viewer. Or consider van Gogh's *Bedroom at Arles.* Although van Gogh said that the picture conveyed "rest," viewers find the swift recession disturbing. Indeed, the perspective in this picture is impossible: If one continues the diagonal of the right-hand wall by extending the dark line at the base, one sees that the bed's rear right foot would be jammed into the wall.

umental. Note too that a larger-than-life portrait will produce an effect (probably it will seem heroic) different from one 10 inches high. If you are working from a reproduction be sure, therefore, to ascertain the size of the original.

What is the **scale**; that is, the relative size? A face that fills a canvas will produce a different effect from a face of the same size that is drawn on a much larger canvas; probably the former will seem more expansive or more energetic, even more aggressive.

**A Note on Nonobjective Painting.** We have already noticed (p. 26) Wassily Kandinsky's comment that "The impact of an acute triangle on a sphere generates as much emotional impact as the meeting of God and Adam in Michelangelo's *Creation*." Kandinsky (1866–1944), particularly in his paintings and writings of 1910–14, has at least as good a title as anyone else to being called the founder of twentieth-century **nonobjective art**. Nonobjective art, unlike figurative art, depends entirely on the emotional significance of color, form, texture, size, and spatial relationships, rather than on representational forms.

The term *nonobjective art* includes **abstract expressionism**—a term especially associated with the work of New York painters in the 1950s and 1960s, such as Jackson Pollock and Mark Rothko, who, deeply influenced by Kandinsky, sought to allow the unconscious to express itself. Nonobjective art is considered synonymous with **pure abstract art**, but it is *not* synonymous with "abstract art," since in most of what is generally called abstract art, forms are recognizable, though simplified.

In several rather mystical writings, but especially in *Concerning the Spiritual in Art* (1910), Kandinsky advanced theories that exerted a great influence on American art after World War II. For Kandinsky, colors were something to be felt and heard. When he set out to paint, he wrote, he "let himself go. . . . Not worrying about houses or trees, I spread strips and dots of paint on the canvas with my palette knife and let them sing out as loudly as I could."

What do pictures "sing"? Like music, pictures (Kandinsky believed) communicate emotional insights into the universe. They reveal the spiritual world that is ordinarily obscured by the physical world:

> Every work of art comes into being in the way that the universe came into being—as a result of catastrophes in which all the instruments play out of tune until finally there sings out what we call "the music of the spheres."

As someone who is or who soon will be writing about art, you may be interested in hearing Kandinsky's view of the ideal critic. "The ideal

critic," he said, is "the one who would seek to *feel* how this or that form has an inner effect, and would then impart expressively his whole experience to the public."

Nonobjective painting is by no means all of a piece; it includes, to consider only a few examples, not only the lyrical, highly fluid forms of Kandinsky and of Jackson Pollock (1912–56) but also the pronounced vertical and horizontal compositions of Piet Mondrian (1872–1944), and the bold, rough slashes of black on white of Franz Kline (1910–62), although Kline's titles sometimes invite the viewer to see the slashes as representations of the elevated railway of Kline's earlier years in New York City. Nonobjective painting is, in fact, not so much a style as a philosophy of art: In their works, and in their writings and their comments, many nonobjective painters emphasized the importance of the unconscious and of chance. Their aim in general was to convey feelings with little or no representation of external forms; the work on the canvas conveyed not images of things visible in the world, but intuitions of spiritual realities. Notice that this is *not* to say that the paintings are "pure form" or that subject matter is unimportant in nonobjective art. To the contrary, the artists often insisted that their works were concerned with what really was real—the essence behind appearances—and that their works were not merely pretty decorations. Two Abstract Expressionists, Mark Rothko (1903–70) and Adolph Gottlieb (1903–74), emphasized this point in a letter published in the *The New York Times* in 1943:

> There is no such thing as good painting about nothing. We assert that the subject is crucial and only that subject-matter is valid which is tragic and timeless. That is why we profess spiritual kinship with primitive and archaic art.
>
> Qtd. in *American Artists on Art from 1940 to 1980,*
> ed. Ellen H. Johnson (1982), p. 14

Similarly, Jackson Pollock, speaking in 1950 of his abstract works created in part by dribbling paint from the can, insisted that the paintings were not mere displays of a novel technique and were not mere designs:

> It doesn't make much difference how the paint is put on as long as something has been said. Technique is just a means of arriving at a statement.
>
> Qtd. in *American Artists on Art from 1940 to 1980,*
> ed. Ellen H. Johnson (1982), p. 10

The **titles** of nonobjective pictures occasionally suggest a profound content (e.g., Pollock's *Guardians of the Secret,* Rothko's *Vessels of Magic*), occasionally a more ordinary one (Pollock's *Blue Poles*), and occa-

sionally something in between (Pollock's *Autumn Rhythm*), but one can judge a picture by its title only about as well as one can judge a book by its cover (i.e., sometimes well, sometimes not at all).

In writing about the work of nonobjective painters, you may get some help from their writings, though of course you may come to feel in some cases that the paintings do not do what the painters say they want the pictures to do. (Good sources for statements by artists are *Theories of Modern Art* [1968], ed. Herschel B. Chipp; *American Artists on Art from 1940 to 1980* [1982], ed. Ellen H. Johnson; and *Art in Theory: 1900–1990* [1992], ed. Charles Harrison and Paul Wood. In reading the comments of artists, however, it is often useful to recall Claes Oldenburg's remark that anyone who listens to an artist talk should have his eyes examined.)

The following comment by a critic, however, does not draw on the painter's writing; rather, the author looks at the painting *Mountains and Sea* (1952) by Helen Frankenthaler (see back cover) and, drawing on his experience as a viewer, puts it in a context of other works. The title of the painting allows a viewer to discern a few recognizable forms, but most of the shapes in the picture are not imitative of external nature, and the writer consequently is not greatly concerned with imitations. The passage occurs in the context of a discussion of the reaction against what the writer calls "the moralizing *fortissimo*" of certain Abstract Expressionists. (Because Jackson Pollock is mentioned by way of comparison, if you are unfamiliar with Pollock's work you might first want to look at p. 217 for a sample.)

> The reaction at first took the form of airy, spattered, lyrically colored and light-surfaced abstract painting whose take-off point was Jackson Pollock's "all-over" paintings from 1949. In them, line was no longer *out*line. It did not mark contours or define edges; it was not touchable, like the cut line along the edge of a Matisse pomegranate; it was almost a function of atmosphere. The artist who did most to grasp and develop this aspect of Pollock's work was Helen Frankenthaler (b. 1928), and she did it with one exquisite painting, *Mountains and Sea*, 1952. It is large, about seven feet by ten, but its effect is that of a watercolour: rapid blots and veil-like washes of pink, blue, and diluted malachite green, dashed down as though the canvas were a page in a sketchbook. Its most obvious affinity is with the luminous, broken-formed landscape that rises from Cézanne's late watercolours; and the raw canvas soaked up the watery pigment just as rag paper absorbs a watercolour wash. Landscape, imagined as Arcadia, remained the governing idea in Frankenthaler's work, and her titles often invoked the idea of Paradise or Eden.
>
> Robert Hughes, *The Shock of the New* (1981), p. 154

Frank Stella, *Tahkt-i-Sulayman I,* 1967. Fluorescent acrylic on canvas, 10' × 20'. (Collection, Mr. Robert Rowan; © 1992 Frank Stella/ARS, New York)

Finally, one additional comment about a very different nonobjective painting, a severely geometric picture by Frank Stella (b. 1936). The picture, one of Stella's Protractor series, is 10 feet tall and 20 feet wide. Robert Rosenblum writes:

Confronted with a characteristic example, *Tahkt-i-Sulayman I,* the eye and the mind are at first simply dumbfounded by the sheer multiplicity of springing rhythms, fluorescent Day-Glo colors, and endlessly shifting planes—all the more so, because the basic components (circles and semi-circles; flat bands of unmodulated color) and the basic design (here a clear bilateral symmetry) are so lucid. But again, as always in Stella's work, the seeming economy of vocabulary is countered by the elusive complexities of the result. At first glance, the overriding pattern is of such insistent symmetrical clarity that we feel we can seize predictable principles of organization and bring to rest this visual frenzy. But Stella permits no such static resolution, for the overall symmetries of the design are contradicted by both the interlace patterns and the colors, which constantly assert their independence from any simple-minded scheme. In a surprising way, this tangle of gyrating energies, released and recaptured, provides a 1960s ruler-and-compass equivalent of the finest Pollocks, even in terms of its engulfing scale (here 20 feet wide), which imposes itself in an almost physical way upon the spectator's world. In this case, the springing vaults of the arcs, some reaching as high as four feet above one's head, turn the painting into something that verges on the architectural, a work that might rest on the floor and be subject to natural physical laws of load and support. Seen on this immense scale, the thrusts and counterthrusts, the taut and perfect spanning of great spaces, the

razor-sharp interlocking of points of stress all contrive to plunge the observer into a dizzying tour-de-force of aesthetic engineering.

*Frank Stella* (1971), pp. 48–49

What brief advice can be given about responding to nonobjective painting? Perhaps only this (and here is something of a repetition of what has already been said about representational drawings and paintings): As you look at the work, begin with your responses to the following:

* The dynamic interplay of colors, shapes, lines, textures (of pigments and of the ground on which the pigments are applied)
* The size of the work (often large)
* The shape of the work (most are rectangular or square, but especially in the 1960s many are triangular, circular, chevron-shaped, diamond-shaped, and so on, with the result that, because they depart from the traditional shape of paintings, they seem almost to be two-dimensional sculptures rather than paintings)
* The title

Later, as has already been suggested, you may want to think about the picture in the context of statements made by the artist—for instance, Pollock's "My concern is with the rhythms of nature, the way the ocean moves. I work inside out, like nature."

Finally, remember that making a comparison is one of the most effective ways of seeing things. How does this work differ from that work, and what is the effect of the difference?

## Sculpture

For what **purpose** was this object made? To edify the faithful? To commemorate heroism? What is expressed through the representation? What, for instance, does the highly ordered, symmetrical form of *King Chefren* (see p. 45) suggest about the man? What is the relationship of naturalism to abstraction? If the sculpture represents a deity, what ideas of divinity are expressed? If it represents a human being as a deity (e.g., Alexander the Great as Herakles, or King Chefren as the son of an Egyptian deity), how are the two qualities portrayed?

If the work is a **portrait**, some of the questions suggested earlier for painted portraits (pp. 31–32) may be relevant. Consider especially whether the work presents a strong sense of an individual or, on the other hand, of a type. Paradoxically, a work may do both: Roman portraits from the first to the middle of the third century are (for the most part) highly

realistic images of the faces of older men, the conservative nobility who had spent a lifetime in public office. Their grim, wrinkled faces are highly individualized, and yet these signs of age and care indicate a rather uniform type, supposedly devoted and realistic public servants who scorn the godlike posturing and feigned spontaneity of such flashy young politicians as Caesar and Pompey. That is, although the model might not in fact have been wrinkled, it apparently was a convention for a portrait bust to show signs of wear and tear, such as wrinkles, thereby indicating that the subject was a hardworking, mature leader. In other societies such signs of mortality may be removed from leaders. For instance, African portrait sculpture of leaders tends to present idealized images. Thus, in Ife bronzes from the twelfth century, rulers show a commanding stance and a fullness of body, whereas captives (shown in order to say something not about themselves but about their conqueror) may be represented with bulging eyes, wrinkled flesh, and bones evident beneath the skin. In keeping with the tradition of idealizing, commemorative images of elders usually show them in the prime of life.

What does the **pose** imply? Effort? Rest? Arrested motion? Authority? In the Lincoln Memorial, Lincoln sits; in the Jefferson Memorial, Jefferson stands, one foot slightly advanced. Lincoln's pose as well as his face suggest weariness, while Jefferson's pose as well as his faintly smiling face suggest confidence and action. How relevant to a given sculpture is Rodin's comment that "The body always expresses the spirit for which it is the shell"?

Are certain bodily features or forms distorted? If so, why? (In most African equestrian sculpture, the rider—usually a chief or an ancestor— dwarfs the horse, in order to indicate the rider's high status.)

To what extent is the **drapery** independent of the body? Does it express or diminish the **volumes** (enclosed spaces, e.g., breasts, knees) that it covers? Does it draw attention to specific points of focus, such as the head or hands? Does it indicate bodily motion or does it provide an independent harmony? What does it contribute to whatever the work expresses? If the piece is a wall or niche sculpture, does the pattern of the drapery help to integrate the work into the façade of the architecture?

What do the **medium** and the **techniques** by which the piece was shaped contribute? (These topics are lucidly discussed by Nicholas Penny in *The Materials of Sculpture* [1994].) Clay is different from stone or wood, and stone or wood can be rough or they can be polished. Would the statue of Chefren (also called Khafre, Egyptian, third millenium BC; see p. 45) have the same effect if it were in clay instead of in highly polished diorite? Can one imagine Daniel Chester French's marble statue of

Lincoln, in the Lincoln Memorial, done in stainless steel? What are the associations of the material? For instance, early in this century welded iron suggested heavy industry, in contrast with bronze and marble, which suggested nobility. Even more important, what is the effect of the tactile qualities; for example, polished wood versus terra cotta? Notice that the tactile qualities result not only from the medium but also from the **facture**; that is, the process of working on the medium with certain tools. An archaic Greek *kouros* ("youth") may have a soft, warm look not only because of the porous marble but because of traces left, even after the surface was smoothed with abrasives, of the sculptor's bronze punches and (probably) chisels.

Consider especially the distinction between **carving** and **modeling**; that is, between cutting away, to release the figure from the stone or wood, and, on the other hand, building up, to create the figure out of lumps of clay or wax. Rodin's *Walking Man* (see p. 150), built up by modeling clay and then cast in bronze, recalls in every square inch of the light-catching surface a sense of the energy that is expressed by the figure. Can one imagine Michelangelo's *David* (see p. 23), carved in marble, with a similar surface? Even assuming that a chisel could in fact imitate the effects of modeling, would the surface thus produced catch the light as Rodin's does? And would such a surface suit the pose and the facial expression of *David?*

Compare *King Chefren* with *Mercury* (see p. 46). *King Chefren* was carved; the sculptor, so to speak, cut away from the block everything that did not look like Chefren. *Mercury* was modeled—built up—in clay or wax, and then cast in bronze. The massiveness or stability of *King Chefren* partakes of the solidity of stone, whereas the elegant motion of *Mercury* suggests the pliability of clay, wax, and bronze.

What kinds of volumes are we looking at? Geometric (e.g., cubical, spherical) or irregular? Is the **silhouette** (outline) open or closed? (In Michelangelo's *David,* David's right side is said to be closed because his arm is extended downward and inward; his left side is said to be open because the upper arm moves outward and the lower arm is elevated toward the shoulder. Still, although the form of *David* is relatively closed, the open spaces—especially the space between the legs—emphasize the potential expansion or motion of the figure. See page 23.) The unpierced, thoroughly closed form of *King Chefren,* in contrast to the open form of Giovanni da Bologna's *Mercury,* implies stability and permanence.

Egyptian, *King Chefren*, ca. 2500 BC. Diorite, 5'6". (Courtesy Hirmer Fotoarchiv, Munich/Egyptian Museum, Cairo)

What is the effect of **color,** either of the material or of the paint? Is color used for realism or for symbolism? Why, for example, in the tomb of Urban VIII, did Giovanni Bernini use bronze for the sarcophagus (coffin), the pope, and Death, but white marble for the figures of Charity and Justice? The whiteness of classical sculpture is usually regarded as suggesting idealized form (though in fact the Greeks tinted the stone and painted in the eyes), but what is the effect of the whiteness of George Segal's plaster casts (see p. 47) of ordinary figures in ordinary situations, in this instance sitting on real bus seats? Blankness?

What is the **size**? *King Chefren* and *David* are larger than life; *Mercury* (69 inches to the tip of his extended finger) somewhat smaller than life. What does the size contribute to the meaning or effect? What effect on you does the size have?

Giovanni da Bologna,
*Mercury,* 1580.
Bronze, 69″.
(Art Resource,
NY/Alinari; National
Museum, Florence.)

What was the original **site** or physical context (e.g., a pediment, a niche, or a public square)?

Is the **base** a part of the sculpture (e.g., rocks, or a tree trunk that helps to support the figure), and, if so, is it expressive as well as

George Segal, *The Bus Riders*, 1964. Plaster, metal, and vinyl, 69″ × 40″ × 76″. (Hirshhorn Museum and Sculpture Garden, Smithsonian Institution, Washington, D.C.; Gift of Joseph H. Hirshhorn, 1966)

functional? George Grey Barnard's *Lincoln—the Man*, a bronze figure in a park in Cincinnati, stands not on the tall classical pedestal commonly used for public monuments but on a low boulder—a real one, not a bronze copy—emphasizing Lincoln's accessibility, his down-to-earthness. Almost at the other extreme, the flying *Mercury* (see p. 46) stands tiptoe on a gust of wind, and at the very extreme, Marino Marini's *Juggler* is suspended above the base, emphasizing the subject's airy skill.

Where is the best place (or where are the best places) to stand in order to experience the work? How close do you want to get? Why?

**A Note on Nonobjective Sculpture.**   Until the twentieth century, sculpture used traditional materials—chiefly stone, wood, and clay—and was representational, imitating human beings or animals by means of masses of material. Sometimes the masses were created by cutting away (as in stone and wooden sculpture), sometimes they were created by adding on (as in clay sculpture, which then might serve as a model

for a work cast in bronze), but in both cases the end result was a representation.

Twentieth-century sculpture, however, is of a different sort. For one thing, it is often been made out of "nonart" materials—plexiglass, celluloid, cardboard, brushed aluminum, galvanized steel, wire, rope, and so forth—rather than made out of wood, stone, clay, and bronze. Second, instead of representing human beings or animals or perhaps ideals such as peace or war or death (ideals that in the past were often represented allegorically through images of figures), much twentieth-century sculpture is concerned with creating spaces. Instead of cutting away or building up material to create representational masses, the sculptors join or assemble material to explore spaces or movement in space. Unlike traditional sculpture, which is usually mounted on a pedestal, announcing that it is a work of art, something to be contemplated as a thing apart from us, the more recent works we are now talking about may rest directly on the floor or ground, as part of the environment in which we move, or they may project from a wall or be suspended by a wire.

In a moment we will look at a work using nontraditional materials, but first let's consider a bit further this matter of nonrepresentational sculpture. Think of a traditional war memorial—for instance, a statue of a local general in a park, or the Iwo Jima Monument representing marines raising an American flag—and then compare such a work with Maya Lin's *Vietnam Veterans Memorial,* dedicated in 1982 (see p. 49). Lin's pair of 200-foot granite walls join to make a wide V, embracing a gently sloping plot of ground. On the walls, which rise from ground level to a height of about 10 feet at the vertex, are inscribed the names of the 57,939 Americans who died in the Vietnam War. Because this monument did not seem in any evident way to memorialize the heroism of those who died in the war, it stirred a great deal of controversy, and finally, as a concession to veterans groups, the Federal Fine Arts Commission came up with a compromise: A bronze sculpture of three larger-than-life armed soldiers (done by Frederick Hart) was placed nearby, thereby celebrating wartime heroism in a traditional way.

Although Lin's work has been interpreted as representational—the V-shaped walls have been seen as representing the chevron of the foot soldier, or as the antiwar sign of a V made with the fingers—clearly these interpretations are far-fetched. The memorial is not an object representing anything, nor is it an object that (set aside from the real world and showing the touch of the artist's hand) is meant to be looked at as a work of art, in the way that we look at a sculpture on a pedestal or at a picture

Maya Lin, *Vietnam Veterans Memorial*, 1980–82. The Mall, Washington, D.C. Black granite. Each wall 10′1″ × 246′9″. (© Duane Preble)

in a frame. Rather, it is a *site*, a place for reflection. *Vietnam Veterans Memorial* belongs to a broad class of sculptures called *primary forms.* These are massive constructions, often designed in accordance with mathematical equations and often made by industrial fabricators. Robert Smithson's *Spiral Jetty* (see p. 2) is another example, though of course it is made of earth and rocks rather than of industrial materials. The spiral is an archetypal form found in all cultures, sometimes interpreted as suggesting an inward journey (the discovery of the self or the return to one's origins), or an outward journey into the cosmos. Yet another example of a primary form is Isamu Noguchi's *Portal* (see p. 50), made of industrial sewer pipe 48 inches in diameter, erected in front of the Justice Center in Cleveland in 1976. Here, the primary or archetypal motif is the gateway, which establishes a site as something of special importance. One example of the gateway is the *torii* that marks the entrance to Japanese Shinto shrines; others include the arch of the Western world, such as the garlanded arch under which a triumphal Roman general passed on the way to the temple of Jupiter, and Eero Saarinen's *Gateway Arch* in St. Louis. A century ago, or even only fifty years ago, it was thought that the appropriate work of art to put in front of a courthouse was a statue of Justice, a

blindfolded woman holding scales. *Portal* is utterly different. One can of course *look* at it simply as an aesthetic object—a work of art set off from our ordinary world—but chiefly, passing it on the street or entering or leaving the Justice Center, one's body *experiences* the twists, the openings, and the size (it is 36 feet tall) as part of one's environment. The building houses courts and a jail, and it is easy to imagine that a judge experiences the gate or arch one way, a prisoner another way.

Let's look at one other nonrepresentational work, Eva Hesse's *Hang Up* (1966), shown on page 51. Hesse, who died of a brain tumor in 1970 at the age of thirty-four, began as a painter but then turned to sculpture, and it is for her work as a sculptor that she is most highly regarded. Her

Isamu Noguchi, *Portal*, 1976. Painted steel, H. 36′. Cleveland, Justice Center. (© Mort Tucker Photography, Inc.)

materials were not those of traditional sculpture; Hesse used string, balloons, wire, latex-coated cloth, and so on, to create works that (in her words) seem "silly" and "absurd." Only occasionally did Hesse create the sense of mass and sturdiness common in traditional sculpture; usually, as in *Hang Up*, she creates a sense that fragile things have been put together, assembled only temporarily. In *Hang Up*, a wooden frame is wrapped with bedsheets, and a half-inch metal tube, wrapped with cord, sweeps out (or straggles out) from the upper left and into the viewer's space, and then returns to the frame at the lower right. The whole, painted in varying shades of gray, has an ethereal look.

Taking a cue from Hesse, who in an interview with Cindy Nemser in *Artforum* (May 1970) said that she tried "to find the most absurd opposites or extreme opposites," and that she wanted to "take order versus chaos, stringy versus mass, huge versus small," we can see an evident

Eva Hesse, *Hang-Up*, 1966. Acrylic on cloth over wood and steel, 72″ × 84″ × 78″. (Through prior gift of Arthur Keating and Mr. and Mrs. Edward Morris, 1988. © 1994, The Art Institute of Chicago. All rights reserved. Reproduced with the permission of the Estate of Eva Hesse)

opposition in the rigid, rectangular frame and the sprawling wire. There are also oppositions between the hard frame and its cloth wrapping or bandaging, and between the metal tubing and its cord wrapping. Further, there is an opposition or contradiction in a frame that hangs on a wall but that contains no picture. In fact, a viewer at first wonders if the frame *does* contain a panel painted the same color as the wall, and so the mind is stimulated by thoughts of illusion and reality. And although the work does not obviously represent any form found in the real world, the bandaging, and perhaps our knowledge of Hesse's illness, may put us in mind of the world of hospitals, of bodies in pain. (The materials that Hesse commonly used, such as latex and fiberglass, often suggest the feel and color of flesh.) In *Hang Up*, the tube, connected at each end to opposite extremes of the swathed frame, may suggest a life-support system.

The title, too, provides a clue; *Hang Up* literally hangs on a wall, but the title glances also at psychological difficulties—anyone's but especially those of the artist, who was experiencing a difficult marriage and who was trying to create a new form of sculpture. If we go back to the idea of oppositions, we can say that the work itself has a hang-up in that it is in conflict with itself; it seems as though it wants to be a painting (the frame), but the painting never materialized and now the work is a sculpture.

In looking at nonobjective sculpture, consider the following:

- The scale (e.g., is it massive, like *Portal,* or on a more domestic scale, or fairly large, like *Hang Up?*)
- The effect of the materials (e.g., soft or hard, bright or dull?)
- The relationships between the parts (e.g., is the emphasis on masses or on planes, on closed volumes or on open assembly? If the work is an assembly, are light materials lightly put together, or are massive materials industrially joined?)
- The site (e.g., if the work is in a museum, does it hang on a wall or does it rest without a pedestal on the floor? If it is in the open, what does the site do to the work, and what does the work do to the site?)
- The title (e.g., is the title playful? Enigmatic? Significant?)

**A Cautionary Word about Photographs of Sculpture.** Photographs of works of sculpture of course are an enormous aid; we can see details of a work that, even if we were in its presence, might be invisible because the work is high above us on a wall or because it is shrouded in darkness. The sculptural programs on medieval buildings, barely visible *in situ,* can be analyzed (e.g., for their iconography and

their style) by means of photographs. But one must remember the following points:

- Because a photograph is two-dimensional, it gives little sense of a sculpture in the round.
- A photograph may omit or falsify color, and it may obliterate distinctive textures.
- The photographer's lighting may produce dramatic highlights or contrasts, or it may (by even lighting) eliminate highlights that would normally be evident. Similarly, lighting may play up details that are meant to be subordinate or unduly emphasize some volumes. Further, a bust (say, a Greek head in a museum) when photographed against a dark background may seem to float mysteriously, creating an effect very different from the rather dry image of the same bust photographed, with its mount visible, against a light gray background.
- A photograph of a work even in its original context (to say nothing of a photograph of a work in a museum) may decontextualize the work, such as by not taking account of the angle from which the work was supposed to be seen. The first viewers of Michelangelo's *Moses* had to look upward to see the image, but almost all photographs in books show it taken straight-on. Similarly, a photo of Daniel Chester French's *Lincoln* can convey almost nothing of the experience of encountering the work as one mounts the steps of the Lincoln Memorial.
- Generally, photographs do not afford a sense of scale; for example, one may see Michelangelo's *David* (about 13 feet tall) as no bigger than a toy soldier, unless, as in the unusual photograph on page 23, human viewers are included.

## Architecture

You may recall from Chapter 1 (p. 5), Auden's comment that a critic can "throw light upon the relation of art to life, to science, economics, religion, etc." Works of architecture, since they are created for use, especially can be seen in the context of the society that produced them. As the architect Louis Sullivan said, "Once you learn to look upon architecture not merely as an art, more or less well or badly done, but as a social manifestation, the critical eye becomes clairvoyant, and obscure, unnoted phenomena become illumined."

The Roman architect Vitruvius suggested that buildings can be judged according to their *utilitas, firmitas,* and *venustas*—that is, according to

their fitness for their purpose, their structural soundness, and their beauty; or, in Richard Krautheimer's version, their function, structure, and design. *Utilitas* ("utility" or "function") gets us thinking about how suitable (convenient, usable) the building is for its purposes. Does the building work? *Firmitas* ("firmness" or "soundness") gets us thinking about the structure and the durability of the materials in a given climate. *Venustas* ("beauty" or "design") gets us thinking about the degree to which the building provides aesthetic pleasure, the degree to which it offers delight. Much (though not all) of what follows is an amplification of these three topics.

What is the *purpose* of the building? For instance, does it provide a residence for a ruler, a place for worship, or a place for legislators to assemble? Was this also its original purpose? If not, what was the building originally intended for?

Does the building appear today as it did when constructed? Has it been added to, renovated, restored, or otherwise changed in form?

What does the building say? "All architecture," wrote John Ruskin, "proposes an effect on the human mind, not merely a service to the human frame." One can distinguish between function as housing and function as getting across the patron's message. A nineteenth-century bank said, by means of its bulk, its bronze doors, and its barred windows, that your money was safe; it also said, since it had the façade of a Greek temple, that money was holy. A modern bank, full of glass and color, is more likely to say that money is fun. Some older libraries look like Romanesque churches, and the massive J. Edgar Hoover FBI building in Washington, D.C., with its masses of precast concrete, looks like a fortress, uninviting, menacing, impregnable. (The pedestrian on Pennsylvania Avenue encounters an austere wall.) What, then, are the architectural traditions behind the building that contribute to the building's expressiveness? The Boston City Hall (see p. 58), for all its modernity and (in its lower part) energetic vitality, is tied together in its upper stories by forceful bands of windows, similar in their effect to a classical building with columns. (Classical façades, with columns, pediments, and arches, are by no means out of date. One can see versions of them, often slightly jazzed up, as the entrances to malls and high-style retail shops that wish to suggest that their goods are both timeless and in excellent taste.)

Here is how Eugene J. Johnson sees (or hears) Mies van der Rohe's Seagram Building (1954–57):

> Austere, impersonal, and lavishly bronzed, it sums up the power, personality, and wealth of the modern corporation, whose public philanthropy

is symbolized by the piazza in front, with its paired fountains—private land donated to the urban populace. If the piazza and twin fountains call to mind the Palazzo Farnese in Rome, so be it, particularly when one looks out from the Seagram lobby across an open space to the Renaissance-revival façade of McKim, Mead and White's Racquet Club which quotes the garden façade of Palazzo Farnese! Mies set up a brilliant conversation between two classicizing buildings, bringing the nineteenth and twentieth centuries together without compromise on either part. Mies was in many ways *the* great classicist of this century. One might say that one of his major successes lay in fusing the principles of the great classical tradition of Western architecture with the raw technology of the modern age.

> "United States of America," in *International Handbook of Contemporary Developments in Architecture,* ed. Warren Sanderson (1981), p. 506

Notice, by the way, how Johnson fuses *description* (e.g., "lavishly bronzed") with interpretive *analysis* (he sees in the bronze the suggestion of corporate power). Notice, too, how he connects the building with history (the debt of the piazza and twin fountains to the Palazzo Farnese), and how he connects it with its site (the "conversation" with a nearby building).

Like other buildings, museums and the exhibition spaces within museums make statements. This is true whether the museum resembles a Greek temple and is entered only after a heavenward ascent up a great flight of steps, or whether it is a Renaissance palace or a modern imitation of one, or whether it is insistently high-tech. In thinking about an exhibition it is usually worth asking oneself what sorts of statements the museum and the exhibition space make. Think too about why the material is being presented, why it is presented in this particular way (e.g., with abundant verbal information appearing on the wall, or with minimal labels, or with such a title as "Festival of Indonesia"), and who the audience is. Here is Paul Goldberger's analysis of the statements made by certain rooms in the Davis Museum, Rafael Moneo's new museum at Wellesley College. (Earlier in the article Goldberger discusses the site of the museum, the exterior of the building, and the galleries in general.)

> All the galleries are pleasing to be in and work well for the art contained within them. The greatest of them, however, and the one thing in the building that confers a truly spectacular architectural experience, is the top floor where the museum's collection of classical antiquities is displayed. It is best entered not from the elevator but by mounting the stairs, for as you climb, the walls surrounding the stair fall away, the skylights that have allowed some modest light to slip into the lower floors

suddenly sprawl out triumphantly, and you float up to what seems like an open roof. And what could be more wonderful than the sense of emerging into the light as you encounter the beginning of Western art? Enhancing the sense that this gallery is different is the floor, which is of concrete rather than the elegant wood of the lower floors, making it feel more like an atelier. The classical pieces look splendid in this modern surrounding, and they are energized by its slightly more hard-edged quality in comparison with the other galleries.

"Sensuous Spaces Armored in Brick,"
*New York Times*, July 31, 1994, p. 30

Do the forms and materials of the building relate to its neighborhood? What does the building contribute to the **site**? What does the site contribute to the building? How big is the building in relation to the

Cambridge City Hall, 1889. (Photograph by G. M. Cushing. In *Survey of Architectural History in Cambridge, Report Two: Mid-Cambridge* [Cambridge Historical Commission, 1967], p. 44)

neighborhood, and in relation to human beings; that is, what is the **scale**? The Cambridge City Hall (1889), atop a slope above the street, crowns the site and announces—especially because it is in a Romanesque style— that it is a bastion of order, even of piety, giving moral significance to the neighborhood below. The Boston City Hall (1968), its lower part in brick, rises out of a brick plaza—the plaza flows into spaces between the concrete pillars that support the building—and seems to invite the crowds from the neighboring shops, outdoor cafés, and marketplace to come in for a look at government of the people by the people, and yet at the same time the building announces its importance.

Does **form** follow **function**? For better or for worse? For example, does the function of a room determine its shape? Are there rooms with geometric shapes irrelevant to their purposes? Louis Sullivan

Boston City Hall. City Hall Plaza Center, 1961–68. (Photograph by Cervin Robinson. In *Architecture Boston* [Boston Society of Architects, 1976], p. 6)

(1856–1924), in rejecting the nineteenth-century emphasis on architecture as a matter of style (in its most extreme form, a matter of superficial decoration), said, "Form ever follows function." Sullivan's comment, with its emphasis on structural integrity—the appearance of a building was to reveal the nature of its construction as well as the nature of its functions or uses—became the slogan for many architects working in the mid-twentieth century. But there were other views. For instance, Philip Johnson countered Sullivan, with "forms always follows forms and not function." In looking at a building, ask yourself if the form is symbolic, as it is, for instance, in Eero Saarinen's Trans World Airlines Terminal (see p. 59) at Kennedy Airport, where the two outstretched wings suggest flight. Saarinen was famous—or notorious—for violating Sullivan's maxim, by beginning not with functions but with expressive images and then concerning himself with making the images work as buildings.

What **materials** are used? How do the materials contribute to the building's purpose and statement? Take, for instance, the materials of some college and university buildings. Adobe works well at the University of New Mexico, but would it be right for the Air Force Academy in Colorado? (The Academy chose different materials—notably aluminum, steel, and glass.) Brick buildings in Collegiate Georgian suggest a connection with the nation's earliest colleges; stone buildings in Collegiate Gothic (pointed arches and narrow windows) are supposed to suggest a preindustrial world of spirituality and scholarship.

The idea that marble—the material of the Parthenon—confers prestige dies hard: The Sam Rayburn House Office Building in Washington, D.C., is clad in marble veneer (costing many millions of dollars) because marble is thought to suggest dignity and permanence. Marble in fact is highly versatile: White or black marble, common in expensive jewelry shops, can seem sleek or aloof; pink or creamy marble, in a boutique with goods for women, can seem soft and warm. Each building material has associations, or at least potential associations. Brick, for instance, often suggests warmth or unpretentiousness and handcraftsmanship. Wood is amazingly versatile. In its rough-bark state it suggests the great outdoors; trimmed and painted it can be the clapboard and shingles of an earlier America; smooth and sleek and unpainted it can suggest Japanese elegance.

Do the exterior walls seem hard or soft, cold or warm? Is the sense of hardness or coldness appropriate? (Don't simply assume that metal must look cold. A metal surface that reflects images can be bright, lively, and playful. Curves and arches of metal can seem warm and "soft.") Does the

Eero Saarinen, Trans World Airlines Terminal, 1956–62. John F. Kennedy Airport, New York. (Eero Saarinen)

material in the interior have affinities with that of the exterior? If so, for better or for worse? (Our experience of an interior brick wall may be very different from our experience of an exterior brick wall.)

Does the exterior stand as a massive sculpture, masking the spaces and the activities within, or does it express them? The exterior of the Boston City Hall (see p. 57) emphatically announces that the building harbors a variety of activities; in addition to containing offices, it contains conference rooms, meeting halls, an exhibition gallery, a reference library, and other facilities. Are the spaces continuous? Or are they static, each volume capped with its own roof?

What is the function of **ornament**, or of any **architectural statuary** in or near the building? To emphasize structure? To embellish a surface? To conceal the joins of a surface?

Does the interior arrangement of spaces say something—for example, is the mayor's office in the city hall on the top floor, indicating that he or she is above such humdrum activities as dog licensing, which is on the first floor?

In a given room, what is the function of the walls? To support the ceiling or the roof? To afford privacy and protection from weather? To provide a surface on which to hang shelves, blackboards, pictures? If glass, to provide a view in—or out?

What is the effect of the floor (wood, tile, brick, marble, carpet)? Notice especially the effect if you move from a room floored with one material (say, wood) to another (say, carpet).

Is the building inviting? The architect Louis Kahn said, "A building should be a . . . stable and *harboring* thing. If you can now [with structural steel] put columns as much as 100 feet apart you may lose more than you gain because the sense of enclosed space disappears." Is the public invited? The Cambridge City Hall has one public entrance, approached by a flight of steps; the Boston City Hall, its lower floor paved with the brick of the plaza, has many entrances, at ground level. What are the implications in this difference?

"There is no excellent Beauty that hath not some strangeness in the proportion" said Francis Bacon, in the early seventeenth century. Does the building evoke and then satisfy a sense of curiosity?

What is the role of **color**? To clarify form? To give sensuous pleasure? To symbolize meaning? (Something has already been said, on p. 58, about the effects of the colors of marble.) Much of the criticism of the Vietnam Veterans Memorial centered on the color of the stone walls. One critic, asserting that "black is the universal color of shame [and] sorrow," called for a white memorial.

What part does the changing **daylight** play in the appearance of the exterior of the building? Does the interior make interesting use of natural light? And how light is the interior? (The Lincoln Memorial, open only at the front, is somber within, but the Jefferson Memorial, admitting light from all sides, is airy and suggestive of Jefferson's rational—sunny, we might say—view of life.)

As the preceding discussion suggests, architectural criticism usually is based on three topics: (1) the building or monument as an envelope (its purpose, structural system, materials, sources of design, history, and design [articulation of the façade, including the arrangement of windows and doors, ornamentation, color]); (2) the interior (hierarchy of spaces, flow of traffic, connection with the exterior); and (3) the site (relationship of the building to the environment). A fourth topic is the architect's philosophy, and the place of the building in the history of the architect's work.

If you are writing about the first or second of these topics—the building as an envelope or the enclosed spaces through which one

moves—you may have only your eyes and legs to guide you when you study the building of your choice, say, a local church or a college building. But if the building is of considerable historical or aesthetic interest, you may be able to find a published *plan* (a scale drawing of a floor, showing the arrangement of the spaces) or an *elevation* (a scale drawing of an external or internal wall). Plans and elevations are immensely useful as aids in understanding buildings.

A few words about the organization of an essay on a building may be useful. Much will depend on your purpose, and on the building, but consider the possibility of using one of these three methods of organization:

1. You might discuss, in this order, *utilitas, firmitas,* and *venustas*—that is, function, structure, and design (see pp. 53–54).

2. You might begin with a view of the building as seen at a considerable distance, then at a closer view, and then go on to work from the ground up, since the building supports itself this way.

3. You might take, in this order, these topics:
   • The materials (smooth or rough, light or dark, and so on)
   • The general form, perceived as one walks around the building (e.g., are the shapes square, rectangular, or circular, or what? Are they simple or complex?)
   • The façades, beginning with the entrance (e.g., is the entrance dominant or recessive? How is each façade organized? Is there variety or regularity among the parts?)
   • The relation to the site, including materials and scale

## Photography

A *photograph* is literally an image "written by light." Although most people today think of a photograph as a flat work on paper produced from a *negative* (in which tones or colors are the opposite from what we normally see) made in a camera, none of these qualities is necessary.[†] Photographs can be made without cameras (by exposing a light-sensitive material directly to light), can be generated without negatives (color slides and Polaroid prints are familiar examples of what are known as *di-*

---

[†]This discussion of photography is by Elizabeth Anne McCauley (University of Massachusetts-Boston), author of numerous studies of the history of photography, including *Industrial Madness: Commercial Photography in Paris, 1848–1871* (New Haven, Conn.: Yale University Press, 1994).

*rect positives*), and can be pieces of fabric, leather, glass, metal, or even a still image on a computer screen. All that you need to have a photograph is a substance that changes its color or tone under the influence of light and that can subsequently be made insensitive to light so that it can be viewed.

Inherent in this requirement that the image be created by light is the fundamental distinction between photography and prior ways of making pictures. Instead of having the hand drag oil paint across a stretched piece of linen or incise lines into a metal plate to generate an engraving, nature itself, with the help of some manufactured lenses and chemically coated sheets of glass, paper, or film, became the artist. Early photographic viewers marveled at the seemingly limitless details that magically appeared on the metal plate used for one of the first processes, the *daguerreotype*. Thus was born the idea that the camera cannot lie and that the image it produced depended on chemistry and optics, not on human skills.

At the same time, photographers and critics who were familiar with the craft realized that there was a huge gap between what the eye saw and the finished photograph. Human beings have two eyes that are constantly moving to track forms across and into space; they perceive through time, not in fixed units; their angle of vision (the horizontal span perceived when holding the eye immobile) is not necessarily that of a lens; their eyes adjust rapidly to read objects both in bright sun and deep shadows. As Joel Snyder and Neil Allen observed in *Critical Inquiry* (Autumn 1975), "a photograph shows us 'what we would have seen' at a certain moment in time, *from* a certain vantage point *if* we kept our head immobile *and* closed one eye *and* if we saw with the equivalent of a 150-mm or 24-mm lens *and if* we saw things in Agfacolor or in Tri-X developed in D-76 and printed on Kodabromide #3 paper" (p. 152). And, they point out, if the eye and the camera saw the world in the same way, then the world would look the way it does in photographs.

Photographers also intervene in every step of the photographic process. They pose sitters; select the time of day or artificial light source; pick the camera, film, exposure time, and amount of light allowed to enter the camera (the lens *aperture*); position the camera at a certain height or distance from the subject; focus on a given plane or area; develop the film to bring out certain features; choose the printing paper and manipulate the print during enlargement and development; and so forth. By controlling the world in front of the camera, the environment within the camera, and the various procedures after the light-sensitive material's ini-

tial exposure to light, the photographer may attempt to communicate a personal interpretation or vision of the world. If he or she succeeds, we may begin to talk about a photographic "style" that may be perceptible in many images made over several years.

Since its invention in the early nineteenth century, photography has taken over many of the functions of the traditional pictorial arts while satisfying new functions, such as selling products or recording events as they actually happen. Because early photography seemed close to observed reality, it was rapidly used any time factual truth was required. Photographs have been taken of ancient and modern architecture, engineering feats, criminals' faces, biological specimens, astronomical phenomena, artworks, slum conditions, and just about anything that needed to be classified, studied, regulated, or commemorated. Because the validity of these images depended on their acceptance as truth, their creators often downplayed their role in constructing the photographs. The photojournalist Robert Capa, talking about his famous views of the Spanish Civil War, said "No tricks are necessary to take pictures in Spain. . . . The pictures are there, and you just take them. The truth is the best picture, the best propaganda."

While statements such as Capa's reveal what photographers once wanted the public to believe about their images, we now no longer accept photographs, even so-called documentary ones, as unmanipulated truth. All photographs are representations, in that they tell us as much about the photographer, the technology used to produce the image, and their intended uses as they tell us about the events or things depicted. In some news photographs, we now know that the event shown was in part staged. For example, the British photographer Roger Fenton, who was one of the first cameramen to record a war, moved the cannonballs that litter the blasted landscape in his famous *Valley of the Shadow of Death*, a photograph taken in 1855 during the Crimean War. Does this make a difference when we look at the picture as evidence of how a battleground appeared? Perhaps not. But we should be careful about ever assuming that from photographic evidence we can always draw valid conclusions about the lives of people, the historical meaning of events, and the possible actions that we should take.

Let's look now at a photograph (shown on p. 64) by Dorothea Lange, an American photographer who made her reputation with photographs of migrant farmers in California during the Depression that began in 1929. Lange's *Migrant Mother, Nipomo, California* (1936) is probably the best-known image of the period. A student made the following entry in a

Dorothea Lange,
*Migrant Mother,
Nipomo, California,*
1936. Gelatin-silver
print. (Collection,
The Museum of
Modern Art,
New York)

journal in which he regularly jotted down his thoughts about the material
in an art course he was taking. (The student was given no information
about the photograph other than its title and date.)

        This woman seems to be thinking. In a way, the
    picture reminds me of a statue called The Thinker,
    of a seated man who is bent over, with his chin
    resting on his hand. But I wouldn't say that this
    photograph is really so much about thinking as it is
    about other things. I'd say that it is about several
    other things. First (but not really in any particu-
    lar order), fear. The children must be afraid, since
    they have turned to their mother. Second, the pic-
    ture is about love. The children press against their
    mother, sure of her love. The mother does not actu-
    ally show her love—for instance, by kissing them, or
    even hugging them—but you feel she loves them.

Third, the picture is about hopelessness. The mother doesn't seem to be able to offer any comfort. Probably they have very little food; maybe they are homeless. I'd say the picture is also about courage. Although the picture seems to me to show hopelessness, I also think the mother, even though she does not know how she will be able to help her children, shows great strength in her face. She also has a lot of dignity. She hasn't broken down in front of the children; she is going to do her best to get through the day and the next day and the next.

Another student wrote:

Is this picture sentimental? I remember from American Lit that good literature is not sentimental. (When we discussed the word, we concluded that "sentimental" meant "sickeningly sweet.") Some people might think that Lange's picture, showing a mother and two little children, is sentimental, but I don't think so. Although the children must be upset, and maybe they even are crying, the mother seems to be very strong. I feel that with a mother like this, the children are in very good hands. She is not "sickeningly sweet." She may be almost overcome with despair, but she doesn't seem to ask us to pity her.

A third student wrote:

Why does this picture bother me? It's like those pictures of the homeless in the newspapers and on TV. A photographer sees some man sleeping in a cardboard box, or a woman with shopping bags sitting in a doorway, and he takes their picture. I suppose the photographer could say that he is calling the public's attention to "the plight of the homeless," but I'm not convinced that he's doing anything more than making money by selling photographs. Homeless people have almost no privacy, and then some photographer comes along and invades even their doorways and cardboard houses. Sometimes the people are sleeping, or even if they are awake they may be in so much despair that they don't bother to tell the photographer to get lost. Or they may be mentally ill and don't know what's happening. In the case of this picture, the woman is not asleep, but she seems so preoccupied that she isn't aware of the photographer. Maybe she has just been told there is no work for her, or maybe she has been told she can't stay if she keeps the children. Should the photographer

> have intruded on this woman's sorrow? This picture
> may be art, but it bothers me.

All of these entries are thoughtful, interesting, and helpful—material that can be the basis of an essay—though of course even taken together they do not provide the last word. But it happens that Lange has written about this picture. She said that she had spent the winter of 1935–36 taking photographs of migrants, and now, in March, she was preparing to drive 500 miles to her home, when she noticed a sign that said, "Pea-Pickers Camp." Having already taken hundreds of pictures, she drove on for 20 miles, but something preyed on her mind, and she made a U-turn and visited the camp. Here is part of what she wrote.

> I saw and approached the hungry and desperate mother, as if drawn by a magnet. I do not remember how I explained my presence or my camera to her, but I do remember she asked me no questions. I made five exposures, working closer and closer from the same direction. I did not ask her name or her history. She told me her age, that she was thirty-two. She said that they had been living on frozen vegetables from the surrounding fields, and birds that the children killed. She had just sold the tires from her car to buy food. There she sat in that lean-to tent with her children huddled around her, and seemed to know that my pictures might help her, and so she helped me. There was a sort of equality about it. . . . What I am trying to tell other photographers is that had I not been deeply involved in my undertaking on that field trip, I would not have had to turn back. What I am trying to say is that I believe this inner compulsion to be the vital ingredient in our work.
>
> Dorothea Lange, "The Assignment I'll Never Forget,"
> *Popular Photography* (February 1960), p. 43

Far from being a neutral document, Lange intended for this photograph to encapsulate her sympathy for displaced migrant workers and her belief that they need government assistance. As comparisons between this justly famous image and the other prints taken at the same time reveal, only this photograph is symmetrical and contrasts the strained face of the mother with the two bedraggled but anonymous children and the almost hidden baby in her lap. Although the clothing, place, and people are real, in the sense that Lange found them in this condition, she undoubtedly encouraged this pose, which echoes traditional representations of the Madonna and child. The tow-headed but grimy children become all children; the mother, seeming to look searchingly off to her right while raising her worn hand tentatively to her chin, could be any American mother worried about her family. The most effective social

document, as Lange herself would readily admit, is not necessarily the spontaneous snapshot taken without the photographer's intervention in the scene. It is the careful combination of subject matter and composition that grabs our attention and holds it.

Some photographs are more obvious in the ways that they reveal the point of view of the person behind the camera and the manipulation of observed reality. Many of these images are intended to be sold and appreciated as aesthetic documents. In other words, the formal properties of the image—its composition, shades of tone or color, quality of light, use of blurs and grain—become as important as or more important than the depicted subject in inspiring feelings or ideas in the viewer. Edward Weston's *Bell Pepper* (1930), placed against a mysterious black background and softly lit from the side, makes us think of the ways that the ever-changing curves and bulges of common vegetables repeat the sensual, intertwined limbs of the human body. By moving close to the isolated object and carefully controlling the lighting, Weston assumes an aesthetic rather than a botanical approach. The picture would not be very successful as an illustration for a book on the various species of peppers and their reproductive structures; it does not present the kind of visual information that we have grown to expect from such illustrations.

In other cases, the distinctions between the artistic photograph and the documentary photograph are less clear from internal evidence. Many nineteenth-century photographs that were originally conceived as records of buildings or machinery have struck recent viewers as beautiful and expressive of a personal vision. The turn-of-the-century French photographer Eugène Atget earned his living selling standard-sized prints of eighteenth-century Parisian architecture and rapidly disappearing street vendors to antiquarians, libraries, cartoonists, and illustrators. By the time of Atget's death in 1927, avant-garde artists were struck by the uncanny stillness and radiant light of many of his photographs and began collecting them as the work of a naive genius. As tastes have changed and the intended functions of photographic images have been forgotten or ignored, our understanding of photography has also shifted from the functional or documentary to the aesthetic. In writing about photographs, you should be aware of the ways that the passage of time and the changes in context transform what photographs mean. We do not respond to a framed photograph on the walls of a museum in the same way that we respond to that photograph reproduced in *Life* magazine.

At various points in the history of the medium, photographers have pointedly taken past or contemporary paintings or drawings as models for

artistic photographs. They introduced Rembrandtesque lighting into portraits or contrived figure compositions imitating Raphael or Millet. In the late nineteenth century, to distinguish their works from the flood of easily made snapshots of family outings, self-proclaimed art photographers used soft-focus and extensive hand manipulation of negatives and prints to make photographs that looked like charcoal drawings. These *pictorialists*, whose goal was to elevate photography to the rank of serious art by imitating the look of that art, were condemned in the early twentieth century by such photographers as Alfred Stieglitz (1864–1946), who argued that the best photographs were those that were honest to the unique properties of camera vision. (There was, however, little recognition that these properties were themselves changing as equipment and processes changed.)

Whereas modern photographers have rarely tried to legitimize their practice by literally copying famous paintings, they have often reintroduced manual manipulations and elaborate staging. A **manipulated photograph** is one in which either the negative or the positive (i.e., the print) has been altered by hand or, more recently, by computer. Negatives may be scratched, drawn on, or pieced together; positive prints may be hand-tinted or have their emulsions (the coating on the paper that contains the light-sensitive material) smeared with a brush. Computer-aided processes are now often used to manipulate images. For instance, images from old magazines can be put into digital form and combined and colorized on a computer, allowing the artist, in David Hockney's words, "to work on photographs the way a draftsman might" (*Aperture*, 1992). Yasumasa Morimura, one of the most ingenious makers of manipulated pictures, uses computer technology to create composite photographs of famous paintings with images of himself—usually costumed in the appropriate period or semi-nude. Thus, for his *Portrait (Nine Faces)*, he used a computer to blend parts of his own face into the nine faces (including the face of the corpse) of Rembrandt's *The Anatomy Lesson*. A **fabricated photograph** is one in which the subject has been constructed or staged to be photographed. In a certain sense, all still lifes are fabricated photographs. More recently, photographers coming out of art school backgrounds have choreographed events or crafted environments to challenge our belief in photographic truth or question conventions of representation. For example, William Wegman made a jungle out of a couple of plants and turned his dog into an elephant by means of a long sock put on to the dog's snout.

When we turn to analyze a photograph, many of the questions on drawing and painting—for example, those on composition and even color—also apply. But because of the different ways that photographs are produced, their peculiar relationship to the physical world as it existed at some point in the past, and their multiple functions, we need to expand our questions to reflect these special concerns.

Our first concern in analyzing a photograph is **identification of the work** (much of this information is often provided by a wall label or photo caption). Who took the photograph? Was it an individual or a photographic firm (usually identified on the negative or in a stamp or label)? Was the positive print produced by the same individual (or firm) who exposed the negative? If the photographer is unknown, can the photograph be assigned to a country or region of production?

What is the **title** of the work? Was the photograph given a title by its creator(s) in the form of an inscription on the negative or positive? Or was the title added by later viewers? What does the title tell you about the intended function of the photograph? Did the photographer identify the **date** of the work? When was the exposure made? When was the positive print made?

What type of **photographic process** was used to produce the negative? The positive? On what sort of paper was the positive printed? Are these processes typical for the period? Why do you think the photographer chose these particular processes?

Analysis of a photographic work also involves looking at its **physical properties**. What are the dimensions of the photograph? Are these typical for the techniques chosen? What effect does the **size** of the work have on the viewer's analysis of it? Is the photograph printed on paper or on some other type of material, such as metal or silk? If the image is on paper, is the paper matte, glossy, or somewhere in between? What is the color of the print? Has it been hand-tinted or retouched? How do the physical properties of the print influence the viewer's reaction? Is the print damaged, torn, abraded, faded? Has the paper been trimmed or cropped? If the image is on metal, has there been corrosion, tarnishing, or other damage that alters your appreciation of the image? Are there signs in the print of damage to the negative?

Briefly describe the **subject** of the photograph. Is it a traditional subject—a landscape, a still life, a portrait, a genre, an allegorical or historical scene, or a documentary? Do the figures or objects in the picture seem arranged by the photographer or caught "as they were"? Are props

included? To what extent did the photographer fabricate or create the image by physically constructing, arranging, or interacting with some or all of its components? How does this affect the viewer's response? In addition, the many **formal properties** of a photograph are relevant to an analysis. If the work is considered as a **two-dimensional** composition, how is the subject represented? Which are the most important forms and where are they located on the picture's plane? Is the composition balanced or unbalanced? How does your eye read the photograph? What did the photographer leave out of the frame? What happens along the edges of the photograph? How obvious and important is the two-dimensional composition?

If the work is considered as a **three-dimensional** composition, where is the main activity taking place—in the foreground, the midground, the background, or a combination of these areas? How did the photographer define (or not define) the three-dimensional space? How can you describe the space—as shallow or deep, static or dynamic, claustrophobic or open, rational or irrational? How important is the three-dimensional composition?

Look for the photographer's choice of **vantage point** and **angle of vision**. How near or far does the main subject appear? Does the photograph draw the viewer's attention to where the photographer was located? How does the position from which the picture was taken contribute to the mood or content of the image? What is the angle of vision? How does it compare with "normal" vision? Is there lens distortion? Why do you think the photographer chose the lens he or she did?

Examine the **detail** and **focus** of the work. Can you characterize the overall focus? Where are the areas of sharp focus? Soft focus? What is the **depth of field** (i.e., the minimum and maximum distances from the camera that are in sharp focus)? How did the photographer use focus to convey meaning? Is the image detailed or grainy? How does the detail or grain contribute to or detract from the image?

What sort of **lighting** was used? Was the photograph taken out-of-doors or inside, in natural or artificial light (or in some combination of the two)? How did the season or time of day affect the lighting conditions? Where is the main light source? The secondary light source? Was a flash used? How can you characterize the lighting—as harsh, subtle, flat, dramatic, magical, or what? What effects do you think the photographer was trying to achieve through the use or control of light?

Consider also **contrast** and **tonal range**. Within the black and white print, what is the range of light and dark? Where are the darkest and

lightest areas? Does the print have high contrast, with large differences in tone from light to dark, or does it have low contrast, with many shades of grey? What overall effect do contrast and tone create? What **exposure time** did the photographer choose? How does the length of the exposure influence the image? Do any blurs or midaction motions signal the passage of time? How does the length of the exposure add or detract from the image?

Taking into consideration the preceding points, what do you think the photographer was trying to say in this image? What aspects of the subject did the photographer want to accentuate? What was the photographer's attitude toward the subject? What does the photograph convey to you today—about a place, a time, a person, an event, or a culture?

## Another Look at the Questions

As the preceding discussion has shown, there are many ways of helping yourself to see. In short, you can stimulate responses (and understanding) by asking yourself two basic questions:

- *What is this doing?* Why is this figure here and not there? Why is the work in bronze rather than in marble? Or put it this way: What is the artist up to?
- *Why do I have this response?* Why do I find this landscape oppressive, this child sentimental but that child fascinating? That is, how did the artist manipulate the materials in order to produce the strong feelings that I experience?

The first of these questions (*What is this doing?*) requires you to identify yourself with the artist, wondering, perhaps, why the artist chose one medium over another, whether pen is better than pencil for this drawing, or watercolor better than oil paint for this painting. One senses that Eugene J. Johnson may have put to himself questions of this sort before making the following points about Eero Saarinen's Terminal Building at Dulles International Airport (1958–62; see p. 72), Washington, D.C.

Rising majestically out of the flat countryside, the broad, low structure echoes, in its strong horizontal roof supported by regularly spaced posts, the classical architecture of Washington, and perhaps even the great porch of George Washington's house at nearby Mount Vernon. Indeed, the whole terminal is a porch. Departing or arriving, the traveler experiences the building as a semi-enclosed space that lies between the

Eero Saarinen, Dulles International Airport Terminal, 1958–62, Washington, D.C.
(Courtesy of the U.S. Department of Transportation)

enclosed space of the airplane or of the bus that brings the traveler to
the terminal proper and the open Virginia landscape that waits outside.
*International Handbook of Contemporary Developments in Archi-*
*tecture,* ed. Warren Sanderson (1981), p. 509

Sometimes artists tell us what they are up to. Van Gogh, for example,
in a letter (August 11, 1888) to his brother, helps us to understand why he
put a blue background behind the portrait of a blond artist: "Behind the
head instead of painting the ordinary wall of the mean room, I paint in-
finity, a plain background of the richest, intensest blue that I can con-
trive, and by the simple combination of the bright head against the rich
blue background, I get a mysterious effect, like a star in the depths of an
azure sky." But, of course, you cannot rely on the artist's statement of in-
tention; the intention may not be fulfilled in the work itself.

The second question (*Why do I have this response?*) requires you to
trust your feelings. If you are amused or repelled or unnerved or soothed,
assume that your response is appropriate and follow it up—but not so
rigidly that you exclude the possibility of other, even contradictory feel-
ings. (The important complement to "Trust your feelings" is "Trust the

work of art." The study of art ought to enlarge feelings, not merely confirm them.)

Almost any art history book that you come across will attempt to answer questions posed by the author. For example, in the introduction to *American Genre Painting: The Politics of Everyday Life* (1991), Elizabeth Johns writes:

> Two simple questions underscore my diagnosis: "Just whose 'everyday life' is depicted?" and "What is the relationship of the actors in this 'everyday life' to the viewers?"

The book contains her answers.

Indeed, most art historians ask the questions "What?" "Why?" and "Who?"—and offer answers.

## FORMAL ANALYSIS

### What Formal Analysis Is

It should be understood that the word *formal* in **formal analysis** is not used as the opposite of *informal,* as in a formal dinner or a formal dance. Rather, a formal analysis is an analysis of the form the artist produces; that is, an analysis of the work of art, which is made up of such things as line, shape, color, texture. These things give the stone or canvas its form, its expression, its content, its meaning. Rudolf Arnheim's assertion that the curves in Michelangelo's *The Creation of Adam* convey "transmitted, life-giving energy" is a brief example. Similarly, one might say that a pyramid resting on its base conveys stability, whereas an inverted pyramid— one resting on a point—conveys instability or precariousness. Even if we grant that these forms may not universally carry these meanings, we can perhaps agree that at least in our culture they do. That is, members of a given *interpretive community* (to use a current term) perceive certain forms or lines or colors or whatever in a certain way.

Formal analysis assumes a work of art is (1) a constructed object (2) with a stable meaning (3) that can be ascertained by studying the relationships between the elements of the work. Thus, a picture (or any other kind of artwork) is like a chair; a chair *can* of course be stood on or burned for firewood or used as a weapon to keep a lion at bay, but it was created with a specific purpose that was evident and remains evident to all competent viewers—in this case, people who are familiar

with chairs—and (a further point) it can be evaluated with reference to its purpose.

## Opposition to Formal Analysis

Given its assumption that artists shape their materials so that a work of art embodies a particular meaning and evokes a pleasurable response in the spectator, formal analysis was especially popular in the early to mid-twentieth century. Since about 1970, however, considering works of art primarily on the basis of formal analysis has been strongly called into question. There has been a marked shift of interest from the work as a thing whose meaning is contained within itself—a decontextualized object—to a thing whose meaning partly, largely, or even entirely consists of its context, its relations to things outside of itself—especially its relationship to the person who perceives it. (This point has been discussed earlier, on pp. 17–19.) Further, there has been a shift from viewing an artwork as a thing of value in itself—or as an object that provides pleasure and that conveys some sort of profound and perhaps universal meaning—to viewing the artwork as an object that reveals the power structure of a society. The work is thus brought down to earth, so to speak, and is said thereby to be "demystified." Thus, the student does not look for a presumed unified whole; on the contrary, the student "deconstructs" the work by looking for "fissures" and "slippages" that give away—reveal, unmask—the underlying political and social realities that the artist sought to cover up with sensuous appeal. A discussion of an early nineteenth-century idyllic landscape painting, for instance, today might call attention not to the elegant brushwork and the color harmonies (which earlier might have been regarded as sources of aesthetic pleasure), or even to the neat hedges and meandering streams (meant to evoke pleasing sensations), but to such social or psychological matters as the painter's unwillingness to depict the hardships of rural life and the cruel economic realities of land ownership in an age when poor families could be driven from their homes at the whim of a rich landowner. Such a discussion might even argue that the picture, by means of its visual seductiveness, seeks to legitimize social inequities. (We will return to the matters of demystification and deconstruction in Chapter 4, when we look at the social historian's approach to artworks, on pp. 104–07.)

We can grant that works of art are partly shaped by social and political forces (these are the subjects of historical and political approaches,

discussed in Chapter 4); and we can grant that works of art are partly shaped by the artist's personality (the subject of psychoanalytical approaches, also discussed in Chapter 4). But this is only to say that works of art can be studied from several points of view; it does not invalidate the view that these works are also, at least in part, shaped by conscious intentions, and that the shapes or constructions that the artists (consciously or not) have produced convey a meaning. Even critics who are not concerned with the artist's intentions have argued on behalf of the study of form. As Michel Foucault puts it in "What Is an Author?" in *The Foucault Reader* (1984), "Criticism should concern itself with the structures of a work, its architectonic forms, which are studied for their intrinsic and internal relationships."

## Formal Analysis Versus Description

Is the term *formal analysis* merely a pretentious substitute for *description?* Not quite. A **description** is an impersonal inventory, dealing with the relatively obvious, reporting what any eye might see: "A woman in a white dress sits at a table, reading a letter. Behind her. . . ." It can also comment on the execution of the work ("thick strokes of paint," "a highly polished surface"), but it does not offer inferences, and it does not evaluate. A highly detailed description that seeks to bring the image before the reader's eyes—a kind of writing fairly common in the days before illustrations of artworks were readily available in books—is sometimes called an *ekphrasis* (plural: *ekphrases*), from the Greek *ek* ("out") and *phrazein* ("tell" or "declare"). Such a description may be set forth in terms that also seek to convey the writer's emotional response to the work. That is, the description may seek to give the reader a sense of being in the presence of the work, especially by commenting on the presumed emotions expressed by the depicted figures. Here is an example: "We recoil with the terrified infant, who averts his eyes from the soldier whose heart is as hard as his burnished armor."

Writing of this sort is no longer common; a description today is more likely to tell us, for instance, that the head of a certain portrait sculpture "faces front; the upper part of the nose and the rim of the right earlobe are missing. . . . The closely cropped beard and mustache are indicated by short random strokes of the chisel," and so forth. These statements, from an entry in the catalog of an exhibition, are all true and they can be useful, but they scarcely reveal the thought, the reflectiveness, that we

associate with analysis. When the entry in the catalog goes on, however, to say that "the surfaces below the eyes and cheeks are sensitively modeled to suggest the soft, fleshly forms of age," we begin to feel that now indeed we are reading an analysis. Similarly, although the statement that "the surface is in excellent condition" is purely descriptive (despite the apparent value judgment in "excellent"), the statement that the "dominating block form" of the portrait contributes to "the impression of frozen tension" can reasonably be called analytic. One reason we can characterize this statement as analytic is that it is concerned with cause and effect: The dominating block form produces an effect—*causes* us to perceive a condition of frozen tension.

Much of any formal analysis will inevitably consist of description ("The pupils of the eyes are turned upward"), and accurate descriptive writing itself requires careful observation of the object and careful use of words. But an essay is a formal analysis rather than a description only if it connects causes with effects, thereby showing *how* the described object works. For example, "The pupils of the eyes are turned upward" is a description, but the following revision is an analytic statement: "The pupils of the eyes are turned upward, suggesting a heaven-fixed gaze, or, more bluntly, suggesting that the figure is divinely inspired."

Another way of putting it is to say that analysis tries to answer the somewhat odd-sounding question, "*How* does the work mean?" Thus, the following paragraph, because it is concerned with *how* form makes meaning, is chiefly analytic rather than descriptive. The author has made the point that a Protestant church emphasizes neither the altar nor the pulpit; "as befits the universal priesthood of all believers," he says, a Protestant church is essentially an auditorium. He then goes on to analyze the ways in which a Gothic cathedral says or means something very different:

> The focus of the space on the interior of a Gothic cathedral is . . . compulsive and unrelievedly concentrated. It falls, and falls exclusively, upon the sacrifice that is re-enacted by the mediating act of priest before the altar-table. So therefore, by design, the first light that strikes the eye, as one enters the cathedral, is the jeweled glow of the lancets in the apse, before which the altar-table stands. The pulsating rhythm of the arches in the nave arcade moves toward it; the string-course moldings converge in perspective recession upon it. Above, the groins of the apse radiate from it; the ribshafts which receive them and descend to the floor below return the eye inevitably to it. It is the single part of a Gothic space in which definiteness is certified. In any other place, for any part which the

eye may reach, there is always an indefinite beyond, which remains to be explored. Here there is none. The altar-table is the common center in which all movement comes voluntarily to rest.

John F. A. Taylor, *Design and Expression in the Visual Arts* (1964), pp. 115–17

In this passage the writer is telling us, analytically, *how* the cathedral means.

## STYLE AS THE SHAPER OF FORM

This chapter has in part been talking about style, and it is now time to define this elusive word. The first thing to say about **style** is that the word is *not* used by most art historians to convey praise, as in "He has style." Rather, it is used neutrally, for everyone and everything made has a style—good, bad, or indifferent. The person who, as we say, "talks like a book" has a style (probably an annoying one), and the person who keeps saying "Uh, you know what I mean" has a style too (different, but equally annoying).

Similarly, whether we wear jeans or painter's pants or gray flannel slacks, we have a style in our dress. We may claim to wear any old thing, but in fact we don't; there are clothes we wouldn't be caught dead in. The clothes we wear are expressive; they announce that we are police officers or bankers or tourists or college students—or at least they show what we want to be thought to be, as when in the 1960s many young middle-class students wore tattered clothing, thus showing their allegiance to the poor and their enmity toward what was called the Establishment. It is not silly to think of our clothing as a sort of art that we make. Once we go beyond clothing as something that merely serves the needs of modesty and that provides protection against heat and cold and rain, we get clothing whose style is expressive.

To turn now to our central topic—style in art—we can all instantly tell the difference between a picture by van Gogh and one by Norman Rockwell or Walt Disney, even though the subject matter of all three pictures may be the same (e.g., a seated woman). How can we tell? By the style—that is, by line, color, medium, and all of the other things we talked about earlier in this chapter. Walt Disney's figures tend to be built up out of circles and ovals (think of Mickey Mouse), and the color shows no modeling or traces of brush strokes; Norman Rockwell's methods of depicting figures are different, and van Gogh's are different in yet other

ways. Similarly, a Chinese landscape, painted with ink on silk or on paper, simply cannot look like a van Gogh landscape done with oil paint on canvas, partly because the materials prohibit such identity and partly because the Chinese painter's vision of landscape (usually lofty mountains) is not van Gogh's vision. Their works "say" different things. As the poet Wallace Stevens put it, "A change of style is a change of subject."

We recognize certain *distinguishing characteristics* (from large matters, such as choice of subject and composition, to small matters, such as kinds of brush strokes) that mark an artist, or a period, or a culture, and these constitute the style. Almost anyone can distinguish between a landscape painted by a traditional Chinese artist and one painted by van Gogh. But it takes considerable familiarity with van Gogh to be able to say of a work, "Probably 1888 or maybe 1889," just as it takes considerable familiarity with the styles of Chinese painters to be able to say, "This is a Chinese painting of the seventeenth century, in fact the late seventeenth century. It belongs to the Nanking School and is a work by Kung Hsien—not by a follower, and certainly not a copy, but the genuine article."

Style, then, is revealed in **form**; an artist creates form by applying certain techniques to certain materials, in order to embody a particular vision or content. In different ages people have seen things differently: the nude body as splendid, or the nude body as shameful; Jesus as majestic ruler, or Jesus as the sufferer on the cross; landscape as pleasant, domesticated countryside, or landscape as wild nature. So the chosen subject matter is not only part of the content, but is also part of that assemblage of distinguishing characteristics that constitutes a style.

All of the elements of style, finally, are expressive. Take ceramics as an example. The kind of clay, the degree of heat at which it is baked, the decoration or glaze (if any), the shape of the vessel, the thickness of its wall, all are elements of the potter's style, and all contribute to the expressive form. But every expressive form is not available in every age; certain visions, and certain technologies, are, in certain ages, unavailable. Porcelain, as opposed to pottery, requires a particular kind of clay and an extremely high temperature in the kiln, and these were simply not available to the earliest Japanese potters. In fact, even the potter's wheel was not available to them; they built their pots by coiling ropes of clay and then, sometimes, they smoothed the surface with a spatula. The result is a kind of thick-walled, low-fired ceramic that expresses energy and earthiness, far different from those delicate Chinese porcelains that express courtliness and the power of technology (or, we might say, of art).

## SAMPLE ESSAY: A FORMAL ANALYSIS

The following sample essay, written by an undergraduate, includes a good deal of description (a formal analysis usually begins with a fairly full description of the artwork), and the essay is conspicuously impersonal (another characteristic of a formal analysis). But notice that even this apparently dispassionate assertion of facts is shaped by a *thesis*. If we stand back from the essay, we can see that the basic argument is this: The sculpture successfully combines a highly conventional symmetrical style, on the one hand, with mild asymmetry and a degree of realism, on the other. Put thus, the thesis does not sound especially interesting, but that is because the statement is highly abstract, lacking in concrete detail. A writer's job is to take that idea (thesis) and to present it in an interesting and convincing way. The idea will come alive for the reader when the writer supports it by calling attention to specific details—the evidence—as the student writer does in the following essay.

<div align="right">

Stephen Beer

Fine Arts 10A

September 10, 1995

</div>

Formal Analysis: Prince Khunera as a Scribe

Prince Khunera as a Scribe, a free-standing
Egyptian sculpture 12 inches tall, now in the Museum
of Fine Arts, Boston, was found at Giza in a temple
dedicated to the father of the prince, King
Mycerinus. The limestone statue may have been a
tribute to that Fourth Dynasty king.[1] The prince,
sitting cross-legged with a scribal tablet on his
lap, rests his hands on his thighs. He wears only a
short skirt or kilt.

The statue is in excellent condition although
it is missing its right forearm and hand. Fragments
of the left leg and the scribe's tablet also have
been lost. The lack of any difference in the carving
between the bare stomach and the kilt suggests that

---

[1] Museum label.

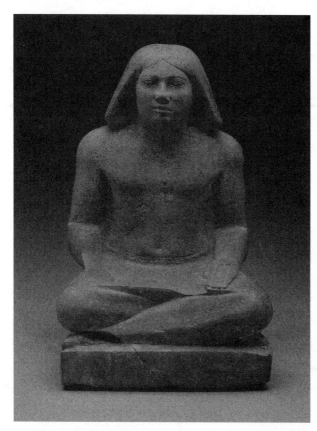

Egyptian, *Seated Statue of Prince Khunera as a Scribe*, 2548–2524 BC. Yellow limestone, 12″. (Courtesy of Museum of Fine Arts, Boston, Museum Expedition)

these two features were once differentiated by contrasting paint that has now faded, but the only traces of paint remaining on the figure are bits of black on the hair and eyes.

The statue is symmetrical, composed along a vertical axis which runs from the crown of the head into the base of the sculpture. The sculptor has relied on basic geometric forms in shaping the statue on either side of this axis. Thus, the piece could be described as a circle (the head) within a

triangle (the wig) which sits atop a square and two
rectangles (the torso, the crossed legs, and the
base). The reliance on basic geometric forms reveals
itself even in details. For example, the forehead is
depicted as a small triangle within the larger
triangular form of the headdress.

On closer inspection, however, one observes
that the rigidity of both this geometric and
symmetric organization is relieved by the artist's
sensitivity to detail and by his ability as a
sculptor. None of the shapes of the work is a true
geometric form. The full, rounded face is more of an
oval than a circle, but actually it is neither. The
silhouette of the upper part of the body is defined
by softly undulating lines that represent the
muscles of the arms and that modify the simplicity
of a strictly square shape. Where the prince's naked
torso meets his kilt, just below the waist, the
sculptor has suggested portliness by allowing the
form of the stomach to swell slightly. Even the
"circular" navel is flattened into an irregular
shape by the suggested weight of the body. The
contours of the base, a simple matter at first
glance, actually are not exactly four-square but
rather are slightly curvilinear. Nor is the symmetry
on either side of the vertical axis perfect: Both
the mouth and the nose are slightly askew; the right
and left forearms originally struck different poses;
and the left leg is given prominence over the right.
These departures from symmetry and from geometry
enliven the statue, giving it both an individuality
and a personality.

Although most of the statue is carved in broad
planes, the sculptor has paid particular attention

to details in the head. There he attempted to render
precisely and with apparent descriptive accuracy the
details of the prince's face. The parts of the eye,
for example—the eyebrow, eyelids, eyeballs, and
sockets—are distinct. Elsewhere the artist has not
worked in such probing detail. The breasts, for
instance, are rendered in large forms, the nipples
being absent. The attention to the details of the
face suggests that the artist attempted to render a
lifelikeness of the prince himself.

The prince is represented in a scribe's pose
but without a scribe's tools. The prince is not
actually doing anything. He merely sits. The absence
of any open spaces (between the elbows and the
waist) contributes to the figure's composure or
self-containment. But if he sits, he sits
attentively: There is nothing static here. The
slight upward tilt of the head and the suggestion
of an upward gaze of the eyes give the impression
that the alert prince is attending someone else,
perhaps his father the king. The suggestion in the
statue is one of imminent work rather than of work
in process.

Thus, the statue, with its variations from
geometric order, suggests the presence, in stone, of
a particular man. The pose may be standard and the
outer form may appear rigid at first, yet the
sculptor has managed to depict an individual. The
details of the face and the overfleshed belly reveal
an intent to portray a person, not just a member of
the scribal profession. Surely when freshly painted
these elements of individuality within the confines
of conventional forms and geometric structure were
even more compelling.

# Behind the Scene: Beer's Essay, from Early Responses to Final Version

Let's go backstage, so to speak, to see how Stephen Beer turned his notes into a final draft.

**Beer's Earliest Responses.** After studying the object and reading the museum label, Beer jotted down some ideas on 3 × 5-inch index cards. What historical information does the label provide? (Beer recorded the material on a note card.) Can the sculpture be called realistic? Yes and no. (Beer put his responses, in words, on the cards.) What is the condition of the piece? (Again he put his responses into writing, on cards.) A day later, when he returned to work on his paper, stimulated by another look at the artwork and by a review of his notes, Beer made additional jottings.

**Organizing Notes.** When the time came to turn the notes into a draft and the revised draft into an essay, Beer reviewed the cards and he added further thoughts. Next, he organized the note cards, putting together into a packet whatever cards he had about (for instance) realism, and putting together, into another packet, whatever cards he had about (again, for instance) background material. Reviewing the cards in each packet, and on the basis of this review discarding a few cards that no longer seemed useful and moving an occasional card to a different packet, Beer started to think about how he might organize his essay.

As a first step in settling on an organization, he arranged the packets into a sequence that seemed reasonable to him. It made sense, he thought, to begin with some historical background and a brief description, then to touch on Egyptian sculpture in general (but he soon decided *not* to include this general material), then to go on to some large points about the particular piece, then to refine some of these points, and finally to offer some sort of conclusion. This organization, he felt, was reasonable and would enable his reader to follow his argument easily.

**Preparing a Preliminary Outline.** In order to get a clearer idea of where he might be going, Beer then keyboarded—following the sequence of his packets—the gist of what at this stage seemed to be the organization of his chief points. In short, he prepared a map or rough

outline so that he could easily see, almost at a glance, if each part of his paper would lead coherently to the next part.

Beer realized that in surveying his outline he might become aware of points that he should have included but that he had instead overlooked.

A tentative outline, after all, is not a straitjacket that determines the shape of the final essay. To the contrary, it is a preliminary map that, when examined, helps the writer to see not only pointless detours—these will be eliminated in the draft—but also undeveloped areas that need to be worked up. As the handwritten additions in Beer's outline indicate, after drafting his map he made some important changes before writing a first draft:

```
Background: Egypt to Boston;
     free-standing, 12" limestone;
     Giza overall view: sitting, hands on thighs
General remarks on Egyptian sculpture
condition:
     some parts missing
     paint almost all gone                    description
symmetry (geometry?)
     square (body)
     circle in a triangle (head)
     two rectangles
variations in symmetry    face not really a circle (oval)
     body varied                navel,
     smaller variations (face, ∧forearms)
realism (yes and no)                Pose:
conclusion, summary (?):        static? Active? Both?
     geometric but varied
     individualized (??)
     combination
```

**Writing a Draft**. Working from his thoughtfully revised outline, Beer wrote a first draft, which he then revised into a second draft. The second draft, when further revised, became the final essay.

**Outlining a Draft.** A good way to test the coherence of a final draft— to see if it indeed qualifies as an essay rather than as a draft—is to outline it, paragraph by paragraph, in *two* ways, indicating what each paragraph *says,* and what each paragraph *does.*

Here is a double outline of this sort for Beer's essay. The italicized words, in (b.), indicate what the writer is *doing* in the paragraph.

1. a. Historical background and brief description
   b. *Introduces* the artwork
2. a. The condition of the artwork
   b. *Provides further overall description, preparatory to the analysis*
3. a. The geometry of the work
   b. *Introduces the thesis,* concerning the basic, overall geometry
4. a. Significant details
   b. *Modifies (refines) the argument*
5. a. The head
   b. *Compares* the realism of head with the breasts, in order to make the point that the head is more detailed
6. a. The pose
   b. *Argues* that the pose is not static
7. a. Geometric, yet individual
   b. *Concludes,* largely by *summarizing*

An outline of this sort, in which you force yourself to consider not only the content but also the function of each paragraph, will help you to see if your essay says something and says it with the help of an effective structure.

# 3

## Writing a Comparison

### COMPARING AS A WAY OF DISCOVERING

Analysis frequently involves comparing: Things are examined for their resemblances to and differences from other things. Strictly speaking, if one emphasizes the differences rather than the similarities, one is contrasting rather than comparing, but we need not preserve this distinction; we can call both processes *comparing*.

Although your instructor may ask you to write a comparison of two works of art, the *subject* of the essay is the *works*, or, more precisely, the subject is the thesis you are advancing; for example, that one work is later than the other, or is more successful. Comparison is simply an effective analytical *technique* to show some of the qualities of the works. We usually can get a clearer idea of what $X$ is when we compare it to $Y$—provided that $Y$ is at least somewhat like $X$. Comparing, in short, is a way of discovering, a way of learning. For example, in a course in architecture you may compare two subway stations (considering the efficiency of the pedestrian patterns, the amenities, and the aesthetic qualities), with the result that you may come to understand both of them more fully; but a comparison of a subway station with a dormitory, no matter how elegantly written, can hardly teach the reader or the writer anything. Nor can a comparison of the House of Commons with the House of Pancakes teach anything, as Judith Stone entertainingly demonstrates in an article published in the *The New York Times Magazine* (26 February 1995): She compares the number (1 House of Commons versus 620 Houses of Pancakes), the tipping practice (not allowed in the House of Commons but permitted in the House of Pancakes), the preferred salutation ("My honorable friend" versus "hon"), and so forth. If you keep in mind the principle that a comparison should help you to learn, you will not make useless comparisons.

Art historians almost always use comparisons when they discuss authenticity: A work of uncertain attribution is compared with undoubtedly

genuine works, on the assumption that the uncertain work, when closely compared with genuine works, will somehow be markedly different, perhaps in brush technique, it is probably not genuine (here we get to the thesis) despite superficial similarities of, say, subject matter and medium. (This assumption can be challenged—a given artist may have produced a work with unique characteristics—but it is nevertheless widely held.)

Comparisons are also commonly used in dating a work, and thus in tracing the history of an artistic movement on the development of an artist's career. The assumption here is that certain qualities in a work indicate the period, the school, perhaps the artist, and even the period within the artist's career. Let's assume, for instance, that there is no doubt about who painted a particular picture, and that the problem is the date of the work. By comparing this work with a picture that the artist is known to have done, say, in 1850, and with yet another that the artist is known to have done in 1870, one may be able to conjecture that the undated picture was done, say, midway between the dated works, or that it is close in time to one or the other.

The assumptions underlying the uses of comparison are that an expert can recognize not only the stylistic characteristics of an artist, but can also identify those that are permanent and can establish the chronology of those that are temporary. In practice these assumptions are usually based on yet another assumption: A given artist's early works are relatively immature; the artist then matures, and if there are some dated works, we can with some precision trace this development or evolution. Whatever the merits of these assumptions, comparison is a tool by which students of art often seek to establish authenticity and chronology.

## TWO WAYS OF ORGANIZING A COMPARISON

We can call the two ways of organizing *block-by-block* (or, less elegantly but perhaps more memorably, *lumping*), and *point-by-point* (or *splitting*). If you compare block-by-block you say what you have to say about one artwork in a block or lump, and then you go on to discuss the second artwork, in another block or lump. If you compare point-by-point, however, you split up your discussion of each work, more or less interweaving your comments on the two things being compared, perhaps in alternating paragraphs, or even in alternating sentences.

Here is a miniature essay—it consists of only one paragraph—that illustrates lumping. The writer compares a Japanese statue of a Buddha

*Shaka nyorai,*
Sakyamuni Buddha,
Japanese, late tenth
century. Wood, 33 ½".
(Denman Waldo
Ross Collection;
courtesy of Museum
of Fine Arts, Boston)

with a Chinese statue of a bodhisattva. (A Buddha has achieved enlight-
enment and has withdrawn from the world. A bodhisattva—in Sanskrit
the term means "enlighted being"—is, like a Buddha, a person of very
great spiritual enlightenment, but unlike a Buddha, a bodhisattva chooses
to remain in this world in order to save humankind.) The writer says what
she has to say about the Buddha, all in one lump, and then in another
lump says what she has to say about the bodhisattva.

     The Buddha, recognizable by a cranial bump that
indicates a sort of supermind, sits erect and
austere in the lotus position (legs crossed, each
foot with the sole upward on the opposing thigh), in
full control of his body. The carved folds of his
garments, in keeping with the erect posture, are
severe, forming a highly disciplined pattern that is
an outward expression of his remote, constrained,

*Bodhisattva Kuan Yin
Seated in Royal Ease
Position,* Chinese,
twelfth century.
Carved wood, 56 ½".
(Harvey Edward
Wetzel Fund; cour-
tesy of Museum of
Fine Arts, Boston)

austere inner nature. The bodhisattva, on the other
hand, sits in a languid, sensuous posture known as
"royal ease," the head pensively tilted downward,
one knee elevated, one leg hanging down. He is
accessible, relaxed, and compassionate.

The structure is, simply, this:

The Buddha (posture, folds of garments, inner nature)
The bodhisattva (posture, folds of garments, inner nature)

If, however, the writer had wished to split rather than to lump, she
would have compared an aspect of the Buddha with an aspect of the bod-
hisattva, then another aspect of the Buddha with another aspect of the
bodhisattva, and so on, perhaps ending with a synthesis to clarify the
point of the comparison. The paragraph might have looked like this:

> The Buddha, recognizable by a cranial bump that
> indicates a sort of supermind, sits erect and
> austere, in the lotus position (legs crossed, each
> foot with the sole upward on the opposing thigh), in
> full control of his body. In contrast, the
> bodhisattva sits in a languid, sensuous posture
> known as "royal ease," the head pensively tilted
> downward, one knee elevated, one leg hanging down.
> The carved folds of the Buddha's garments, in
> keeping with his erect posture, are severe, forming
> a highly disciplined pattern, whereas the
> bodhisattva's garments hang naturalistically. Both
> figures are spiritual but the Buddha is remote,
> constrained, and austere; the bodhisattva is
> accessible, relaxed, and compassionate.

In effect the structure is this:

The Buddha (posture)
The bodhisattva (posture)
The Buddha (garments)
The bodhisattva (garments)
The Buddha and the bodhisattva (synthesis)

Here is an outline, paragraph by paragraph, of an essay constructed on the principle of splitting. The essay (printed on pp. 93–95) compares two fifteenth-century Italian low-relief carvings of the Madonna and Child, one by Desiderio da Settignano, the other by Agostino di Duccio. (The illustrations appear on p. 94.)

The two were contemporaries, but their work is markedly different. Desiderio's Madonna has a "natural, homely humanity while Agostino's is elegantly aristocratic."

The differences are evident if we look at the hair; in Desiderio it is less clearly defined than in Agostino, who "treated the hair as a highly stylized pattern of regular lines." The drapery reveals a similar difference.

A comparison of the right forearms and hands of the two Virgins reveals a difference. Agostino. . . ; Desiderio. . . .

The outlines and modeling of the contours differ.

Conclusion: This is not to say that Agostino's relief is more carefully designed or that Desiderio's is more naturalistic—only that Desiderio's design is less obtrusive.

In a comparison it is usually advisable to begin by defining the main issue—here, although the works are of the same period, one depicts "homely humanity," the other depicts "aristocratic" figures. Then proceed with a comparative analysis, probably treating first the major aspects (e.g., composition, space, color) and next the finer points. But a comparison need not employ this structure, and indeed an essay that uses splitting too rigidly is likely to produce a Ping-Pong effect. There is also the danger that the essay will not come into focus—the point will not be grasped—until the essayist stands back from the seven-layer cake and announces, in the concluding paragraph, that the odd layers taste better. In one's preparatory thinking one may employ splitting in order to get certain characteristics clear in one's mind (line in Desiderio, line in Agostino; hair in each; treatment of arms in each), but one must come to some conclusions about what these add up to *before* writing the final version.

The final version should not duplicate the thought processes; rather, since the point of a comparison is *to make a point*, it should be organized so as to make the point clearly and effectively. Lumping will often do the trick. After reflection you may decide that although there are superficial similarities between $X$ and $Y$, there are essential differences; in the finished essay, then, you probably will not wish to obscure the main point by jumping back and forth from one work to the other, working through a series of similarities and differences. It may be better to announce your thesis, then discuss $X$, and then $Y$.

Whether in any given piece of writing you should compare by lumping or by splitting will depend largely on your purpose and on the complexity of the material. Lumping is usually preferable for long, complex comparisons, if for no other reason than to avoid the Ping-Pong effect, but no hard-and-fast rule covers all cases here. Some advice, however, may be useful:

- **If you split**, in rereading your draft:
  — *Ask yourself if your imagined reader can keep up with the back-and-forth movement.* Make sure (perhaps by a summary sentence at the end) that the larger picture is not obscured by the zig-zagging.
  — *Don't leave any loose ends.* Make sure that if you call attention to points 1, 2, and 3, in $X$, you mention all of them (not just 1 and 2) in $Y$.
- **If you lump**, do not simply comment first on $X$ and then on $Y$.
  — *Let your reader know where you are going*, probably by means of an introductory sentence.

*— Don't be afraid in the second half to remind the reader of the first half.* It is legitimate, even desirable, to relate the second half of the comparison (chiefly concerned with Y) to the first half (chiefly concerned with X). Thus, you will probably say things like "Unlike X, Y shows . . . " or "Although Y superficially resembles X in such-and-such, when looked at closely Y shows. . . ." In short, a comparison organized by lumping will not break into two separate halves if the second half develops by reminding the reader how it differs from the first half.

Again, the point of a comparison is to call attention to the unique features of something by holding it up against something similar but significantly different. If the differences are great and apparent, a comparison is a waste of effort. (Blueberries are different from elephants. Blueberries do not have trunks. And elephants do not grow on bushes.) Indeed, a comparison between essentially and obviously unlike things will merely confuse, for by making the comparison, the writer implies that there are significant similarities, and readers can only wonder why they do not see them. The essays that do break into two unrelated halves are essays that make uninstructive comparisons: The first half tells the reader about five qualities in El Greco; the second half tells the reader about five different qualities in Rembrandt. You will notice in the student essay later in this chapter (pp. 96–103) that the second half occasionally looks back to the first half.

## SAMPLE ESSAYS: TWO COMPARISONS

The first of these essays, already introduced in outline form on page 90, is reprinted from a book. It compares two objects more or less simultaneously. The second essay, by an undergraduate, discusses one object first and then discusses the second. Thus, the second essay lumps rather than splits. It does not break into two separate parts because at the start it looks forward to the second object, and in the second half of the essay it occasionally reminds us of the first object.

By the way, when you read the student's essay, don't let its excellence discourage you into thinking that you can't do as well. This essay, keep in mind, is the product of much writing and rewriting. As Rebecca Bedell wrote, her ideas got better and better, for in her drafts she sometimes put down a point and then realized that it needed strengthening (e.g., with concrete details) or that—come to think of it—the

point was wrong and ought to be deleted. She also derived some minor assistance—for facts, not for her fundamental thinking—from books, which she cites in footnotes.

**L. R. Rogers**

## Two Low Relief Carvings from the Fifteenth Century

We turn now to two fifteenth-century Italian low relief carvings on the theme of the Madonna and Child. Desiderio da Settignano's all too short thirty-five years of life (1430–64) began and ended during the lifetime of Agostino di Duccio (1418–81). Yet although the two artists were contemporaries who almost certainly knew of each other's work, it would be difficult to find two artists who display a greater difference in the qualities of their lines. Desiderio's lines are full of minute changes of direction and breaks in continuity. They have a nervous delicacy, a gentleness, and quiet unassertiveness which is appropriate, in our example, to the character and mood expressed in a more directly psychological way in the faces of Mary and the Child. They are neither rhetorical nor merely decorative but describe the form and represent material qualities in a naturalistic manner. There is nothing arbitrary about them. For the most part they are not clear-cut lines; their depth and intensity varies and they have an irregular scratched rather than a sharp-edged quality . Many of them are little more than short incised "touches" with the chisel. Agostino's relief is also gentle and delicate but it is in every respect more self-consciously "designed," more contrived, than Desiderio's. Both Madonnas are human rather than divine but Desiderio's is a natural, homely humanity while Agostino's is elegantly aristocratic and artificial. If there is anything supernatural about Agostino's relief, it is a supernatural prettiness and sweetness.

The differences between the two works may be brought out more clearly if we compare a few details. Consider the treatment of the hair. In Desiderio's relief it is rendered as a vaguely unified plastic mass in which curls are merely hinted at by irregular incised lines. The hair of Desiderio's Child has a soft, downy appearance and merges with the form of the forehead without any clear line of demarcation. Agostino, on the other hand, has treated the hair as a

Desiderio da Settignano,
*Virgin and Child,*
1455–60. Marble,
23 ¼″ × 17 ¾″.
(Philadelphia Museum of
Art; purchased by the
Committee of the W. P.
Wilstach Collection)

Agostino da Duccio,
*Virgin and Child with
Four Angels,* ca. 1460.
Marble, 35″ × 30 ¼″.
(The Louvre, Paris; Art
Resource, NY/Giraudon)

highly stylized pattern of regular lines. These fall into graceful waves, and on the Child they twist round to form elegant tight little spiral curls. A similar difference pervades the drapery of the two reliefs. Desiderio's treatment is spare, full of irregularities, crumpled passages, and straightness. There are no lines which seem to be there purely for their own sake. Agostino's lines on the other hand are mostly decorative and are intended to be enjoyed for their own sake. They are full of graceful curves and elegant rhythms and counter-rhythms. Their linear design is confidently, even exuberantly, lyrical.

A comparison of the similarly positioned right forearms and hands of the two Virgins is most revealing. Agostino makes one continuous curve of the upper line of the forearm and the hand and carries the line right through to the ends of the extended first finger and thumb. But the line of Desiderio's arm and hand changes direction abruptly where the hand broadens out at the wrist. And although there is a connection through from the arm across the hand and into the extended finger, it is a straight line, not an elegant curve, and it is not continuous. Notice, too, the contrast in the lines of the fingers themselves in the two reliefs.

The outlines of the fleshy parts of Desiderio's figures—the head, arms, and shoulders of the Child, for example—are softer and more variable than those of Agostino's. This is true also of the modeling inside the contours. The lines down the left arms of both infants clearly show the difference. Finally, the lines of the facial features—the center line of the nose, the outlines of the lips and the eyes—are sharper in the Agostino than in the Desiderio, where their softness contributes to the "dewy" look of the faces.

It would be wrong to conclude from all this that Agostino's relief is more carefully designed and that Desiderio's merely describes the forms naturalistically. Desiderio's relief is in fact designed with extreme care and sensitivity. Indeed, according to John Pope-Hennessy, "in composition this is Desiderio's finest and most inventive Madonna relief."* Pope-Hennessy does complain, however, that its execution is "rather dry" and inferior to that of some of the sculptor's other works. The crux of the matter is that in this work of Desiderio's the design is less obtrusive than it is in the Agostino.

---

*Italian Renaissance Sculpture* (London: Phaidon, 1958), p. 303.

Brief marginal annotations have been added to the following essay in order to help you appreciate the writer's skill in presenting her ideas.

Rebecca Bedell

FA 232 American Art

November 10, 1978

*Title is focused, and, in "Development," implies the thesis*

John Singleton Copley's Early Development:

From <u>Mrs. Joseph Mann</u> to <u>Mrs. Ezekial Goldthwait</u>

*Opening paragraph is unusually personal but engaging, and it implies the problem the writer will address*

Several Sundays ago while I was wandering through the American painting section of the Museum of Fine Arts, a professorial bellow shook me. Around the corner strode a well-dressed mustachioed member of the art historical elite, a gaggle of note-taking students following in his wake. "And here," he said, "we have John Singleton Copley." He marshalled his group about the rotunda, explaining that, "as one can easily see from these paintings, Copley never really learned to paint until he went to England."

*Thesis is clearly announced*

A walk around the rotunda together with a quick leafing through a catalog of Copley's work should convince any viewer that Copley reached his artistic maturity years before he left for England in 1774. A comparison of two paintings at the Museum of Fine Arts, <u>Mrs. Joseph Mann</u> of 1753 and <u>Mrs. Ezekial Goldthwait</u> of ca. 1771, reveals that Copley had made huge advances in his style and technique even before he left America; by the time of his departure he was already a great portraitist. Both paintings are half-length portraits of

John Singleton Copley, *Mrs. Joseph Mann,* 1753. Oil on canvas, 36″ × 28 ¼″. (Gift of Frederick and Holbrook Metcalf; courtesy of Museum of Fine Arts, Boston)

John Singleton Copley, *Mrs. Ezekial Goldthwait,* ca. 1771. Oil on canvas, 50″ × 40″. (Bequest of John T. Bowen in memory of Eliza M. Bowen; courtesy of Museum of Fine Arts, Boston)

*Brief description of the first work*

seated women, and both are accompanied by paired portraits of their husbands.

The portrait of Mrs. Joseph Mann, the twenty-two-year-old wife of a tavern keeper in Wrentham, Massachusetts,[1] is signed and dated J. S. Copley 1753. One of Copley's earliest known works, painted when he was only fifteen years old, it depicts a robust young woman staring candidly at the viewer. Seated outdoors in front of a rock outcropping, she rests her left elbow on a classical pedestal and she dangles a string of pearls from her left hand.

*Relation of the painting to its source*

The painting suffers from being tied too closely to its mezzotint prototype. The composition is an almost exact mirror image of that used in Isaac Beckett's mezzotint after William Wissing's <u>Princess Anne</u> of ca. 1683.[2] Pose, props, and background are all lifted directly from the print. Certain changes, however, were necessary to acclimatize the image to its new American setting. Princess Anne is shown provocatively posed in a landscape setting. Her blouse slips from her shoulders to

---

[1] Jules David Prown, <u>John Singleton Copley</u> (Cambridge, Mass.: Harvard University Press, 1966), I, 110.

[2] Charles Coleman Sellers, "Mezzotint Prototypes of Colonial Portraiture: A Survey Based on the Research of Waldon Phoenix Belknap, Jr.," <u>Art Quarterly</u> 20 (1957), 407-68. See especially plate 16.

reveal an enticing amount of bare bosom.
Her hair curls lasciviously over her
shoulders and a pearl necklace slides
suggestively through her fingers as though,
having removed the pearls, she will proceed
further to disrobe. But Copley reduces the
sensual overtones. Mrs. Mann's bodice is
decorously raised to ensure sufficient
coverage, and the alluring gaze of the
princess is replaced by a cool stare.
However, the suggestive pearls remain
intact, producing an oddly discordant note.

*First sentence of paragraph is both a transition and a topic sentence: the weakness of the painting*

The picture has other problems as
well. The young Copley obviously had not
yet learned to handle his medium. The brush
strokes are long and streaky. The shadows
around the nose are a repellent greenish
purple and the highlight on the bridge was
placed too far to one side. The highlights
in the hair were applied while the
underlying brown layer was still wet so
that instead of gleaming curls he produced
dull gray smudges. In addition, textural
differentiation is noticeably lacking. The
texture of the rock is the same as the
skin, which is the same as the satin and

*Concrete details support the paragraph's opening assertion*

the grass and the pearls. The anatomy is
laughable: There is no sense of underlying
structure. The arms and neck are the
inflated tubes so typical of provincial
portraiture. The left earlobe is missing
and the little finger on the left hand is
disturbingly disjointed. Light too appears
to have given Copley trouble. It seems, in
general, to fall from the upper left, but

the shadows are not consistently applied.
And the light-dark contrasts are rather too
sharp, probably due to an overreliance on
the mezzotint source.

*Transition ("Despite its faults") and statement of idea that unifies the paragraph*

Despite its faults, however, the
painting still represents a remarkable
achievement for a boy of fifteen. In the
crisp linearity of the design, the sense of
weight and bulk of the figure, the hint of
a psychological presence, and especially in
the rich vibrant color, Copley has already
rivaled and even surpassed the colonial
painters of the previous generation.

*Transition ("about seventeen years later") and reassertion of central thesis*

In Mrs. Ezekial Goldthwait, about
seventeen years later and about four years
before Copley went to England, all the early
ineptness had disappeared. Copley has arrived
at a style that is both uniquely his own
and uniquely American; and in this style he
achieves a level of quality comparable to
any of his English contemporaries.

*Brief description of the second picture*

The substantial form of Mrs.
Goldthwait dominates the canvas. She is
seated at a round tilt-top table, one hand
extended over a tempting plate of apples,
oranges, and pears. A huge column rises in
the right-hand corner to fill the void.

*Biography, and (in rest of paragraph) its relevance to the work*

The fifty-seven-year-old Mrs.
Goldthwait, wife of a wealthy Boston
merchant, was the mother of fourteen
children; she was also a gardener noted for
her elaborate plantings.[3] Copley uses this

---

[3] Prown, p. 76.

fertility theme as a unifying element in
his composition. All the forms are plump
and heavy, like Mrs. Goldthwait herself.
The ripe, succulent fruit, the heavy,
rotund mass of the column, the round top of
the table--all are suggestive of the
fecundity of the sitter.

*The most obvious characteristic of the work*

The painting is also marked by a
painstaking realism. Each detail has been
carefully and accurately rendered, from the
wart on her forehead to the wood grain of
the tabletop to the lustrous gleam of the
pearl necklace. As a painter of fabrics
Copley surpasses all his contemporaries.
The sheen of the satin, the rough, crinkly
surface of the black lace, the smooth,
translucent material of the cuffs--all are
exquisitely rendered.

*"But" is transitional, taking us from the obvious (clothing) to the less obvious (character)*

But the figure is more than a
mannequin modeling a delicious dress. She
has weight and bulk, which make her
physical presence undeniable. Her face
radiates intelligence, and her open,
friendly personality is suggested by the
slight smile at the corner of her lips and
by her warm, candid gaze.

*Brief reminder of the first work, to clarify our understanding of the second work*

The rubbery limbs of Copley's early
period have been replaced by a more
carefully studied anatomy (not completely
convincing, but still a remarkable
achievement given that he was unable to
dissect or to draw from nude models). There
is some sense for the underlying armature
of bone and muscle, especially in the
forehead and hands. And in her right hand

it is even possible to see the veins running under her skin.

*Further comparison, again with emphasis on the second work*

Light is also treated with far greater sophistication. The chiaroscuro is so strong and rich that it calls to mind Caravaggio's tenebroso. The light falls almost like a spotlight onto the face of Mrs. Goldthwait, drawing her forward from the deep shadows of the background, thereby enhancing the sense of a psychological presence.

*Reassertion of the thesis, supported by concrete details*

Copley's early promise as a colorist is fulfilled in mature works such as Mrs. Goldthwait. The rich, warm red-brown tones of the satin, the wood, and the column dominate the composition. But the painting is enlivened by a splash of color on either side--on the left by Copley's favorite aqua in the brocade of the chair, and on the right by the red and green punctuation marks of the fruit. The bright white of the cap, set off against the black background, draws attention to the face, while the white of the sleeves performs the same function for the hands.

*Summary, but not mere rehash; new details*

Color, light, form, and line all work together to produce a pleasing composition. It is pleasing, above all, for the qualities that distinguish it from contemporary English works: for its insistence on fidelity to fact, for its forthright realism, for the lovingly delineated textures, for the crisp clarity of every line, for Mrs. Goldthwait's

charming wart and her friendly double chin,
for the very materialism that marks this
painting as emerging from our pragmatic
mercantile society. In these attributes lie
the greatness of the American Copleys.

*Further summary, again heightening the thesis*

Not that I want to say that Copley
never produced a decent painting once he
arrived in England. He did. But what
distinguishes the best of his English works
(see, for example Mrs. John Montressor
and Mrs. Daniel Denison Rogers)[4] is not
the facile, flowery brushwork or the
fluttery drapery (which he picked up from
current English practice) but the very
qualities that also mark the best of his
American works--the realism, the sense of
personality, the almost touchable textures
of the fabrics, and the direct way in which
the sitter's gaze engages the viewer.
Copley was a fine, competent painter in
England, but it was not the trip to England
that made him great.

Works Cited

Prown, Jules David. John Singleton Copley.
    2 vols. Cambridge, Ma.: Harvard Uni-
    versity Press, 1966.

Sellers, Charles Colleman. "Mezzotint Pro-
    totypes of Colonial Portraiture: A
    Survey Based on the Research of Waldon
    Phoenix Belknap, Jr." Art Quarterly 20
    (1967): 407-68.

---

4 Prown, plates.

# 4

## Some Critical Approaches

Most of this book thus far has been devoted to writing about what we perceive when we look closely at a work of art, but it is worth noting that other kinds of writing can also help a reader to see (and therefore to understand better) a work of art. For example, one might discuss not a single picture but, say, a motif: Why does the laborer becomes a prominent subject in nineteenth-century European painting? Or how does the theme of leisure differ between eighteenth-century and nineteenth-century painting; that is, what classes are depicted, how aware of each other are the figures in a painting, what are the differences in the settings and activities—and why?

### SOCIAL HISTORY:
### THE NEW ART HISTORY AND MARXISM

Discussions of subject matter may be largely **social history**, wherein the aesthetic qualities of the work of art (as well as such matters as whether a work is by Rembrandt or by a follower) may be of minor importance. Social historians assume that every work (if carefully scrutinized) tells a story of the culture that produced it. Thus, Gary Schwartz, in *Rembrandt: His Life, His Paintings* (1985), says that his intention is to study Rembrandt as "an artistic interpreter of the literary, cultural, and religious ideas of a fairly fixed group of patrons" (page 9). Notice the interest in patrons. Much social history is interested in patronage, confronting such questions as "Why did portraiture in Italy in the late fifteenth century show an increased interest in capturing individual likeness?" and "Why did easel painting (portable pictures) come into being when they did?" The social historian usually offers answers in terms of who was paying for the pictures. Obviously the medieval church wanted images very different from those wanted by, say, a Renaissance duke or the wealthy wife of a nineteenth-century businessman.

Let's briefly consider what the social historian's point of view may reveal if we scrutinize, say, French "Orientalist" paintings—nineteenth-century pictures of north Africa (e.g., Morocco and Algeria) by such artists as Delacroix and Gérôme, painted for the middle-class European market. We might find that these paintings do not simply depict north Africa; rather, the paintings also depict the colonialist's Eurocentric view that this region is a place of savagery and abundant sexuality (beautiful slaves, male and female). The pictures offer voyeuristic pleasure by providing images of carnal creatures, and at the same time the pictures allow the viewer comfortably to feel that the region is badly in need of European law and order. Even Matisse's pictures of bare-breasted odalisques reclining on cushions and staring blankly can reasonably be said, by our current standards, to embody the colonialist's views, or at least the early twentieth-century bourgeois male's views of north Africa and of women as sensuous and passive, waiting to be enlivened by the white male who gazes at the pictures. And of course white males were the chief purchasers. (We will return to this idea—that the *gaze* of the viewer implies power over the depicted subject—when we discuss images of female nudes as viewed by males later in the chapter.)

In this view, then, a work of art (like a religious, legal, or political system) is a creation deeply implicated in the values of the culture that produced and consumed it. The work is a "text" whose attractive surface is a mask. The student, by resisting its aesthetic seductions and perhaps by "reading against the grain" (a common expression referring to the attempt to get at what the artist may have tried to hide or may have been unaware of), "interrogates" or "demystifies" or "deconstructs" the work.

The study of the social history of art, especially of matters of class, gender, and ethnicity, and especially when conducted in a somewhat confrontational manner, is sometimes called the **New Art History**, to distinguish it from the earlier art history that was concerned chiefly with such matters as biography, stylistic development, attribution, aesthetic quality, and symbolic meanings of subjects. This new approach was summed up more than twenty years ago in Kurt Forster's "Critical History of Art, or Transfiguration of Values?" published in *New Literary History* (1972). Dismissing the traditional art history, Forster argued that because its practitioners admired the objects they studied, art historians could not study them critically—that is, they could not see that these objects served the vested interests of the classes in power. Calling for a new approach, Forster argued that "the only means of gaining an adequate grasp of old artifacts lies in the dual critique of the ideology which

sustained their production and use, and of the current cultural interests that have turned works of art into a highly privileged class of consumer and didactic goods" (pp. 463–64).

A chief goal of the New Art History is to unearth the often neglected, forgotten, or unperceived ideological assumptions or social meanings that inform artworks. Another goal is to show that works of art do not merely reflect ideology but also actively participate in ideological conflicts. That is, they produce political actions. Thus, to take a recent example, in *Fauve Painting: The Making of Cultural Politics* (1992), James D. Herbert claims that "Matisse's pictures of African objects played a part in authorizing, in the name of knowledge, further colonial incursions into the massive continent to the south" (p. 11). (Herbert does not, however, say who felt authorized by Matisse's pictures.)*

The interest in patrons is only one aspect of the social historian's concern with the production and consumption of art. Obviously other points of interest include the particular artists in any given period and the sorts of training they received. In *Art News* (January 1971), Linda Nochlin asks a fascinating sociological question: "Why Have There Been No Great Women Artists?" (The essay is reprinted in Nochlin's book, *Women, Art, and Power and Other Essays*, 1988.) Nochlin rejects the idea that women lack artistic genius, and instead she finds her answer "in the nature of given social institutions." For instance, women did not have access to nude models (an important part of the training in the academies), and women, though tolerated as amateur painters, were rarely given official commissions. And, of course, women were expected to abandon their careers for love, marriage, and the family. Furthermore, during certain periods, women artists were generally confined to depicting a few subjects. In the age of Napoleon, for example, they usually painted scenes not of heroism but of humble, often sentimental domestic subjects such as a girl mourning the death of a pigeon.

The social historian assumes that works of art carry ideas, and that these ideas are shaped by specific historical, political, and social circumstances. The works are usually said to constitute ideologies of power, race, and gender. Architecture especially, being made for obvious uses (think of castles, cathedrals, banks, museums, schools, libraries, homes, malls), often is usefully discussed in terms of the society that produced it. (Architecture has been called "politics in three dimensions.")

---

*For a collection of essays along these lines, see A. L. Rees and Frances Borzello, eds., *The New Art History* (1986).

Social historians whose focus is **Marxism** especially examine works of art as reflections of the values of the economically dominant class and as participants in political struggles. Works of art themselves do some sort of work. For Marxists, this work usually is, at bottom, the reinforcement of the class ideology. In the words of Nicos Hadjinicolaou, in *Art History and Class Struggle* (1978), "Pictures are often the product in which the ruling classes mirror themselves" (p. 102). But of course the mirror is not really a mirror but a presentation of the ways in which the ruling classes wish to be seen. For instance, the landowners whose wealth is derived from the soil, or more precisely from the agricultural labor of peasants, may present themselves as in harmony with nature, or as the judicious and loving caretakers of God's earth. Artworks thus are masks; their surface is a disguise, and the Marxist art historian's job is to discover the underlying political and economic significance. Where does beauty come in? To the question, "Why does this work give me pleasure?" the Marxist historian—or at least Hadjinicolaou—replies in this way:

> Aesthetic effect is none other than the pleasure felt by the observer when he recognizes himself in a picture's visual ideology. It is incumbent on the art historian to tackle the tasks arising out of the existence of this recognition. . . . This means that from now on the idealist question "What is beauty?" or "Why is this work beautiful?" must be replaced by the materialist question, "By whom, when and for what reasons was this work thought beautiful?"
>
> Nicos Hadjinicolaou, *Art History and Class Struggle* (1978), pp. 182–83

In thinking about such writings, as in thinking about whatever you read, it is useful to ask yourself what the author's premises are, and to remind yourself that the author's position is not completely objective.

## GENDER STUDIES: FEMINIST CRITICISM AND GAY AND LESBIAN STUDIES

**Gender studies**, a comprehensive field including feminist and gay and lesbian historical scholarship and criticism, attempts to link all aspects of cultural analysis concerning sexuality and gender. These methodologies usually assume that although our species has a biologically fixed sex division between male and female (a matter of chromosomes, hormones, and anatomical differences), the masculine and feminine roles we live out are not "natural" or "essential" or "innate" but are established or

"constructed" by the society in which we live. Society—or cultural interpretation—it is argued, exaggerates the biological sexual difference (male, female) into gender difference (masculine, feminine), producing ideals and patterns of gender (masculinity, femininity) and of sexual behavior (e.g., the idea that heterosexuality is the only natural behavior). In our patriarchal culture, it is argued, parents, siblings, advertisements, and so forth teach us that males are masculine (strong, active, rational) and that females are feminine (weak, passive, irrational), and we (or most of us) play male or female roles in a social performance, "constructing" ourselves into what society expects of us. Simone de Beauvoir, an early exponent of the feminist theory of gender, in *The Second Sex* (1949) puts it this way: a "Woman" is constructed as "Man's Other," thus "one is not born a woman; one becomes one." Because (according to the view that gender is socially constructed) ideals and patterns change from one time or culture to another, analysis based on this awareness can help the viewer better understand works of art by or about men and women, heterosexual and homosexual.

**Feminist art history and criticism** begins with the fact that men and women are different. As Mary D. Garrard puts it:

> The definitive assignment of sex roles in history has created fundamental differences between the sexes in their perception, experience and expectations of the world, differences that cannot help but be carried over into the creative process where they have sometimes left their tracks.
>
> *Artemisia Gentileschi: The Image of the Female Hero in Italian Baroque Art* (1989), p. 202

One can of course make further distinctions, arguing, for instance, that the experiences of women of color differ from those of white women, but here we will concern ourselves only with the most inclusive kind of feminist writing. This writing is especially interested in two topics: (1) how women are portrayed in art, and (2) whether women (because of their biology or socialization or both) create art and see art differently from men. The first topic is centered on subject matter: How do images of women (created chiefly by men) define "being female"? Are women depicted as individuals with their own identity, or chiefly as objects for men to consume?

The second topic, women as artists and viewers of art, is closely related to the first. It is probably true that in a world of predominantly male-created public works of art, the implied viewer is male. Consider pictures of nude females. To use the current language, the bearer of the

*gaze* (and therefore the one who wields the power) is male; the object of the gaze, the "powerless Other," is female. (The relationship corresponds to that in Orientalist paintings, where the European artists and spectators look at and presumably degrade a foreign culture.) It is widely agreed, for instance, that Renoir's pictures of nude women were created largely for the enjoyment of men, but how do women viewers respond to Renoir's pictures? Or take Picasso's *Les Demoiselles d'Avignon* (see p. 20), a brothel scene. One critic has said:

> Everything about the *Demoiselles,* and most of all the brothel situation it forces on the viewer, designates that viewer as male. To pretend . . . that women can play the customer—in *that* brothel in particular—or that as gendered subjects they can relate to the work on terms equal to men denies the intensity, force, and vehemence with which Picasso differentiated and privileged the male as viewer.

In this assertion true? All viewers will, obviously, have to form their own answers.

Why, one can ask, do some heterosexual women take pleasure in some images of female nudity? Here are two of the many answers that have been offered: (1) These women, socialized by a patriarchal culture, may negate their own experience and identify with the heterosexual masculine voyeuristic gaze; or (2) some female viewers may narcissistically identify themselves with the female image depicted. (This second explanation is often used to account for images of female nudity found in advertising that is directed toward women.)

Guerrilla Girls, *Do Women Have to Be Naked?* Poster, ink and color on paper, 11″ × 28″. Since 1985 a group of women, wearing gorilla masks, have put up posters and issued other materials calling attention to the underrepresentation of women in the art world. The image on this poster is based on Ingres's *Odalisque.* (Private collection. Courtesy of Guerrilla Girls)

How female viewers respond to Degas's images of nude women bathing themselves, often in highly contorted positions, has recently evoked abundant commentary. For Griselda Pollock, in *Dealing with Degas* (1992), these images show "obsessive, repetitious re-enactments of sadistic voyeurism. . . . The model's body [is] debased and abused," and a female viewer is "forced to take up the proferred sadistic masculine position and symbolically enact the violence of Degas's representation, or identify masochistically with the bizarrely posed and cruelly drawn bodies" (p. 33). But, to take only one countervoice, Wendy Lesser in an essay called "Degas's Nudes" (in *His Other Half: Men Looking at Women through Art*, 1991), sees empathy rather than aggression, and sensuousness rather than sadism. Lesser argues that the woman viewer is encouraged to identify herself with these deeply absorbed unselfconscious women bathing themselves.

To turn to women as artists: Are the images created by women different from those created by men? In working in the "masculine" genre of the female nude, does a female artist (e.g., Suzanne Valadon) produce images that significantly differ from the images produced by males working in the same artistic milieu?

Some writers have emphasized connections between events in the lives of women artists and their work. For instance, we know that Artemisia Gentileschi was raped by one of her father's apprentices. Some scholars have suggested that Gentileschi's depiction of Judith, the beautiful widow who according to the Bible saved the Hebrews by beheading Holofernes, an Assyrian general, was Gentileschi's way of taking revenge on men. Other writers, however, have pointed out that the subject was painted by men as well as by women, and still others have expressed uneasiness over the tendency to interpret the work of women in terms of their lives. Mary D. Garrard, in *The New York Times* (22 September 1991), calls attention to the implications in some biographical studies: "The art of women is defined in private and personal terms while the art of men is elevated to the level of 'universal' expression."

A glance at certain writings about Frida Kahlo, the politically radical painter, supports Garrard's comment. Kahlo suffered greatly, both physically (at the age of eighteen she was partly paralyzed by a traffic accident) and mentally (her husband, the painter Diego Rivera, was notoriously unfaithful). Discussions of Kahlo's work usually emphasize the connection of the imagery with her suffering, and they tend to neglect the strong political (Marxist and nationalistic) content.

Speaking of "strong" ideas, keep in mind that such words as *strong, energetic, vigorous, forceful,* and *powerful,* when used to describe art-works, are not gender-neutral but are loaded in favor of male values. Indeed, much of the language of art criticism—*masterpiece* is another example—tends to put women and their work at a disadvantage. From here it is a relatively short step to arguing that the traditional distinction between "high art" (a portrait of Henry VIII by Holbein) and "low art" (a quilt by an anonymous woman) masquerades as a universal truth, but it is really a patriarchal concept designed to devalue female creativity.°

**Gay and lesbian art criticism,** like feminist criticism, operates from the principle that varieties of sexual orientation make important differences in how artists portray the world, love, and Eros, and in how viewers receive and interpret those images.†

Again like feminist art criticism and historical scholarship, gay and lesbian criticism faces certain problems of definition and scope. Most broadly, it means both art *about* gay men and lesbians (or, more generally, homosexuality and bisexuality in all their various forms) and art *by* gay and lesbian artists. "Gay art" is not synonymous with erotic art or pornography. It can include, for example, genre scenes of gay life (Francis Bacon, David Hockney), portraits of famous individuals who were gay or lesbian (Berenice Abbott's photographs of the literary lesbians of Paris

---

°Examples of feminist criticism and historical scholarship can now be found in almost all journals devoted to art, but they are especially evident in *Women and Art, Woman's Art Journal,* and *Women's Art.* For collections of feminist essays, see Norma Broude and Mary D. Garrard, eds., *Feminism and Art History* (1982); Arlene Raven, Cassandra L. Langer, and Joanna Frueh, eds., *Feminist Art Criticism* (1988); and Norma Broude and Mary D. Garrard, eds., *The Expanding Discourse: Feminism and Art History* (1992). For a survey of feminist art history, see Thalia Gouma-Petersen and Patricia Mathews, "The Feminist Critique of Art History," *Art Bulletin* 69 (1987), 326–57; and the follow-up by Norma Broude, Mary D. Garrard, Thalia Gouma-Peterson, and Patricia Mathews, "An Exchange on the Feminist Critique of Art History," *Art Bulletin* 71 (1989), 124–27. For a valuable survey of feminist methods and themes, see Lisa Tickner, "Feminism, Art History, and Sexual Difference," *Genders* 3 (1988), 92–129. For the most complete listing of feminist writing about art—including more than a thousand items, with brief summaries—see, Cassandra Langer, *Feminist Art Criticism: An Annotated Bibliography* (1993).

†This discussion of gay and lesbian criticism is by James M. Saslow (Queens College, City University of New York), author of numerous studies, including *Ganymede in the Renaissance: Homosexuality in Art and Society* (New Haven, Conn.: Yale University Press, 1986).

in the period between the two world wars), political art around social is-
sues of special concern to lesbians and gay men (today, AIDS posters),
and mythological or historical subjects (Jupiter and his cupbearer
Ganymede, the lesbian poet Sappho).

Gay and lesbian art writing looks at homosexuality both as subject
matter/text and as a factor that may help to shape the work of the individ-
ual artist or creator. It asks about differences or parallels in the ways that
love, sexuality, gender, and daily life are depicted by heterosexuals and
homosexuals; and it seeks to uncover distinctive expressions of the gay
and lesbian experience that have, in the past, often been suppressed or
misunderstood (e.g., Greek vase paintings of homosexual courtship, Cara-
vaggio's mythologized portraits of Roman boys, Rosa Bonheur's self-
representation in male dress). It should be emphasized, however, that
not all art by gay people (or by heterosexual men or women) can be re-
duced to biographical illustration.

In fact, while biography and psychology are important tools in un-
derstanding some art by gays and lesbians, gay art criticism is linked
equally closely to both political and social history. Political because,
throughout much of Western history at least, homosexual expression,
when not silenced, has often been forced to operate indirectly, in a sort
of code. Moreover, while heterosexuals have also represented scenes of
homosexual life (for example, Brueghel's *Village Kermesse at Hoboken,*
with its male couple embracing at a carnival), their "outsider" images
have often propagated negative attitudes that need to be placed in histor-
ical perspective.

In confronting images, it is important to avoid projecting one's own
moral attitudes back onto earlier art. One should not assume, for exam-
ple, that all cultures "naturally" condemn homosexuality; rather, one
should try to discern what artists were trying to say within their own cul-
tural framework. Gay art criticism is thus closely linked to social history,
in that understanding of art about gay experience requires an under-
standing of attitudes about sex and gender in various societies. Indeed,
not only attitudes but also the very definitions of sexual identities and
roles have varied greatly throughout history. "Homosexuality" is itself a
modern Western term, and vase-paintings of male adolescents addressed
to Greek men (who were generally what we would now call bisexual), or
woodblocks showing two women making love in China (where no equiva-
lent of a contemporary lesbian culture existed), need to be understood in
terms of the categories of sexual experience and the social patterns con-
structed by those cultures.

Much of what has just been said concerns iconography (see p. 115); in formal and visual terms, the issue of the *gaze,* adopted from feminist criticism, is important in gay and lesbian analysis as well. By "the gaze" I mean the act of looking itself, including both how it is established within works of art and what kind of outside viewer is implied. Students should ask such questions of pictures as "*Who* is doing the looking?" and "*Who* or *what* is being looked at?" Consider, for example, the different possible meanings of a male figure when he is painted or looked at by different viewers:

1. A heterosexual male artist, for whom the sitter and his body are primarily an opportunity for scientific study, a traditional subject for drawing class, and the like
2. A gay male artist, for whom the subject also has an erotic interest, and perhaps some significant biographical connection to the painter (e.g., Michelangelo's drawings of handsome young men and mythological boys)
3. A heterosexual woman, who, like a gay man, may also be erotically interested in the figure (the question of why there are no "academic" drawings by women before this century is a related question for feminist history as well)
4. A lesbian artist, who, like the heterosexual male, has no erotic interest in the sitter, but who might feel political or cultural solidarity (e.g., Romaine Brooks's portrait of Jean Cocteau).*

## BIOGRAPHICAL STUDIES

**Biographical writing** has already been glanced at in the preceding comments on gender criticism, but of course it need not be rooted in gender. True, one might study the degree to which Picasso's style changed as he changed wives or mistresses, but one could also study his changes in style as he changed literary friends—Apollinaire affecting Picasso's Cubism, Cocteau his Neoclassicism, and Breton his Surrealism. John Richardson's *A Life of Picasso,* in fact, is built on a remark by

---

*For a guide to the existing literature in this rapidly expanding field, consult *Bibliography of Gay and Lesbian Art* (New York: College Art Association, Gay and Lesbian Caucus, 1994). A second edition, edited by Ray Anne Lockard, is in preparation.

Picasso: "My work is like a diary. To understand it, you have to see how it mirrors my life."

One problem underlying biographical studies—often studies of the relations between artists and their patrons, their workshops, and their friends and spouses—is that they rely on written documents, and the survival of such sources is almost a matter of chance. Furthermore, although defenders of biographical studies argue that the writings are concerned with the issues that most concerned the artists themselves—such things as "Who is paying?" and "How is the workshop organized?"—a reader may feel that a biographical approach to art history conveys very little sense of what the works of art look like.

## PSYCHOANALYTIC STUDIES

Many of today's biographical studies can be called **psychoanalytic studies**. Such writings follow in the tradition of Sigmund Freud's *Leonardo da Vinci: A Psychosexual Study of Infantile Reminiscence* (1910), which seeks to reconstruct Leonardo's biography and psychic development by drawing on certain documents and, especially, by analyzing one of Leonardo's memories (for Freud, a fantasy) of an experience while he was an infant. Thus, it seems that Leonardo had two "mothers," a biological mother (a peasant woman) and a stepmother (the woman who was Leonardo's father's wife). In accord with this information, Freud sees in *The Madonna, Child, and St. Anne* Leonardo's representation of himself as the Christ Child, the peasant woman as St. Anne, and the stepmother as the Madonna. St. Anne's expression, in Freud's analysis, is both envious (of the stepmother) and joyful (because she is with the child whom she bore).

In a 1931 letter Freud wrote that an artist's entire repertory might be traced back to "the experience and conflicts of early years," and most psychoanalytic studies of artists have followed Freud in concentrating on early experiences, but there are exceptions. A recent example is a psychoanalytic study of Winslow Homer, which argues that his works are related to crises in his life. For instance, *The Life Line* and *The Undertow*, two pictures that show men rescuing women, are said to reveal Homer's love for his mother and his desire to rescue her from death. (In reading symbolic interpretations, it is well to remember Freud's comment that "sometimes a cigar is just a cigar.")

Psychoanalytic interpretations of works of art, then, are likely to see the artwork as a disguised representation of the artist's mental life, and

especially as a manifestation of early conflicts and repressed sexual desires. The assumption is that the significant "meaning" of the work is the personal meaning that it had (consciously or unconsciously) for the artist. However, as we have seen (pp. 13–14), this view is not popular today. Further, in some psychoanalytic studies the works of art almost disappear. For instance, many pages have been written about why van Gogh cut off the lower part of his left ear and took it to a brothel, where he gave it to a prostitute with the request that she "keep this object carefully." Among the theories offered to explain van Gogh actions are the following: (1) Van Gogh was frustrated by the engagement of his brother, Theo, and by his failure to establish a working relationship with Paul Gauguin. He first directed his aggression toward Gauguin, and then toward himself. (2) Van Gogh identified himself with prostitutes as social outcasts. He had written that "the whore is like meat in a butcher shop," and so now he treated his body like a piece of meat. (3) He experienced auditory hallucinations, and so he cut off a part of his ear, thinking it was diseased.*

Although most psychoanalytic studies of art have been concerned with the process of artistic creation (the study of Winslow Homer is an example), especially in recent years psychoanalysis has been interested in a second area, the source of aesthetic enjoyment. Studies of this topic, often couched in terms of *the gaze,* are primarily concerned with how differences in pleasure are linked to differences in gender and class.

## ICONOGRAPHY AND ICONOLOGY

One kind of highly specialized study that keeps the image in view is **iconography** (Greek for "image writing"), or the identification of images with symbolic content or meaning. In Erwin Panofsky's words, iconography is concerned with "conventional subject matter," the iconographer showing us that certain forms are (for example) saints or gods or allegories. An iconographic study might point out that a painting by Rembrandt of a man holding a knife is not properly titled either *The Butcher* or *The Assassin,* as it used to be called, since it depicts St. Bartholomew, who, because he was skinned alive with a knife, is regularly depicted with

---

*On van Gogh, see William M. Runyan, *Life Histories and Psychobiography* (New York: Oxford University Press, 1982), pp. 38–41. For a survey of psychoanalytic scholarship and art, see Jack Spector, "The State of Psychoanalytic Research in Art History," *Art Bulletin* 70 (1988), 49–76.

a knife in his hand. (Saints often hold an *attribute*—that is, some object that serves to identify them. St. Peter, e.g., holds keys, in accordance with Jesus's words to Peter, as reported in Matthew 16:19: "I will give you the keys of the kingdom.")
    But is every image of a man holding a knife St. Bartholomew? Of course not, and if, as in Rembrandt's painting, the figure wears contemporary clothing and has no halo, skepticism is warranted. Why can't the picture be of an assassin—or of a butcher or a cook or a surgeon? But a specialist in the thought (including the art) of the period might point out that the identification of this figure with St. Bartholomew is reasonable on two grounds. First, the picture, dated 1661, seems to belong to a series of pictures of similar size, showing half-length figures, all painted in 1661, and at least some of these surely depict apostles. For example, the man with another man at his right is Matthew, for if we look closely, we can see that the trace of a wing protrudes from behind the shoulder of the accompanying figure, and a winged man (or angel) is the attribute or symbol of Matthew. In another picture in this series a man leaning on a saw can reasonably be identified as Simon the Zealot, who was martyred by being sawn in half. Second, because the Protestant Dutch were keenly interested in the human ministry of Christ and the apostles, images of the apostles were popular in seventeenth-century Dutch art, and it is not surprising that Rembrandt's apostles look more like solid citizens of his day than like exotic biblical figures. In short, to make the proper identification of an image, one must understand how the image relates to its contemporary context.
    The study of iconography is not limited to the study of artists of the past. Scholars who write about the Mexican painter Frida Kahlo (1907–54), for instance, call attention to her use of Christian, Aztec, and Marxist images. They point out that in her *Self-Portrait with Thorn Necklace and Hummingbird* (1940), the thorn necklace alludes not only to the crown of thorns placed on Jesus's head—Kahlo as guiltless sufferer—but probably also alludes to the mutilation that Aztec priests inflicted on themselves with thorns and spines. The hummingbird, sacred to Huitzilopichtli, god of the sun and of war, is an Aztec symbol of the souls of warriors who died in battle or on a sacrificial stone. Or take another of Kahlo's self-portraits, *Marxism Will Give Health to the Sick* (1954); see p. 117), painted a few months before she died. As noted earlier in the chapter, in her youth Kahlo had been partly paralyzed by a traffic accident. In this picture she shows herself strapped in an orthopedic corset, but discarding her crutches. (The painting is in the tradition of an *ex-voto,* a pic-

Frida Kahlo,
*Marxism Will Give
Health to the Sick,*
1954. Oil on ma-
sonite, 30″ × 24″.
(Collection of the
Frida Kahlo
Museum, Mexico
City. Photograph:
Cenidiap/INBA,
Mexico.
Reproduction autho-
rized by the Instituto
Nacional de Bellas
Artes y Literatura)

ture given to a church in fulfillment of a vow made by someone who
prayed to a saint for help, and whose prayer was answered, for instance,
by a miraculous cure. Such pictures customarily show the saint at the top,
and the recipient of the miracle in the center; for Kahlo, Karl Marx is
contemporary humanity's savior.) In the upper right, Marx strangles an
eagle with Uncle Sam's head (i.e., Marxism destroys American imperial-
istic capitalism). Below Uncle Sam are red rivers—presumably rivers of
the blood of America's victims—and a shape that probably represents the
mushroom cloud of an atomic bomb. At the top left, the dove of peace
counterbalances the wicked eagle. Beneath the dove a globe shows Russia,
from which flow not rivers of blood but blue rivers, rivers of life-giving,
cleansing water. Kahlo, holding a red book (Marx's teachings), is sup-
ported by large hands (great power) near Marx; in one of the hands is an
eye, a symbol of knowledge (Marx sees all and understands all).

The Tehuana dress that Kahlo wears in this picture also appears in several of her other paintings. Janice Helland, speaking of this dress in another painting, explains the iconography thus:

> This traditional costume of Zapotec women from the Isthmus of Tehuantepec is one of the few recurring indigenous representations in Kahlo's work that is not Aztec. Because Zapotec women represent an ideal of freedom and economic independence, their dress probably appealed to Kahlo.
>
> "Aztec Imagery in Frida Kahlo's Paintings," *Women's Art Journal* 11
> (Fall 1990–Winter 1991), pp. 9–10

Helland cites three references supporting her interpretation of the Tehuana dress.

**Iconology** (Greek for "image study") is the interpretation, especially through literary, religious, and philosophic texts, of the image for evidence of the cultural attitudes that produced what can be called the meaning or content of the work. For instance, iconology can teach us the significance of changes in pictures of the Annunciation, in which the angel Gabriel confronts Mary. These changes reveal cultural changes. Early paintings show a majestic Gabriel and a submissive Virgin. Gabriel, crowned and holding a scepter, is the emblem of sovereignty. But from the fifteenth century onward the Virgin is shown as the Queen of the Angels, and Gabriel, kneeling and thus no longer dominant, carries a lily or a scepter tipped with a lily, emblem of the Virgin's purity. In this example, then, iconology—the study of iconography—calls to our attention evidence of a great change in religious belief.

The identification of images with symbolic content is not, of course, limited to images in Western art. Here is a brief passage discussing a veranda post (see p. 119) for a palace, carved by an African sculptor, Olowe, whom John Pemberton III calls "perhaps the greatest Yoruba carver of the twentieth century." (Olowe of Ise died in 1938.) The post shows a seated king wearing a conical beaded crown that is topped by a bird whose beak reaches halfway down the crown. Beneath the king are a kneeling woman and a palace servant, and behind the king is the senior queen. Pemberton says:

> When the crown . . . is placed upon his head by the senior queen, his destiny (*ori*) is linked to all who have worn the crown before him. The great bird on the crown refers to "the mothers," a collective term for female ancestors, female deities and for older living women, whose power over the reproductive capacities of all women is held in awe by Yoruba

The central veranda
post carved by Olowe
of Ise for the palace
courtyard of the
Ogaga of Ikere,
Nigeria, 1910–14.
Wood with pigment,
6'1". (The Art
Institute of Chicago.
Major Acquisitions
Centennial
Endowment)

men. Referring to the cluster of birds on his great crown, the Orangun-
Ila said: "Without 'the mothers,' I could not rule." Thus, the bird on the
Ogoga's crown and the senior queen, whose breasts frame the crown,
represent one and the same power—the hidden, covert, reproductive
power of women, upon which the overt power of Yoruba kings ulti-
mately depends. . . .

John Pemberton III, "The Carvers of the Northeast," in *Yoruba:*
*Nine Centuries of African Art and Thought,*
ed. Allen Wardwell (1989), p. 206

Until fairly recently, discussions of African art rarely went beyond speaking of its "brute force," its "extreme simplifications," and its influence on Picasso and other European artists. But it is now recognized that African art, like the art of other cultures, expresses thought—for instance, ideas of power such as prestige, wealth, and fertility—in material form. In short, the forms of African art embody world views.

This discussion of iconography has spoken of "the proper identification of an image." Here we have a clue to the chief assumption of those who study iconography: A work of art is a unified whole, and its meaning is what the creator took it to be or intended it to be. We have also seen, however, that many art historians today (especially those associated with the New Art History) would argue with this assumption.*

---

*For a discussion of the strengths and limitations of iconographic studies, see the excellent introduction to Brendan Cassidy, ed., *Iconography at the Crossroads* (1993).

# 5

# In Brief: How to Write an Effective Essay

All writers must work out their own procedures and rituals, but the following basic suggestions will help you write effective essays. They assume that you will take notes by hand, on index cards, rather than use a word processor. But because it is highly preferable to use a word processor—not only for drafting the paper but also for taking notes—these comments are followed by a brief discussion of writing with a computer.

## GETTING TO A FIRST DRAFT

1. **Look at the work or works carefully.**
2. **Choose a worthwhile and compassable subject**, something that interests you and is not so big that your handling of it must be superficial. As you work, shape your topic, narrowing it, for example, from "Egyptian Sculpture" to "Black Africans in Egyptian Sculpture," or from "Frank Lloyd Wright's Development" to "Wright's Johnson Wax Company as an Anticipation of His Guggenheim Museum."
3. **Keep your purpose in mind**. Although your instructor may ask you, perhaps as a preliminary writing assignment, to jot down your early responses—your initial experience of the work—it is more likely that he or she will ask you to write an analysis in which you will connect details and draw inferences. Another possibility is that your instructor will ask you to write an evaluation, perhaps in terms of cultural or aesthetic values. The purpose of the paper will in large measure determine what is relevant.
4. **Keep looking at the art** you are writing about (or reproductions of it), jotting down notes on all relevant matters. You can generate ideas

by asking yourself questions, such as those given on pages 28–73. As you look and think, reflect on your observations and record them. (By the way, if you are writing about an object in a museum, it is a good idea to choose an object that is reproduced on a postcard; the picture will help you to keep the object in mind when you are back in your room, writing.) If you have an idea, jot it down; don't assume that you will remember it when you get around to writing your essay. A sheet of paper is a good place for initial jottings, but many people find that—if they are not taking notes on a word processor—in the long run it is easiest to use 4 × 6-inch cards, writing on one side only (notes on the reverse side usually get overlooked). Put only one point on each card, and put a brief caption on the card (e.g., Site of *David*); later you can easily rearrange the cards so that relevant notes are grouped together.

5. **Sort out your note cards, putting together what belongs together**. Three separate cards with notes about the texture of the materials of a building, for instance, probably belong together in a packet. Reject cards irrelevant to your topic.

6. **Organize your packets of cards into a reasonable sequence**. Your cards contain ideas (or at least facts that you can think about); now the packets of cards have to be put into a coherent sequence. When you have made a tentative arrangement, review it; you may discover a better way to group your notes, and, of course, you may want to add to your notes. If so, start reorganizing.

On the whole, it is usually best to devote the beginning of your paper to a statement of the problem. (Usually this means identifying the work[s] of art that you will discuss, and announcing your thesis.) Then go on, probably, to a discussion of how the object is structured artistically (e.g., composition, space, line, light), and then, finally, give a more general interpretation and evaluation. Such an organization takes the reader with you; the reader sees the evidence and thus is prepared to accept your conclusions.

In general, organize the material from the simple to the complex, in order to ensure intelligibility. If, for instance, you are discussing the composition of a painting, it probably will be best to begin with the most obvious points, and then to turn to the subtler but perhaps equally important ones. Similarly, if you are comparing two sculptures, it may be best to move from the most obvious contrasts to the least obvious. When you have arranged your notes into a meaningful sequence of packets, you have approximately divided your material into paragraphs.

7. **Get it down on paper**. Most essayists find it useful to jot down some sort of **outline**, a map indicating the main idea of each paragraph and, under each main idea, supporting details that give it substance. An outline—not necessarily anything highly formal with capital and lower-case letters and roman and arabic numerals, but merely key phrases in some sort of order—will help you to overcome the paralysis called "writer's block" that commonly afflicts professional as well as student writers. For an example of a student's rough outline, see the jottings on page 84 that were turned into an essay on the sculpture *Seated Statue of Prince Khunera as a Scribe*.

A page of paper with ideas in some sort of sequence, however rough, ought to encourage you that you do have something to say. And so, despite the temptation to sharpen another pencil or to put a new ribbon into the typewriter, the best thing to do at this point is to follow the advice of Isaac Asimov, author of 225 books: "Sit down and start writing."

If you don't feel that you can work from note cards and a rough outline, try another method: Get something down on paper, writing (preferably on a word processor) freely, sloppily, automatically, or whatever, but allow your ideas about what the work means to you and how it conveys its meaning—rough as your ideas may be—to begin to take visible form. If you are like most people, you can't do much precise thinking until you have committed to paper at least a rough sketch of your initial ideas. Later you can push and polish your ideas into shape, perhaps even deleting all of them and starting over, but it's a lot easier to improve your ideas once you see them in front of you than it is to do the job in your head. On paper one word leads to another; in your head one word often blocks another.

Just keep going; you may realize, as you near the end of a sentence, that you no longer believe it. Okay; be glad that your first idea led you to a better one, and pick up your better one and keep going with it. What you are doing is, in a sense, by trial and error pushing your way not only toward clear expression but also toward sharper ideas and richer responses.

## GETTING TO A READABLE DRAFT

1. **Keep looking and thinking**, asking yourself questions and providing tentative answers, searching for additional material that strengthens or weakens your main point; take account of it in your outline or draft.

2. **With your outline or draft in front of you, write a more lucid version**, checking your notes for fuller details. If, as you work, you find that some of the points in your earlier jottings are no longer relevant, eliminate them; but make sure that the argument flows from one point to the next. It is not enough to keep your thesis in mind; you must keep it in the reader's mind. As you write, your ideas will doubtless become clearer; some may prove to be poor ideas. (We rarely know exactly what our ideas are until we have them set down on paper. As the little girl said, replying to the suggestion that she should think before she spoke, "How do I know what I think until I see what I say?") Not until you have written a draft do you really have a strong sense of what you feel and know, and of how good your essay may be.

If you have not already made an outline, at this stage it is probably advisable to make one, thus ensuring that your draft is reasonably organized. Try to jot down, in sequence, each major point, and each subpoint. You may find that some points need amplification, or that a point made on page 3 really ought to go on page 1. Again, put yourself in the reader's shoes, and try to make sure that the paper not only has an organization, but that the organization will be clear to your reader.

3. **After a suitable interval, preferably a few days, revise and edit the draft**. To write a good essay you must be a good reader of the essay you are writing. We're not talking at this stage about proofreading or correcting spelling errors, though later of course you must engage also in those activities.

## REVISING

In revising their work, writers ask themselves such questions as

Do I mean what I say?
Do I say what I mean? (Answering this question will cause you to ask yourself such questions as, "Do I need to define my terms? Add examples to clarify? Reorganize the material so that a reader can grasp it?")

During this part of the process of writing, you do your best to read the draft in a skeptical frame of mind. In taking account of your doubts, you will probably unify, organize, clarify, and polish the draft.

- *Unity* is achieved partly by eliminating irrelevancies. These may be small (a sentence or two) or large (a paragraph or even a whole page

or two). You wrote the material and now you are fond of it, but if it is irrelevant you must delete it.

- *Organization* is largely a matter of arranging material into a sequence that will assist the reader to grasp the point. If you reread your draft and jot down a paragraph outline—a series of sentences, one under the other, each sentence summarizing one paragraph— you can then see if the draft has a reasonable organization, a structure that will let the reader move easily from the beginning to the end.

- *Clarity* is achieved largely by providing concrete details, examples, and quotations to support generalizations, and by providing helpful transitions ("for instance," "furthermore," "on the other hand," "however").

- *Polish* is small-scale revision. For instance, one deletes unnecessary repetitions, combines choppy sentences into longer sentences, and breaks overly long sentences into shorter sentences.

After producing a draft that seems good enough to show to someone, writers engage in yet another activity. They edit. **Editing** includes such work as checking the accuracy of quotations by comparing them with the original, checking a dictionary for the spelling of doubtful words, and checking a handbook for doubtful punctuation—for instance, whether a comma or a semicolon is needed in a particular sentence.

## PEER REVIEW

Your instructor may encourage (or even require) you to discuss your draft with another student or with a small group of students. That is, you may be asked to get a review from your peers. Such a procedure is helpful in several ways. First, it gives the writer a real audience, readers who can point to what pleases or puzzles them, who make suggestions, who may often disagree (with the writer or with each other), and who frequently, though not intentionally, *misread.* Though writers don't necessarily like everything they hear (they seldom hear "This is perfect. Don't change a word!"), reading and discussing their work with others almost always gives them a fresh perspective on their work, and a fresh perspective may stimulate thoughtful revision. (Having your intentions *misread,* because your writing isn't clear enough, can be particularly stimulating.)

QUESTIONS FOR PEER REVIEW    Fine Arts 10

Read each draft once, quickly. Then read it again, with
the following questions in mind.

1. What is the essay's topic? Is it one of the assigned
   topics, or a variation of one of them? Is the title ap-
   propriate? Does the draft show promise of fulfilling the
   assignment?

2. Looking at the essay as a whole, what thesis (main
   idea) is stated or implied? If implied, try to state it
   in your own words.

3. Is the thesis plausible? How might it be strengthened?

4. Looking at each paragraph separately:
   a. What is the basic point?
   b. How does each paragraph relate to the essay's main
      idea or to the previous paragraph?
   c. Should some paragraphs be deleted? Be divided into
      two or more paragraphs? Be combined? Be put else-
      where? (If you outline the essay by jotting down the
      gist of each paragraph, you will get help in answer-
      ing these questions.)
   d. Is each sentence clearly related to the sentence
      that precedes and to the sentence that follows?
   e. Is each paragraph adequately developed? Are there suf-
      ficient details to support the generalizations?
   f. Are the introductory and concluding paragraphs ef-
      fective?

5. Are the necessary illustrations included, and are they
   adequately identified?

6. What are the paper's chief strengths?

7. Make at least two specific suggestions that you think
   will assist the author to improve the paper.

The writer whose work is being reviewed is not the sole beneficiary. When students regularly serve as readers for each other, they become better readers of their own work, and consequently better revisers. And, as you probably know, learning to write is in large measure learning to read.

If peer review is a part of the writing process in your course, the instructor may distribute a sheet with some suggestions and questions. See page 126 for an example of such a sheet.

## PREPARING THE FINAL VERSION

1. **If you have received comments from a reader, consider them carefully.** Even if you disagree with them, they may alert you to places in your essay that need revision, such as clarification.

In addition, if a friend, a classmate, or another peer reviewer has given you some help, acknowledge that help in a footnote or endnote. (If you look at almost any book or any article in *Art Bulletin* you will notice that the author acknowledges the help of friends and colleagues. In your own writing follow this practice.) Here are four sample acknowledgments from papers by students:

> I wish to thank Anna Aaron for numerous valuable suggestions.

> I wish to thank Paul Gottsegen for calling my attention to passages that needed clarification, and Jane Leslie for suggesting the comparison with Orozco's murals at Dartmouth College.

> Emily Andrews called my attention to recent studies of Mayan art.

> I am indebted to Louise Cort for explaining how Shigaraki ceramics were built and fired.

2. **Type or write a clean copy**, following the principles concerning margins, pagination, footnotes, and so on, set forth in Chapter 7. If you have borrowed any ideas, be sure to give credit, usually in footnotes, to your sources. Remember that plagiarism is not limited to the unacknowledged borrowing of words; a borrowed idea, even when put into your own words, requires acknowledgment. (On giving credit to sources, see pp. 161–65.)

3. **Proofread and make corrections** as explained on pages 157–58.

In short, ask these questions:

- Is the writing true (do you have a point that you state accurately)?
- Is the writing good (do your words and your organization clearly and effectively convey your meaning)?

All of this adds up to Mrs. Beeton's famous recipe: "First catch your hare, then cook it."

## GUIDELINES ON WRITING WITH A COMPUTER

Computers can help you to research and write papers.° Word-processing programs facilitate note-taking, drafting, and revising. They also save you time in preparing footnotes, tables of contents, and bibliographies. They may even reduce the stress associated with writing. Database software simplifies the task of storing large quantities of research information for lengthy papers, such as theses or dissertations. And through the Internet and CD-ROM you can gain access to images of works of art in museum collections.

### Preparing to Write

**Initial Note-taking.**   Your first notes probably will be on scraps of paper or in the margins of your textbook, but once you go beyond these you can use a word processor, for instance, to brainstorm. By means of *free association*—writing down whatever comes to mind, without fretting about spelling, punctuation, or logic—you will probably find that you can generate ideas, at least some of which will lead to something. Or you can try *listing;* for example, if you are going to write about a work of sculpture, you might enter on the screen

```
pose
size
material
pedestal
context
```

---

°This discussion of writing with a computer is by Mark H. Beers, associate editor of the Merck Manuals, and Stephen K. Urice, director of the Rosenbach Museum and Library.

and then insert your thoughts about each of these. (You can generate ideas about a topic by asking yourself some of the questions set forth on pp. 28–73.)

Because the computer lets you move text easily, you may decide to rearrange the sequence; in any case, you will find yourself effortlessly inserting additional material. As you organize your notes, you will see—before your eyes, on the computer screen—the backbone of a paper emerging. If you have a laptop, take it to the library and put your research notes directly into your computer file. The computer is especially handy for long quotations; later you can move ("cut and paste") information from your notes into the appropriate place in your draft, without retyping the material.

Sophisticated computer users, especially when they are working on a large project, may decide to use database software to organize initial notes. By placing your notes into a database, you can simplify the tasks of keeping track of where ideas came from, retaining accurate information on references, developing chronologies, relating specific examples to ideas, and relating one idea to the next.

**Recording Sources.**   Index cards were once a great way to record sources, but now, with word-processing and database software, you can more easily keep track of sources. When using the word processor, keep all of your references in one file and use a standard bibliographic format, such as this one:

> Harper, Prudence Oliver. The Royal Hunter: Art of
> the Sassanian Empire. New York: Asia Society,
> 1978.

The computer will allow you to sort the list, at least by the first word (author's last name) in each entry. As you write your paper, you can insert ("copy and paste") each reference into the appropriate footnote or endnote (making the appropriate changes to format, as needed).

If you envision using many sources, a database—which provides much more power than word-processing software—may offer a better approach. Many programs come with a template for references so that all you have to do is enter the information in the preexisting fields. Then you can sort or limit the references by title, author, or source, or, in fact, by any of the ideas you have drawn from the source, such as the work of art the source refers to, the artist it discusses, or the dates in history that it covers. For example, when writing a long paper on the sculptures from

the Parthenon (the so-called Elgin Marbles), a reference in your database might have the following usable fields:

```
Author:   John Henry Merryman
Title:    Thinking about the Elgin Marbles
Source:   Michigan Law Review
Cite:     Vol. 83, 1985, pp. 1881-1923
Art:      Greek
Period:   Classical
Dates:    440-432 BC
Artist:   Phidias
Topic 1:  Classical sculpture
Topic 2:  Cultural repatriation
Quote 1:  "Elgin removed (or took from the ground
          where they had fallen or from the
          fortifications and other structures in
          which they had been used as building
          materials) portions of the frieze,
          metopes, and pediments" (pp. 1883-1884).
Quote 2:  "Despite national laws limiting the export
          of cultural property, some of it still
          finds its way abroad" (p. 1889)
Quote 3:  "That, in the end, is what the law and
          politics of cultural property are about:
          the cultural heritage of all mankind"
          (p. 1923).
```

**Outlining.**    Almost all word-processing software has sophisticated outlining capabilities. As a first step in drafting your paper, let the computer help you create an outline. How do you want to organize your paper at the simplest level?

Let's take as an example a paper on early Impressionist painters. You might start your outline with the basic points you wish to cover:

```
  I. Who were the early Impressionist painters?
 II. What are the characteristics of their works?
III. Who were their predecessors?
 IV. What are their major works?
  V. What did contemporary reviewers think about
     their works?
 VI. How did they influence later artists?
```

Next, you would flesh out the outline—that is, add details—so that it begins to hold the issues you will discuss. For instance, item III might be turned into this:

```
III. Who were their predecessors?
    A. French
        1. Eugène Delacroix (1798-1863)
        2. Barbizon school (mid-nineteenth century):
           François Millet (1814-75)
        3. Honoré Daumier (1808-79)
        4. Camille Corot (1796-1875)
        5. Gustave Courbet (1819-77)
    B. English
        1. Joseph Mallord William Turner (1775-1851)
        2. John Constable (1776-1837)
        3. E. P. Frith (1819-1909)
    C. Other Countries
        1. Germany: Caspar David Friedrich
           (1774-1840)
        2. Spain: Francisco Goya (1746-1828)
```

At this stage, many writers find it useful to add further details to their outline, in effect producing much of the paper without worrying (at this point) about stylistic niceties. For instance, item III might be amplified along these lines:

```
III. Who were their predecessors? French
     Impressionism was influenced by radical
     changes earlier in the nineteenth century
     in the manner of painting, subject matter,
     point of view, purpose
     A. French
         1. Eugène Delacroix (1798-1863): Contrast
            Delacroix's work to the work of Jean-
            Auguste-Dominique Ingres (1780-1867),
            representing complete opposites in early
            nineteenth-century French painting style
            and subject matter. Painterly style of
            Delacroix versus linear style of Ingres,
            predecessor of Impressionist painters'
            brushwork and style.
```

When you move items around in your outline, the software automatically renumbers and re-letters the components of the outline. Further, when you expand or contract your discussions or change the level of any item, the software automatically takes care of the formatting. Take advantage of these capabilities to help organize your thoughts before you

begin writing your draft. (Of course, you are indeed writing a draft even at this stage, but it feels more like preliminary fiddling.)

## Writing a First Draft

Many students find that preparing a first draft with a computer is less intimidating than preparing it with pen and paper or on a typewriter. As we have just seen, the computer allows you to write freely, adding material—at exactly the right place—whenever it occurs to you. Your original outline probably is an excellent starting point, but don't hesitate to reorganize the elements if, as you add details, you realize that a different sequence is preferable.

If you took extensive notes—for instance, some quotations of considerable length—you can now effortlessly copy these quotations into the appropriate places in your draft. You can then edit a quotation—for instance, by abridging it and indicating each omission with an ellipsis, or three spaced periods—or you may decide to replace the quotation with a brief summary. (You must, of course, give credit to the source even if you do not directly quote a single word; not to give credit for a borrowed idea is to plagiarize. See pp. 161–62.)

Virtually all software programs now handle footnotes and endnotes. The software can easily format the notes and place them where you want them. As you move blocks of text, the notes will follow and will automatically be renumbered. If (as is likely) you will provide a bibliography at the end of your paper, the computer will generate the bibliography automatically if you instruct the software to do so by marking each reference.

## Revising a Draft

When you have a completed rough draft, read it from beginning to end. You can do this initially on the computer screen, and doubtless you will be able to see some things that need revising. But you probably will not be able to get a strong sense of *how a reader will react* to the essay until you print it out and read it on paper. (Remember: An effectively written paper is one that *guides the reader's reactions.* For example, it builds its paragraphs so that a reader does *not* mentally say, "This is going on too long," or "I don't see what the writer is getting at. I need a specific example.") When you see your work on paper, and you try to experience it *from the reader's point of view,* you will find that some paragraphs are too long, some too short, some lack transitions, and so forth.

When you make a printout of your draft for editing, give yourself enough room to write in. Set the margins to at least 1.5 inches and double-space the text. Anything less than these settings will not give you enough space to make notes or to indicate the changes you decide to make in the next draft.

**Saving and Backing Up.**   When you are working on the computer, *save your work often.* Most software allows you to set an automatic "save" every few minutes. Use this feature; the last thing you want to happen is to lose some keen writing because your roommate kicked the computer plug out of the socket. Further, remember to *back up your work.* Dogs do not eat homework very often, but faulty hard drives do devour manuscripts.

**Proofreading.**   The computer can help you proofread your work. Use the spell checker to find typographical errors and misspellings. Always check spelling before printing. But you will still have to proofread the printed paper because the spell checker can't tell if you have typed the *right* word. For example, if you typed *from* when you meant *form,* the spell checker won't catch the error.

Many computer programs also have grammar checkers. Although you can't rely on these programs, they can be helpful in finding pesky errors that plague writing, such as "Does the question mark go inside or outside the quotation mark?" The grammar checker may also point out overuse of the passive voice, faulty agreement of subject and verb, and overly long sentences.

## Graphics and the Computer

On occasion, it may be appropriate to add graphics to a paper, such as a neatly designed table, figure, or timeline. Many word-processing programs allow you to clip a piece of artwork and add it to the page. Such an image is useful when referring to a specific work or a detail of a work.

Advances in computer technology may allow you to view works of art in exciting new ways. Although it is always best to see the actual artwork you are writing about, sometimes you must rely on a picture of it. Printed pictures are always problematic: The colors are often inaccurate in color pictures, while black-and-white images leave out much of the drama and information.

Some museum collections are already available on CD-ROM for display on your computer screen in high resolution with full-color graphics. For example, several hundred pictures from the Louvre and other museums now can be purchased on a CD-ROM. If you are familiar with the Internet, explore how to access high-resolution graphics from computers in museums around the country using Web browsers. Many of these images can be printed. Most equipment is limited to printing them in black and white, but the technology of color printing is quickly becoming more available.

In short, the computer and its applications will facilitate your efforts to write about art. Take advantage of these resources; they can ease the chores that inevitably accompany research, and they can assist you in producing a paper that will interest your readers.

## The Final Document

Once your text says what you want it to say, let the computer help you make its presentation attractive. For example, you will probably want a cover page, including a title, the name and number of the course, the instructor's name (correctly spelled, please), the date of submission, and, of course, your name. Give this information in a visually pleasing way. You will likely choose a larger typefont for the title, so that it stands out. Play with different fonts and point sizes—but be careful. Unless you are experienced with print layout, think twice—make it three times—before using more than three fonts in a document.

Decide if you want footnotes or endnotes. (Almost all readers find footnotes more convenient, simply because they spare the reader the bother of thumbing through the pages. But there is yet another possibility. Some writers give the page number of the source in parentheses in the text, and give full bibliographic citations, alphabetically by last name, in a list headed "works cited.") In addition, be sure that the pages are numbered consecutively. Most instructors will suggest that you use a header (perhaps in a smaller font size than the text) with your name, a short title of the paper, and the page number.

If your instructor provides guidelines about format (line spacing, margins, and so on) follow them exactly. If the instructor does not, you may follow the instructions given in Chapter 7 (pp. 154–57). Most instructors and readers prefer one-inch margins, and double-spaced text.

Some instructors will limit the length of the paper. Don't try to beat the page limit by minimizing the font size or reducing the margins. (Speaking roughly, a page of double-spaced material contains about 250 words. Your software probably can count words and can give you an exact number.)

It is now time to print the final version of your paper. Although it is reasonable to print draft copies on cheap paper, use good quality paper for the copy that you will submit. Good paper holds ink better and is easier for your reader to handle. *Don't forget to make a copy for yourself,* both of what you have printed *and* of the computer file. If your instructor loses your work, you'll need a duplicate on paper; if your computer crashes, you'll be glad to have a copy stored away on a disk.

# 6

## Style in Writing

### PRINCIPLES OF STYLE

Writing is hard work (Lewis Carroll's school in *Alice's Adventures in Wonderland* taught reeling and writhing), and there is no point in fooling ourselves into believing that it is all a matter of inspiration. Many of the books that seem, as we read them, to flow so effortlessly were in fact the product of innumerable revisions. "Hard labor for life" was Joseph Conrad's view of his career as a writer. This labor, for the most part, is not directed to prettifying language but to improving one's thoughts and then getting the words that communicate these thoughts exactly. There is no guarantee that effort will pay off, but failure to expend effort is sure to result in writing that will strike the reader as confused. It won't do to comfort yourself with the thought that you have been misunderstood. You may know what you *meant to say*, but your reader is the judge of what indeed you *have said*. Keep in mind Henri Matisse's remark: "When my words were garbled by critics or colleagues, I considered it my fault, not theirs, because I had not been clear enough to be comprehended."

Many books have been written on the elements of good writing, but the best way to learn to write is to do your best, revise it a few days later, hand it in, and then study the annotations an experienced reader puts on your essay. In revising the annotated passages, you will learn what your weaknesses are in writing. After drafting your next essay, put it aside for a day or so, and then reread it, preferably aloud. You may find much that bothers you. (If you read it aloud, you will probably catch choppy sentences, needless repetitions, and unpleasant combinations of words, such as "We see in the sea. . . .") If the argument does not flow, check to see whether your organization is reasonable and whether you have made adequate transitions. Do not hesitate to delete interesting but irrelevant material that obscures the argument. Make the necessary revisions again and again if there is time. Revision is indispensable if you wish to avoid

(in Somerset Maugham's words) "the impression of writing with the stub of a blunt pencil."

Even though the best way to learn to write is by writing and by heeding the comments of your readers, a few principles can be briefly set forth here. These principles will not suppress your particular voice; rather, they will get rid of static, enabling your voice to come through effectively. You have something to say, but you can say it only after your throat is cleared of "Well, what I meant was" and "It's sort of, well, you know." Your readers do *not* know; they are reading in order to know. This chapter will help you let your individuality speak clearly.

## GET THE RIGHT WORD

### Denotation

Be sure the word you choose has the right explicit meaning, or denotation. Don't say "tragic" when you mean "pathetic," "carving" when you mean "modeling," or "print" when you mean a photographic reproduction of a painting.

### Connotation

Be sure the word you choose has the right association or implication—that is, the right connotation. Here is an example of a word with the wrong connotation for its context: "Close study will *expose* the strength of Klee's style." "Reveal" would be better than "expose" here; "expose" suggests that some weakness will be brought to light, as in "Close study will expose the flimsiness of the composition."

Sometimes our prejudices blind us to the unfavorable connotations of our vocabulary. Writing about African architecture, one student spoke of "mud huts" throughout the paper; a more respectful term for the same type of building would be "clay house" or "earthen compound." If you submit your paper to a colleague for peer review, urge your reviewer to question your use of words that may have inappropriate connotations.

### Concreteness

Catch the richness, complexity, and uniqueness of what you see. Do not write "His expression lacks emotion" if you really mean the expression is icy, or indifferent, or whatever. But concreteness is not only a matter of

getting the exact word—no easy job in itself. If your reader is (so to speak) to see what you are getting at, you have to provide some details. Instead of writing "The influence of photography on X is small," write "The influence of photography is evident in only six paintings."

Compare the rather boring statement, "Thirteenth-century sculpture was colored," or even "Thirteenth-century sculpture was brightly painted and sometimes adorned with colored glass," with these sentences rich in concrete detail:

### Concrete
Color was an integral part of sculpture and its setting. Face and hands were given their natural colors; mouth, nose, and ears were slightly emphasized; the hair was gilded. Dresses were either covered in flowers or painted in vigorous colors: ornaments, buckles, and hems were highlighted by brilliant colors or even studded with polished stones or colored glass. The whole portal looked like a page from an illuminated manuscript, enlarged on a vast scale.

> Marcel Aubert, *The Art of the High Gothic Era*, trans.
> Peter Gorge (1965), p. 60

## Tone

Remember, when you are writing, *you* are the teacher. You are trying to help someone to see things as you see them, and it is unlikely that either solemnity or heartiness will help anyone see anything your way. There is rarely a need to write that Daumier was "incarcerated" or (at the other extreme) "thrown into the clink." "Imprisoned" or "put into prison" will probably do the job best. Be sure, also, to avoid shifts in **tone**. Consider this passage, from a book on modern sculpture:

### Faulty
We forget how tough it was to make a living as a sculptor in this period. Rare were supportive critics, dealers, and patrons.

Although "tough" is pretty casual ("difficult" might be better), "tough" probably would have been acceptable if it had not been followed, grotesquely, by the pomposity of "Rare were supportive critics." The unusual word order (versus the normal order, "Supportive critics were rare") shows a straining for high seriousness that is incompatible with "tough."

Nor will it do to "finagle" with an inappropriate expression by putting it in "quotes." As the previous sentence indicates, the apologetic quota-

tion marks do not make such expressions acceptable, only more obvious and more offensive. The quotation marks tell the reader that the writer knows he or she is using the wrong word but is unwilling to find the right word. If for some reason a relatively low word is the right one, use it and don't apologize with quotation marks.

## Repetition

Although some **repetitions**—say, of words or phrases like "surely" and "it is noteworthy that"—reveal a tic that ought to be cured by revision, don't be afraid to repeat a word if it is the best word. Notice that in the following paragraph the writer does not hesitate to repeat "Impressionism," "Impressionist," "face," and "portrait" (three times each), and "portraiture" and "photography" (twice each).

### *Effective*

We can follow the decline of portraiture within Impressionism, the art to which van Gogh assumed allegiance. The Impressionist vision of the world could hardly allow the portrait to survive; the human face was subjected to the same evanescent play of color as the sky and sea; for the eyes of the Impressionist it became increasingly a phenomenon of surface, with little or no interior life, at most a charming appearance vested in the quality of a smile or a carefree glance. As the Impressionist painter knew only the passing moment in nature, so he knew only the momentary face, without past or future; and of all its moments, he preferred the most passive and unconcerned, without trace of will or strain, the outdoor, summer holiday face. Modern writers have supposed that it was photography that killed portraiture, as it killed all realism. This view ignores the fact that Impressionism was passionately concerned with appearances, and was far more advanced than contemporary photography in catching precisely the elusive qualities of the visible world. If the portrait declines under Impressionism it is not because of the challenge of the photographer, but because of a new conception of the human being. Painted at this time, the portraits of van Gogh are an unexpected revelation. They are even more surprising if we remember that they were produced just as his drawing and color was becoming freer and more abstract, more independent of nature.

<div align="right">Meyer Schapiro, <em>Vincent van Gogh</em><br>(1952), pp. 16–17</div>

When you repeat words or phrases, or when you provide clear substitutes (such as "he" for "van Gogh"), you are helping the reader to keep step with your developing thoughts.

An ungrounded fear of repetition often produces a vice known as *elegant variation*. Having mentioned "painters," the writer then speaks of

"artists," and then (more desperately) of "men and women of the brush." This use of synonyms is far worse than repetition; it strikes the reader as silly. Or, it may be worse than silly. Consider:

**Confusing**
Corot attracted the timid painters of his generation; bolder artists were attracted to Manet.

The shift from "painters" to "artists" makes us wonder if perhaps Manet's followers—but not Corot's—included etchers, sculptors, and so on. Probably the writer did *not* mean any such thing, but his words prompt us to think in the wrong direction.

Be especially careful not to use variations for important critical terms. If, for instance, you are talking about "nonobjective art," don't switch to "abstract art" or "nonrepresentational art" unless you tell the reader why you are switching.

## The Sound of Sense, the Sense of Sound

Avoid jingles and other repetitions of sound, as in these examples:

**Annoying**
The reason the season is autumn . . .

Circe certainly . . .

Michelangelo's Medici monument . . .

These irrelevant echoes call undue attention to the words and thus get in the way of the points you are making. But wordplay can be effective when it contributes to meaning. For example, in this sentence:

**Effective**
The walls of Sian both defended and defined the city.

The echo of "defended" in "defined" nicely emphasizes the unity in this duality.

## WRITE EFFECTIVE SENTENCES

## Economy

Say everything relevant, but say it in the fewest words possible. For example, the following sentence

**Wordy**

There are a few vague parts in the picture that give it a mysterious quality.

can be written more economically as

**Revised**

A few vaguely defined parts give the picture a mysterious quality.

(Nothing has been lost by the deletion of "There are" and "that.") Even more economical is

**Revised**

A few vague parts add mystery to the picture.

The original version says nothing that the second version does not say and says nothing that the third version—nine words against fifteen—does not say. If you find the right nouns and verbs, you can often delete adjectives and adverbs. (Compare "a mysterious quality" with "mystery.")

Something is wrong with a sentence if you can delete words and not sense the loss. A chapter in a recent book begins:

**Wordy**

One of the principal and most persistent sources of error that tends to bedevil a considerable proportion of contemporary analysis is the assumption that the artist's creative process is a wholly conscious and purposive type of activity.

Well, there is something of interest here, but it comes along with a lot of hot air. Why that weaseling ("*tends to* bedevil," "*a considerable* proportion"), and why "type of activity" instead of "activity"? Those spluttering *p*'s ("principal and most persistent," "proportion," "process," "purposive") are a giveaway; the writer has not sufficiently revised his writing. It is not enough to have an interesting idea; the job of writing requires *re*writing, revising. The writer of this passage should have revised it—perhaps on rereading it an hour or a day later—and produced something like this:

**Revised**

One of the chief errors bedeviling much contemporary criticism is the assumption that the artist's creative process is wholly conscious and purposive.

Possibly the author thought that a briefer and clearer statement would not do justice to the complexity of the main idea, but more likely he

simply neglected to reread and revise. The revision says everything that the original says, only better.

Of course, when we are drafting an essay we sometimes put down what is more than enough. There's nothing wrong with that—anything goes in a draft—but when we revise we need to delete the redundancies. Here is part of a descriptive entry from an exhibition catalog:

**Redundant**
A big black bird with a curved beak is perched on a bare, wintry branch that has lost all its leaves.

If the branch is "bare," it has lost its leaves. No need to write it twice.

The **passive voice** (wherein the subject receives the action) is a common source of wordiness. In general, do not write "The sculpture was carved by Michelangelo" (the subject—"the sculpture"—receives the action—"was carved"). Instead, use the **active voice,** in which the subject acts on the object: "Michelangelo carved the sculpture" (the subject—"Michelangelo"—acts—"carved the sculpture"). Even though the revision is a third shorter, it says everything that the longer version says. Here is another example (from an otherwise excellent catalog of an exhibition of Raphael and his circle):

**Passive**
Our knowledge of Raphael's later development is not so complete as to enable the possibility that this drawing is by him to be entirely excluded.

Notice that the passive ("to be entirely excluded") is accompanied by other kinds of wordiness (for instance, "this drawing is by him" could be more precisely stated as "this drawing is his"), but one might begin by getting rid of the passive:

**Active**
Our knowledge of Raphael's later development is not so complete as to enable us to exclude the possibility that the drawing is by him.

But the passive voice has its uses. For instance, when the doer is unknown ("The picture was stolen Monday morning"), or is unimportant ("Drawings should be stored in light-proof boxes), or is too obvious to be mentioned ("The inscription has never been deciphered"). In short, use the active voice rather than the passive voice unless you believe that the passive especially suits your purpose.

## Parallels

Use **parallels** to clarify relationships. Few of us are likely to compose such deathless parallels as "I came, I saw, I conquered," or "of the people, by the people, for the people," but we can see to it that coordinate expressions correspond in their grammatical form. A parallel such as "He liked to draw and to paint" (instead of "He liked drawing and to paint") neatly says what the writer means. Notice the clarity and the power of the following sentence on Henri de Toulouse-Lautrec:

> **Parallel**
> The works in which he records what he saw and understood contain no hint of comment—no pity, no sentiment, no blame, no innuendo.
> Peter and Linda Murray, *A Dictionary of Art and Artists,*
> 4th ed. (1976), p. 451

The following wretched sentence seems to imply that "people" and "California and Florida" can be coordinate:

> **Faulty**
> The sedentary Pueblo people of the southwestern states of Arizona and New Mexico were not as severely affected by early Spanish occupation as were California and Florida.

This sort of fuzzy writing is acceptable in a first or even a second draft, but not in a finished essay.

## Subordination

First, a word about short sentences. They can, of course, be effective ("Rembrandt died a poor man"), but unless what is being said is especially weighty, short sentences seem childish. They may seem choppy, too, because the periods keep slowing the reader down. Consider these sentences:

> **Choppy**
> He was assured of government support. He then started to dissociate himself from any political aim. A long struggle with the public began.

There are three ideas here, but they probably are not worth three separate sentences. The choppiness can be reduced by combining them, subordinating some parts to others. In **subordinating**, make sure that the less important element is subordinate to the more important. In the

following example the first clause ("As soon as he was assured of government support"), summarizing the writer's previous sentences, is a subordinate or dependent clause; the new material is made emphatic by being put into two independent clauses:

**Revised**

As soon as he was assured of government support, he started to dissociate himself from any political aim, and the long struggle with the public began.

The second and third clauses in this sentence, linked by "and," are coordinate—that is, of equal importance.

We have already discussed parallels ("I came, I saw, I conquered") and pointed out that parallel or coordinate elements should appear so in the sentence. The following line gives van Gogh and his brother Theo equal treatment:

Van Gogh painted at Arles, and his brother Theo supported him.

This is a **compound sentence**—composed of two or more clauses that can stand as independent sentences but that are connected with a coordinating conjunction such as *and, but, for nor, yet;* or with a correlative conjunction such as *not only . . . but also;* or with a conjunctive adverb such as *also,* or *however* (these require a semicolon); or with a colon, semicolon, or (rarely) a comma.

A **complex sentence** (an independent clause and one or more subordinate clauses), however, does not give equal treatment to each clause; whatever is outside the independent clause is subordinate, less important. Consider this sentence:

Supported by Theo's money, van Gogh painted at Arles.

The writer puts van Gogh in the independent clause ("van Gogh painted at Arles"), subordinating the relatively unimportant Theo. Notice, by the way, that emphasis by subordination often works along with emphasis by position. Here the independent clause comes after the subordinate clause; the writer appropriately puts the more important material at the end—that is, in the more emphatic position.

Had the writer wished to give Theo more prominence, the passage might have run:

Theo provided money, and van Gogh painted at Arles.

Here Theo stands in an independent clause, linked to the next clause by "and." Each of the two clauses is independent, and the two men (each in an independent clause) are now of approximately equal importance. If the writer wanted instead to deemphasize van Gogh and to emphasize Theo, the sentence might read:

> While van Gogh painted at Arles, Theo provided the money.

Here van Gogh is reduced to the subordinate clause ("while van Gogh painted at Arles"), and Theo is given the dignity of the only independent clause ("Theo provided the money"). (Notice again that the important point is also in the emphatic position, near the end of the sentence. A sentence is likely to sprawl if an independent clause comes first, preceding a long subordinate clause of lesser importance, such as the sentence you are now reading.)

In short, though simple sentences and compound sentences have their place, they make everything of equal importance. Since everything is not of equal importance, you must often write complex and compound-complex sentences, subordinating some ideas to other ideas.

But note: You need not, of course, worry about subtle matters of emphasis while you are drafting your essay. When you reread the draft, however, you may feel that certain sentences dilute your point, and it is at this stage that you should check to see if you have adequately emphasized what is important.

## WRITE UNIFIED AND COHERENT PARAGRAPHS

A paragraph is normally a group of related sentences. These sentences explore one idea in a coherent (organized) way.

### Unity

If your essay is some five hundred words long—about two double-spaced typewritten pages—you probably will not break it down into more than four or five parts or paragraphs. (But you *should* break your essay down into paragraphs—that is, coherent blocks that give the reader a rest between them. One page of typing is about as long as you can go before the reader needs a slight break.) A paper of five hundred words with a dozen

paragraphs is probably faulty not because it has too many ideas but because it has too few *developed* ideas. A short paragraph—especially one consisting of a single sentence—is usually anemic; such a paragraph may be acceptable when it summarizes a highly detailed previous paragraph or group of paragraphs, or when it serves as a transition between two complicated paragraphs, but usually summaries and transitions can begin the next paragraph.

The unifying idea in a paragraph may be explicitly stated in a **topic sentence**. Most commonly, the topic sentence is the first sentence, forecasting what is to come in the rest of the paragraph; or it may be the second sentence, following a transitional sentence. Less commonly, it is the last sentence, summarizing the points that the paragraph's earlier sentences have made. Least commonly—but thoroughly acceptable—the paragraph may have no topic sentence, in which case it has a **topic idea**—an idea that holds the sentences together although it has not been explicitly stated. Whether explicit or implicit, an idea must unite the sentences of the paragraph. If your paragraph has only one or two sentences, the chances are that you have not adequately developed its idea.

A paragraph can make several points, but the points must be related, and the nature of the relationship must be indicated so that there is, in effect, a single unifying point. Here is a satisfactory paragraph about the first examples of Egyptian sculpture in the round. (The figures to which the author refers are not reproduced here.)

### Unified

Sculpture in the round began with small, crude human figures of mud, clay, and ivory (Fig. 4). The faces are pinched out of the clay until they have a form like the beak of a bird. Arms and legs are long rolls attached to the slender bodies of men, while the hips of the women's figures are enormously exaggerated. A greater variety of attitudes and better workmanship are found in the ivory figurines which sometimes have the eye indicated by the insertion of a bead (Fig. 4). It is the carving of animals, however, such as the ivory hippopotamus from Mesaeed in Fig. 4, or the pottery figure (Fig. 6) which points the way toward the rapid advance which was to be made in the Hierakonpolis ivories and in the small carvings of Dynasty I.

William Stevenson Smith, *Ancient Egypt,* 4th ed. (1960), p. 20

Smith is talking about several kinds of objects, but his paragraph is held together by a unifying topic idea. The idea is this:

Although most of the early sculpture in the round is crude, some pieces anticipate the later, more skilled work.

Notice, by the way, that Smith builds his material to a climax, beginning with the weakest pieces (the human figures) and moving to the best pieces (the animals).

The beginning and especially the end of a paragraph are usually the most emphatic parts. A beginning may offer a generalization that the rest of the paragraph supports. Or the early part may offer details, preparing for the generalization in the later part. Or the paragraph may move from cause to effect. Although no rule can cover all paragraphs (except that all must make a point in an orderly way), one can hardly go wrong in making the first sentence either a transition from the previous paragraph or a statement of the paragraph's topic. Here is a sentence that makes a transition and states the topic:

> Not only representational paintings but also abstract paintings have a kind of subject matter.

This sentence gets the reader from subject matter in representational paintings (which the writer has been talking about) to subject matter in abstract paintings (which the writer goes on to talk about).

Consider the following two effective paragraphs on Anthony Van Dyck's portrait of Charles I.

### Unified

Rather than begin with an analysis of Van Dyck's finished painting of Charles I, let us consider the problem of representation as it might have been posed in the artist's mind. Charles I saw himself as a cavalier or perfect gentleman, a patron of the arts as well as the embodiment of the state's power and king by divine right. He prided himself more on his dress than on robust and bloody physical feats. Van Dyck had available to him precedents for depicting the ruler on horseback or in the midst of a strenuous hunt, but he set these aside. How then could he show the regal qualities and sportsmanship of a dismounted monarch in a landscape? Compounding the artist's problem was the King's short stature, just about 5 feet, 5 inches. To have placed him next to his horse, scaled accurately, could have presented an ungainly problem of their relative heights. Van Dyck found a solution to this last problem in a painting by Titian, in which a horse stood with neck bowed, a natural gesture that in the presence of the King would have appropriate connotations. Placing the royal pages behind the horse and farther from the viewer than the King reduced their height and obtrusiveness, yet furnished some evidence of the ruler's authority over men. Nature also is made to support and suitably frame the King. Van Dyck stations the monarch on a small rise and paints branches of a tree overhead to resemble a royal canopy. The low horizon line and our point of view, which allows the King to

Anton Van Dyck, *Charles I,* ca. 1635. Oil on canvas, 8′1″ × 6′ 11 ½″. (The Louvre, Paris; Art Resource, NY/Lauros-Giraudon)

look down on us, subtly increase the King's stature. The restful stance yet inaccessibility of Charles depends largely upon his pose, which is itself a work of art, derived from art, notably that of Rubens. Its casualness is deceptive; while seemingly at rest in an informal moment, the King is every inch the perfect gentleman and chief of state. The cane was a royal prerogative in European courts of the time, and its presence along with the sword symbolized the gentleman-king.

Just as the subtle pose depicts majesty, Van Dyck's color, with its regal silver and gold, does much to impart grandeur to the painting and to achieve a sophisticated focus on the King. The red, silver, gold, and black of his costume are the most saturate and intense of the painting's colors and contrast with the darker or less intense coloring of adjacent areas. Largely from Rubens, Van Dyck had learned the painterly tricks by which materials and textures could be vividly simulated, so that the eye moves with pleasure from the silvery silken sheen of the coat to the golden leather sword harness and then on to the coarser surface of the

horse, with a similar but darker combination of colors in its coat and mane. Van Dyck's portrait is evidence that, whatever one's sympathy for the message, the artist's virtuosity and aesthetic can still be enjoyed.

Albert E. Elsen, *Purposes of Art* (1972), pp. 221–22

Let's pause to look at the structure of these two paragraphs. The first begins in effect by posing a question (What were the problems Van Dyck faced?) and then goes on to discuss Van Dyck's solutions. This paragraph could have been divided into two, the second beginning "Nature also"; that is, if Elsen had felt that the reader needed a break he could have provided it after the discussion of the king's position and before the discussion of nature and the king's pose within nature. But in fact a reader can take in all of the material without a break, and so the topic idea is "Van Dyck's solutions to the problem."

The second paragraph grows nicely out of the first, largely because Elsen begins the second paragraph with a helpful transition "Just as." The topic idea here is the relevance of the picture's appeal through color; the argument is supported with concrete details, and the paragraph ends by pushing the point a bit further: The colors in the painting not only are relevant to the character portrayed but also have a hold on us.

## Coherence

If a paragraph has not only unity but also a structure, then it has **coherence**; its parts fit together. Make sure that each sentence is properly related to the preceding and the following sentences. Nothing is wrong with such obvious **transitions** as *moreover, however, but, for example, this tendency, in the next chapter,* and so on; but, of course, (1) these transitions should not start every sentence (they can be buried thus: "Degas, moreover, . . ."), and (2) they need not appear anywhere in the sentence. The point is not that transitions must be explicit but that the argument must proceed clearly. The gist of a paragraph might run thus: "Speaking broadly, there were in the Renaissance two traditions of portraiture. . . . The first. . . . The second. . . . The chief difference. . . . But both traditions. . . ."

Consider the following lucid paragraph from an essay on Auguste Rodin's *Walking Man:*

### Coherent

*L'Homme qui marche* is not really walking. He is staking his claim on as much ground as his great wheeling stride will encompass. Though his body's axis leans forward, his rearward left heel refuses to lift. In fact, to

Auguste Rodin, *L'homme qui marche,* 1877. Bronze, 7′11 ¾″. Rodin Museum, Paris. (Foto Marburg/Art Resource, NY)

hold both feet down on the ground, Rodin made the left thigh (measured from groin to patella) one-fifth as long again as its right counterpart.

Leo Steinberg, *Other Criteria* (1972), p. 349

Notice how easily we move through the paragraph: The figure "is not. . . . He is. . . . Though. . . . In fact. . . ." These little words take us neatly from point to point.

## Introductory Paragraphs

Vasari, in *Lives of the Painters,* tells us that Fra Angelico "would never take his pencil in his hand till he had first uttered a prayer." One can easily understand his hope for divine assistance. Beginning a long poem, Lord Byron aptly wrote, "Nothing so difficult as a beginning." Of course, your job is made easier if your instructor has told you to begin your analysis with some basic facts: identification of the object (title, museum, museum number), subject matter (e.g., mythological, biblical, portrait), and technical information (material, size, condition). Even if your instructor has not told you to begin thus, you may find it helpful to start along these lines. The mere act of writing *anything* will probably help you to get going.

Still, almost all writers—professional as well as student writers—find that the beginning paragraphs of their drafts are false starts. In your finished paper the opening cannot be mere throat clearing. It should be interesting and informative. Don't take your title ("Space in Manet's *A Bar at the Folies-Bergère*") and merely paraphrase it in your first sentence: "This essay will study space in Manet's *A Bar at the Folies-Bergère.*" There is no information about the topic here, at least none beyond what the title already gave, and there is no information about you either—that is, there is no sense of your response to the topic, such as might be present in, say,

The space in *A Bar at the Folies-Bergère* is puzzling; one at first wonders where the viewer is supposed to be standing.

Here is a surefire way to begin:

- Identify the artwork(s) you will discuss.
- Suggest your thesis in the opening paragraph, moving from a generalization ("The space in the picture is puzzling") to some supporting details ("Where is the man standing, whose reflection we see in the upper right?").

Such an introduction quickly and effectively gets down to business; especially in a short paper, there is no need (or room) for an in-depth introduction.

Notice in the following example, the opening paragraph from an essay on Buddhist art in Japan, how the writer moves from a "baffling diversity" to "one major thread of continuity."

### Effective Opening
Amid the often baffling diversity which appears in so much of the history of Japanese art, one major thread of continuity may be traced throughout the evolution of religious painting and sculpture. This tradition was based on the great international style of East Asian Buddhist imagery, which reached its maturity during the early eighth century in T'ang China and remained a strong influence in Japan through the thirteenth century.

John Rosenfield, *Japanese Arts of the Heian Period: 794–1185*
(1967), p. 23

Similarly, in the next example, the paragraph moves from a general comment about skin-clinging garments to an assertion of the thesis (the convention is exaggerated in English Neoclassical art), and this thesis is then supported with concrete details.

### Effective Opening
The pictorial and sculptural custom of clothing the nude in skin-clinging dress has many and often-copied Classical precedents, but the erotic emphasis of this convention seems exaggerated in English art of the Neoclassic period more than at other times and places. The shadowy meeting of thighs, the smooth domes of bosom and backside, are all insisted on more pruriently through the lines of the dress than they were by contemporary French artists or by Botticelli and Mantegna and Desiderio da Settignano, who were attempting the same thing in the Renaissance—or, indeed, than by the Greek sculptors. The popular artists Rowlandson and Gillray naturally show this impulse most blatantly in erotic cartoons and satirical illustrations, in which women have enormous bubbly hemispheres fore and aft, outlined by the emphatically sketched lines of their dress.

Anne Hollander, *Seeing through Clothes* (1978), p. 118

## Concluding Paragraphs

The preceding discussion of opening paragraphs quotes Lord Byron: "Nothing so difficult as a beginning." But he went on to add, "Unless perhaps the end."

In conclusions, as in introductions, try to say something interesting. It is not of the slightest interest to say "Thus we see . . . ," and then go on to echo the title and the first paragraph. There is some justification for a summary at the end of a long paper because the reader may have half forgotten some of the ideas presented thirty pages earlier, but a paper that can easily be held in the mind needs something different. A good concluding paragraph does more than provide an echo of what the writer has already said. It may round out the previous discussion, normally with a few sentences that summarize (without the obviousness of "We may now summarize"), but usually it also draws an inference that has not previously been expressed, thus setting the previous material in a fresh perspective. A good concluding paragraph closes the issue while enriching it.

Notice how the example that follows wraps things up and, at the same time, opens outward by suggesting a larger frame of reference. This conclusion brings to a satisfying end a discussion of Bernini's piazza of St. Peter's.

### Effective Ending

As happens with most new and vital ideas, after initial sharp attacks the colonnades became of immense consequence for the further history of architecture. Examples of their influence from Naples to Greenwich and Leningrad need not be enumerated. The aftermath can be followed up for more than two and a half centuries.

Rudolf Wittkower, *Art and Architecture in Italy: 1600–1750*, 3rd ed. (1973), p. 196

Pretty much the same technique is used at the end of Elsen's second paragraph on Van Dyck's *Charles I* (p. 149), where the writer moves from a detailed discussion of the picture to the assertion that the picture continues to attract us.

Finally, don't feel that you must always offer a conclusion in your last paragraph. When you have finished your analysis, it may be enough to stop—especially if your paper is fairly short, let's say fewer than five pages. If, for example, you have throughout your paper argued that a certain Japanese print shows a Western influence in its treatment of space, you need scarcely reaffirm the overall thesis in your last paragraph. Probably it will be conclusion enough if you just offer your final evidence, in a well-written sentence, and then stop.

# 7

## Manuscript Form

### BASIC MANUSCRIPT FORM

Much of what follows is nothing more than common sense. Unless your instructor specifies something different, you can adopt these principles as a guide to basic manuscript format.

1. **Use 8½ × 11-inch paper of good weight.** Do not use paper torn out of a spiral notebook; ragged edges distract a reader. If you have written your essay on a computer and have printed it on a continuous roll of paper, remove the strips from each side of the sheets and separate the sheets before you hand in the essay.

2. **Write on one side of the page only.** If you typewrite, double-space, typing with a reasonably fresh ribbon. If you submit a handwritten copy, use lined paper and write, in black or dark blue ink, on every other line if the lines are closely spaced. A word to the wise: Instructors strongly prefer typed papers.

3. **Put your name, instructor's name, class or course number, and the date** in the upper right-hand corner of the first page. It is a good idea to put your name in the upper right corner of each subsequent page, so the instructor can easily reassemble your essay if somehow a page gets detached and mixed with other papers.

4. **Center the title of your essay** about two inches from the top of the first page. Capitalize the first letter of the first and last words of your title, the first word after a semicolon or colon if you use either one, and the first letter of all the other words except articles (*a, an, the*), conjunctions (*and, but, or,* etc.), and prepositions (*about, in, on, of, with,* etc.), thus:

```
The Renaissance and Modern Sources of Manet's Olympia
```

(Some handbooks advise that prepositions of five or more letters—*about, beyond*—be capitalized.) Notice that your title is neither underlined nor enclosed in quotation marks, though of course if, as here, your

title includes the title of a work of art (other than architecture), that title is underlined to indicate italics.

5. **Begin the essay an inch or two below the title.** If your instructor prefers a title page, do not number it, but begin the essay on the next page.

6. **Leave an adequate margin**—an inch or an inch and a half—at top, bottom, and sides, so that your instructor can annotate the paper.

7. **Number the pages consecutively,** using arabic numerals in the upper right-hand corner. If you give the title on a separate page, do not number that page; the page that follows it is page 1.

8. **Indent the first word of each paragraph** five spaces from the left margin.

9. **When you refer to a work illustrated in your essay, include helpful identifying details** in parentheses, thus:

> Vermeer's The Studio (Vienna, Kunsthistorisches Museum, Figure 6) is now widely agreed to be an allegorical painting.

But if in the course of the essay itself you have already mentioned where the picture is, do not repeat such information in the parenthetic material.

10. **If possible, insert photocopies of the illustrations at the appropriate places** in the paper, unless your instructor has told you to put all of the illustrations at the rear of the paper. Number the illustrations (each illustration is called a *Figure*) and give captions that include, if possible, artist (or, for anonymous works, the culture), title (underlined), date, medium, dimensions (height precedes width), and present location. Here are examples:

> Figure 1. Japanese, Flying Angel, second half of the eleventh century. Wood with traces of gesso and gold, $33^{1}/_{2}$" × 15". Museum of Fine Arts, Boston.

> Figure 2. Diego Velázquez, Venus and Cupid, ca. 1644-48. Oil on canvas, 3' $11^{7}/_{8}$" × 5' $9^{1}/_{4}$". National Gallery, London.

Note that in the second example the abbreviation *ca.* stands for *circa*, Latin for "about."

If there is some uncertainty about whether the artist created the work, precede the artist's name with *Attributed to*. If the artist had an

active studio, and there is uncertainty about the degree of the artist's involvement in the work, put *Studio of* before the artist's name.

**Four other points about captions for illustrations:**

- If you use the abbreviation *BC* ("before Christ") or *AD* ("anno domini," i.e., "in the year of our Lord"), do not put a space between the letters.
- *BC* follows the year (7 BC) but *AD* precedes the year (AD 10).
- The abbreviations *BC* and *AD* are falling out of favor, and are being replaced with *BCE* ("before the Common Era") and *CE* ("Common Era", i.e., common to Judaism and Christianity).
- Some instructors may ask you to cite also your source for the illustration, thus:

```
Figure 3. Japanese, Head of a Monk's Staff,
late twelfth century. Bronze, 9¹/₄". Peabody Museum,
Salem, Massachusetts. Illustrated in John
Rosenfield, Japanese Arts of the Heian Period:
794-1185 (New York: Asia Society, 1967), p. 91.
```

If, in your source, the pages with plates are unnumbered, give the plate number where you would ordinarily give the page number.

11. **If a reproduction is not available,** be sure when you refer to a work to tell your reader where the work is. If it is in a museum, give the acquisition number, if possible. This information is important for works that are not otherwise immediately recognizable. A reader needs to be told more than that a Japanese tea bowl is in the Freer Gallery. The Freer has hundreds of bowls, and, in the absence of an illustration, only the acquisition number will enable a visitor to locate the bowl you are writing about.

12. **Make a photocopy of your essay, or print a second copy** from the computer, so that if the instructor misplaces the original you need not write the paper again. It's a good idea to keep notes and drafts, too, until the instructor returns the original. Such material may prove helpful if you are asked to revise a paper, substantiate a point, or supply a source that you inadvertently omitted.

13. **Fasten the pages of your paper with a staple or paper clip** in the upper left-hand corner. (Find out which sort of fastener your instructor prefers.) Stiff binders are unnecessary; indeed they are a nuisance to the instructor, for they add bulk and they make it awkward to write annotations.

## CORRECTIONS IN THE FINAL COPY

Your extensive revisions should have been made in your drafts, but minor last-minute revisions may be made on the finished copy. In proofreading you may catch some typographical errors, and you may notice some minor weaknesses. (It's not a bad idea to read the paper aloud to someone, or to yourself. Your tongue will trip over phrases in which a word is omitted, or sentences that are poorly punctuated. Some people who have difficulty spotting errors report that they find they are helped when they glide a pencil at a moderate speed letter by letter over the page. Without a cursor, they say, their minds and eyes read in patterns and they miss typos.

Let's say that in the final copy you notice an error in agreement between subject and verb: "The weaknesses in the draftsmanship is evident." The subject is "weaknesses" (not "draftsmanship") and so the verb should be "are," not "is." You need not retype the page, or even erase. You can make corrections with the following proofreader's symbols.

*Changes* in wording may be made by crossing through words and rewriting just above them, either on the typewriter or by hand in ink or colored pencil:

```
                                          are
The weaknesses in the draftsmanship is̶ evident.
```

*Additions* should be made above the line, with a caret ( ∧ ) below the line at the appropriate place:

```
                                       are
The weaknesses in the draftsmanship∧evident.
```

*Transpositions* of letters may be made thus:

```
The weaknesses in ht̶e̶ draftsmanship are evident.
```

*Deletions* are indicated by a horizontal line through the word or words to be deleted. Delete a single letter by drawing a vertical or diagonal line through it.

```
The weaknesses in i̶n̶ the draftsmanship are evident.
```

*Separation* of words accidentally run together is indicated by a vertical line, *closure* by a curved line connecting the things to be closed up:

```
The weaknesses|in the d raftsmanship are evident.
```

*Paragraphing* may be indicated by the symbol ¶ before the word that is to begin the new paragraph.

```
The weaknesses are evident. ¶ For instance, the
draftsmanship is hesitant, and the use of color is. . . .
```

## QUOTATIONS AND QUOTATION MARKS

If you are writing a research paper, you will, of course, include quotations, almost surely from scholars who have worked on the topic, and possibly from documents such as letters or treatises written by the artist or by the artist's contemporaries. But even in a short analysis, based chiefly on looking steadily at the object, you may want to quote a source or two—for example, your textbook. The following guidelines tell you how to give quotations and how to cite your sources—but remember, a good paper is not a bundle of quotations.

1. **Be sparing in your use of quotations.** Use quotations as evidence, not as padding. If the exact wording of the original is crucial, or especially effective, quote it directly, but if it is not, don't bore the reader with material that can be effectively reduced either by summarizing or by cutting. If you cut, indicate ellipses as explained later (in point 5).

2. **Identify the speaker or writer of the quotation,** so that readers are not left with a sense of uncertainty. Usually this identification precedes the quoted material (e.g., you write something like "Rachel Miller argues" or "Kenneth Clark long ago pointed out"), in accordance with the principle of letting readers know where they are going. But occasionally the identification may follow the quotation, especially if it will prove something of a pleasant surprise. For example, in a discussion of Jackson Pollock's art, you might quote a hostile comment on one of the paintings and then reveal that Pollock himself was the speaker. (Further suggestions about leading into quotations are given on p. 210.)

3. **Distinguish between short and long quotations,** and treat each appropriately. *Short quotations* (usually defined as fewer than five lines of prose) are enclosed within quotation marks and run into the text (rather than set off, without quotation marks).

```
Michael Levey points out that "Alexander
singled out Lysippus to be his favorite sculptor,
because he liked the character given him in
```

```
Lysippus' busts." In making this point, Levey is not
taking the familiar view that. . . .
```

A *long quotation* (usually five or more lines of typewritten prose) is *not* enclosed within quotation marks. To set it off instead, the usual practice is to triple-space before and after the quotation and single-space the quotation, indenting five spaces—ten spaces for the first line if the quotation begins with the opening of a paragraph. (Note: The suggestion that you single-space longer quotations seems reasonable but is at odds with various manuals that tell how to prepare a manuscript for publication. Such manuals usually say that material that is set off should be indented ten spaces and double-spaced. Find out if your instructor has a preference.)

4. **An embedded quotation** (i.e., a quotation embedded in a sentence of your own) must fit grammatically into the sentence of which it is a part. For example, suppose you want to use Zadkine's comment, "I do not believe that art must develop on national lines."

*Incorrect*
```
        Zadkine says that he "do not believe that art
must develop on national lines."
```
*Correct*
```
        Zadkine says that he does "not believe that art
must develop on national lines."
```
*Correct*
```
        Zadkine says, "I do not believe that art must
develop on national lines."
```

Don't try to introduce a long quotation (say, more than a complete sentence) into the middle of one of your own sentences. It is almost impossible for the reader to come out of the quotation and to pick up the thread of your own sentence. It is better to lead into the long quotation with "Jones says"; and then, after the quotation, to begin a new sentence of your own.

5. **The quotation must be exact.** Any material that you add within a quotation must be in square brackets (not parentheses), thus:

```
    Pissarro, in a letter, expressed his belief
that "the Japanese practiced this art [of using
color to express ideas] as did the Chinese."
```

If you wish to omit material from within a quotation, indicate the ellipsis by three spaced periods. If a sentence ends in an omission, add a closed-

up period and then three spaced periods to indicate the omission. The following example is based on a quotation from the sentences immediately before this one:

```
The manual says that "if you . . . omit
material from within a quotation, [you must]
indicate the ellipsis. . . . If a sentence ends in
an omission, add a closed-up period and then three
periods. . . ."
```

Notice that although material preceded "if you," an ellipsis is not needed to indicate the omission because "if you" began a sentence in the original. (Notice, too, that although in the original *if* was capitalized, in the quotation it is reduced to lowercase in order to fit into the sentence grammatically.) Customarily initial and terminal omissions are indicated only when they are part of the sentence you are quoting. Even such omissions need not be indicated when the quoted material is obviously incomplete—when, for instance, it is a word or phrase.

6. **Punctuation is a bit tricky.** Commas and periods go *inside* the quotation marks; semicolons and colons go *outside* the marks. Question marks, exclamation points, and dashes go inside if they are part of the quotation, outside if they are your own.

```
The question Jacobs asked is this: "Why did
perspective appear when it did?" Can we agree with
Jacobs that "perspective appeared when scientific
thinking required it"?
```

7. **Use single quotation marks for material contained within a quotation** that itself is within quotation marks. In the following example, a student quotes William Jordy (the quotation from Jordy is enclosed within double quotation marks), who himself quoted Frank Lloyd Wright (the quotation within Jordy's quotation is enclosed within single quotation marks):

```
William H. Jordy believes that to appreciate
Wright's Guggenheim Museum one must climb up it, but
he recognizes that "Wright . . . recommended that
one take the elevator and circle downward. 'The
elevator is doing the lifting,' as he put it, 'the
visitor the drifting from alcove to alcove.'"
```

8. **Use quotation marks around titles of short works**—that is, for titles of chapters in books and for stories, essays, short poems, songs, lectures, and speeches. Titles of unpublished works, even book-length dissertations, are also enclosed in quotation marks. But underline—to indicate *italics*—titles of pamphlets, periodicals, and books. Underline also titles of films, radio and television programs, ballets and operas, and works of art except architecture. Thus: Michelangelo's *David,* Picasso's *Guernica,* Frank Lloyd Wright's Guggenheim Museum.

*Exception:* Titles of sacred writings (e.g., the Old Testament, the Hebrew Bible, the Bible, Genesis, Acts, the Gospels, the Quran) are neither underlined nor enclosed within quotation marks. (Incidentally, it is becoming customary to speak of the Hebrew Bible or of the Hebrew Scriptures, rather than of the Old Testament, and some writers speak of the Christian Scriptures rather than of the New Testament. The underlying idea is that the Hebrew writings are implicitly diminished when they are regarded as "Old" writings that are replaced by "New" ones.)

To cite a book of the Bible with chapter and verse, give the name of the book, then a space, then an arabic numeral for the chapter, a period, and an arabic numeral (*not* preceded by a space) for the verse, thus: Exodus 20.14–15. (The older method of citation, with a small roman numeral for the chapter and an arabic numeral for the verse, is no longer common.) Standard abbreviations for the books of the Bible (for example, 2 Cor. for 2 Corinthians) are permissible in citations.

## ACKNOWLEDGING SOURCES

### Borrowing without Plagiarizing

You must acknowledge your indebtedness for material when

1. You quote directly from a work.
2. You paraphrase or summarize someone's words (the words of the paraphrase or summary are your own, but the points are not, and neither, probably, is the structure of the sentences).
3. You appropriate an idea that is not common knowledge.

Let's suppose you want to make use of William Bascom's comment on the earliest responses of Europeans to African art:

> The first examples of African art to gain public attention were the bronzes and ivories which were brought back to Europe after the sack of Benin by a British military expedition in 1897. The superb technology of

the Benin bronzes won the praise of experts like Felix von Luschan who wrote in 1899, "Cellini himself could not have made better casts, nor anyone else before or since to the present day." Moreover, their relatively realistic treatment of human features conformed to the prevailing European aesthetic standards. Because of their naturalism and technical excellence, it was at first maintained that they had been produced by Europeans—a view that was still current when the even more realistic bronze heads were discovered at Ife in 1912. The subsequent discovery of new evidence has caused the complete abandonment of this theory of European origins of the bronzes of Benin and Ife, both of which are cities in Nigeria.

William Bascom, *African Art in Cultural Perspective* (1973), p. 4

1. **Acknowledging a direct quotation.** You may want to use some or all of Bascom's words, in which case you will write something like this:

> As William Bascom says, when Europeans first
> encountered Benin and Ife works of art in the late
> nineteenth century, they thought that Europeans had
> produced them, but the discovery of new evidence
> "caused the complete abandonment of this theory of
> European origins of the bronzes of Benin and Ife,
> both of which are cities in Nigeria."[1]

Notice that the digit, indicating a footnote, is raised, and that it follows the period and the quotation mark. (The form of footnotes is specified on pp. 167–73.)

2. **Acknowledging a paraphrase or summary.** Summaries (abridgments) are usually superior to paraphrases (rewordings, of approximately the same length as the original) because summaries are briefer, but occasionally you may find that you cannot abridge a passage in your source and yet you don't want to quote it word for word—perhaps because it is too technical or because it is poorly written. Even though you are changing some or all of the words, you must give credit to the source because the idea is not yours, nor, probably, is the sequence of the presentation. Here is an example:

### Summary

> William Bascom, in <u>African Art</u>, points out that
> the first examples of African art--Benin bronzes
> and ivories--brought to Europe were thought by
> Europeans to be of European origin, because of their

> naturalism and their technical excellence, but
> evidence was later discovered that caused this
> theory to be abandoned.

Not to give Bascom credit is to plagiarize, even though the words are yours. The offense is just as serious as not acknowledging a direct quotation. And, of course, if you say something like this and do not give credit, you are also plagiarizing, even though almost all of the words are your own.

### Plagiarized Summary

> The earliest examples of African art to become
> widely known in Europe were bronzes and ivories that
> were brought to Europe in 1897. These works were
> thought to be of European origin, and one expert
> said that Cellini could not have done better work.
> Their technical excellence, as well as their
> realism, fulfilled the European standards of the
> day. The later discovery of new evidence at Benin
> and Ife, both in Nigeria, refuted this belief.

It is pointless to offer this sort of rewording: If there is a point, it is to conceal the source and to take credit for thinking that is not your own.

3. **Acknowledging an idea.** Let us say that you have read an essay in which Seymour Slive argues that many Dutch still lifes have a moral significance. If this strikes you as a new idea and you adopt it in an essay—even though you set it forth entirely in your own words and with examples not offered by Slive—you should acknowledge your debt to Slive. Not to acknowledge such borrowing is plagiarism. Your readers will not think the less of you for naming your source; rather, they will be grateful to you for telling them about an interesting writer.

In short, acknowledge your source (1) if you quote directly, and put the quoted words in quotation marks; (2) if you summarize or paraphrase someone's material, even though not one word of your source is retained; and (3) if you borrow a distinctive idea, even though the words and the concrete application are your own.

## Fair Use of Common Knowledge

If in doubt as to whether to give credit (either in a footnote or merely in an introductory phrase such as "William Bascom says"), give credit. But as you begin to read widely in your field or subject, you will develop a

sense of what is considered common knowledge. Unsurprising definitions in a dictionary can be considered common knowledge, and so there is no need to say "According to Webster, a mural is a picture or decoration applied to a wall or ceiling." (That's weak in three ways: It's unnecessary, it's uninteresting, and it's inexact, since "Webster" appears in the titles of several dictionaries, some good and some bad.)

Similarly, the date of Picasso's death can be considered common knowledge. Few can give it when asked, but it can be found in many sources, and no one need get the credit for providing you with the date. Again, if you simply *know*, from your reading of Freud, that Freud was interested in art, you need not cite a specific source for an assertion to that effect, but if you know only because some commentator on Freud said so, and you have no idea whether the fact is well known or not, you should give credit to the source that gave you the information. Not to give credit—for ideas as well as for quoted words—is to plagiarize.

With matters of interpretation the line is less clear. For instance, almost all persons who have published discussions of van Gogh's *The Potato Eaters* have commented on its religious implications or resonance. In 1950, for example, Meyer Schapiro wrote, "The table is their altar . . . and the food a sacrament. . . ." In 1971 Linda Nochlin wrote that the picture is an "overtly expressive embodiment of the sacred," and in 1984 Robert Rosenblum commented on the "almost ritualistic sobriety that seems inherited from sacred prototypes." Of course if you got this idea from one source, you should cite the source, but if in your research you encountered it in several places, it will be enough if you say something like, "The sacramental quality of the picture has been widely noted." You need not cite half a dozen references—though you may wish to add, "first by," or "most recently by," or some such thing, in order to lend a bit of authority to your paper.

### "But How Else Can I Put It?"

If you have just learned—say, from an encyclopedia—something that you sense is common knowledge, you may wonder, "How can I change into my own words the simple, clear words that this source uses in setting forth this simple fact?" For example, if before writing about Rosa Bonheur's painting of Buffalo Bill (he took his Wild West show to France), you look him up in the *Encyclopedia Britannica,* you will find this statement about Buffalo Bill (William F. Cody): "In 1883 Cody organized his first Wild West exhibition." You cannot use this statement as your own,

word for word, without feeling uneasy. But to put in quotation marks such a routine statement of what can be considered common knowledge, and to cite a source for it, seems pretentious. After all, the *Encyclopedia Americana* says much the same thing in the same routine way: "In 1883, . . . Cody organized Buffalo Bill's Wild West." It may be that the word "organized" is simply the most obvious and the best word, and perhaps you will end up using it. Certainly to change "Cody organized" into "Cody presided over the organization of" or "Cody assembled" or some such thing, in an effort to avoid plagiarizing, would be to make a change for the worse and still to be guilty of plagiarism. But you won't get yourself into this mess of wondering whether to change clear, simple wording into awkward wording if in the first place, when you take notes, you summarize your sources, thus: "1883: organized Wild West," or "first Wild West: 1883." Later (even if only thirty minutes later), when drafting your paper, if you turn this nugget—probably combined with others—into the best sentence you can, you will not be in danger of plagiarizing, even if the word "organized" turns up in your sentence.

Notice that *taking notes* is part of the trick; this is not the same thing as copying or photocopying. Photocopying machines are great conveniences but they also make it easy for us not to think; we later may confuse a photocopy of an article with a thoughtful response to an article. The copy is at hand, a few words underlined, and we use the underlined material with the mistaken belief that we have absorbed it.

If you take notes thoughtfully, rather than make copies mindlessly, you will probably be safe. Of course, you may want to say somewhere that all your facts are drawn from such-and-such a source, but you offer this statement not to avoid charges of plagiarism but for three other reasons: to add authority to your paper, to give respectful credit to those who have helped you, and to protect yourself in case your source contains errors of fact.

## FOOTNOTES AND ENDNOTES

### Kinds of Notes

In speaking of kinds of notes, this paragraph does not distinguish between **footnotes,** which appear at the bottom of the page, and **endnotes,** which appear at the end of the essay; for simplicity *footnote* will cover both terms. Rather, a distinction is being made between (1) notes

that give the sources of quotations, facts, and opinions used and (2) notes that give additional comment that would interrupt the flow of the argument in the body of the paper. This second type perhaps requires a comment. You may wish to indicate that you are familiar with an opinion contrary to the one you are offering, but you may not wish to digress upon it during the course of your argument. A footnote lets you refer to it and indicate why you are not considering it. Or a footnote may contain full statistical data that support your point but that would seem unnecessarily detailed and even tedious in the body of the paper. This kind of footnote, giving additional commentary, may have its place in research papers and senior theses, but even in such essays it should be used sparingly, and it rarely has a place in a short analytical essay. There are times when supporting details may be appropriately relegated to a footnote, but if the thing is worth saying, it is usually worth saying in the body of the paper. Don't get into the habit of affixing either trivia or miniature essays to the bottom of each page of an essay.

## Footnote Numbers and Positions

Number the notes consecutively throughout the essay or chapter. Although some instructors allow students to group all the notes at the rear of the essay, most instructors—and surely all readers—believe that the best place for a note is at the foot of the appropriate page. If you type all your notes in your draft, when typing your final copy you can easily gauge how much space the footnotes for any given page will require.

If you use a word processor, your software may do much of the job for you. It probably can automatically elevate the footnote number, and it can automatically print the note on the appropriate page. (For more on using a computer, see pp. 128–35 in Chapter 5.)

## Footnote Style

To indicate that there is a footnote, put a raised arabic numeral (without a period and without parentheses) after the final punctuation of the sentence, unless clarity requires it earlier. (In a sentence about Claude Monet, Camille Pissarro, and Alfred Sisley you may need a footnote for each and a corresponding numeral after each name instead of one numeral at the end of the sentence, but usually a single reference at the end will do. The single footnote might explain that Monet says such and such in a book entitled ———, Pissarro says such and such in a book entitled ———, and Sisley says such and such in a book entitled ———.)

If you are using a word processor, your software program can probably format the notes automatically. If you are using a typewriter, double-space twice (i.e., skip four lines) at the bottom of the page before giving the first footnote. Then indent five spaces, raise the typewriter carriage half a line, and type the arabic numeral (without a period). Lower the carriage to the regular position, skip one space, and type the footnote, single-spacing it. (Some manuals suggest double-spacing footnotes that run more than one line. Ask your instructors for their preference.) If the note runs more than one line, the subsequent lines are flush with the left margin, but each new note begins with the indentation of five spaces. Each note begins with the indented, raised numeral, then a capital letter, and ends with a period or other terminal punctuation. Double-space between footnotes.

## FIRST REFERENCE TO A BOOK

Here is a typical first reference to a book:°

   1 Michael Levey, Painting at Court (New York:
New York University Press, 1971), p. 134.

Notice that you give the author's name as it appears on the title page, *first name first.* You need not give the subtitle, but if you do give it, put a colon between the title and the subtitle and underline the subtitle. The name of the city (without the state or country) is usually enough; but if the city is not well known, or may be confused with another city of the same name (Cambridge, England, and Cambridge, Massachusetts), the state or country is added. The name of the publisher (here New York University Press) may be shortened. (Thus, Little, Brown and Company may be shortened to Little, Brown.) If the date is not given, in place of it put "n.d." The conventional abbreviation for *page* is "p." and for *pages* is

---

°Different publishers and different periodicals have different styles for documenting sources. Some, for example, do not require that the name of the publisher of a book be given in a footnote or endnote. The College Art Association does not use the same style even in two of its own publications, *Art Bulletin* and *Art Journal,* and most university presses use a style different from the styles of these two journals. (For the style used by *Art Bulletin,* see "Notes for Contributors," in the June 1990 issue. *Art Journal* will, on request, provide its "Guidelines for Contributors." Both style guides are available at no cost from the College Art Association, 275 Seventh Avenue, New York, NY 10001.)

If your instructor asks you to use in-text parenthetical citations rather than footnotes or endnotes, consult Joseph Gibaldi, *MLA Handbook for Writers of Research Papers,* 4th ed. (1995). For other systems of documentation, consult *The Chicago Manual of Style,* 14th ed. (1993).

"pp." (*not* "pg." and "pgs."). If a pamphlet is unpaginated, simply put "unpaginated" where you would ordinarily put the page number. If plates in an article or book are unpaginated, put "Plate 1" (or whatever the number) where you would ordinarily put the page number.

If you give the author's name in the body of the page—for example, in such a phrase as "Levey says that Rubens"—do not repeat the name in the footnote. Merely begin with the title:

1 Painting at Court (New York: New York University Press, 1971), p. 134.

But do not get carried away by the principle of not repeating in the note any material already given in the body of the paper. If the author and the title are given, convention nevertheless requires you to repeat the title—though not the author's name—in the first note citing the source.

### For a Book in One Volume, by One Author, Revised Edition

2 Rudolf Wittkower, Art and Architecture in Italy, 1600-1750, 3rd ed. rev. (Harmondsworth, England: Penguin, 1973), p. 187.

### For A Book In One Volume, By One Author, Later Reprint

3 Erwin Panofsky, Studies in Iconology (1939; rpt. New York: Harper & Row, 1962), pp. 126-27.

### For A Book In More Than One Volume

4 Ronald Paulson, Hogarth: His Life, Art, and Times (New Haven, Conn.: Yale University Press, 1971), II, 161.

Notice that the volume number is given in roman numerals, the page number in arabic numerals, and abbreviations such as "vol." and "p." are *not* used.

### For A Book by More Than One Author

5 Romare Bearden and Harry Henderson, A History of African-American Artists from 1792 to the Present (New York: Pantheon, 1994), pp. 612-13.

The name of the second author, like that of the first, is given *first name first*. If there are more than three authors, give the full name of the first author and add *et al.*, the Latin abbreviation for "and others."

### For An Edited or Translated Book

6 The Letters of Peter Paul Rubens, trans. and ed. Ruth Magurn (Cambridge, Mass.: Harvard University Press, 1955), p. 238.

⁷ Dietrich Seckel, The Art of Buddhism, trans.
Ann E. Keep (New York: Crown, 1964), p. 208.

⁸ Charles Pellet, "Jewelers with Words," in
Islam and the Arab World, ed. Bernard Lewis (New
York: Knopf, 1976), p. 151.

As note 8 indicates, when you are quoting from an essay in an edited
book, you begin with the essayist (first name first) and the essay, then go
on to give the title of the book and the name of the editor, first name first.

### For A Signed Encyclopedia Article

⁹ Thomas M. Messer, "Picasso, Pablo,"
Encyclopedia Americana, 1979, XXII, 67.

The publisher and place of publication need not be given for an encyclo-
pedia article. If the article is signed, begin with the author's name (first
name first); if it is unsigned, simply begin with the title of the article, in
quotation marks. Some manuals say that references to alphabetically
arranged articles (signed or unsigned) need not include the volume and
page number, but if you do include them, as here, use roman numerals
for the volume (but do *not* write "vol.") and arabic numerals for the page
(but do *not* write "p.").

The most recent edition of the *Encyclopaedia Britannica* comprises
three groups of books, called *Propaedia, Micropaedia,* and *Macropaedia,*
so you must specify which of the three groups you are referring to. The
following example cites an unsigned article on Picasso.

### For An Unsigned Encyclopedia Article

¹⁰ "Picasso, Pablo (Ruiz y)," Encyclopedia
Britannica: Micropaedia, 1974, VII, 987.

### REFERENCES TO INTRODUCTIONS AND REPRINTED ESSAYS

You may need to footnote a quotation from someone's introduction (say,
Kenneth Clark's) to someone else's book (say, James Hall's). If, for exam-
ple, in your text you say, "As Kenneth Clark points out," the footnote will
cite Hall's book.

### For an Introduction to a Book

¹¹ Introduction to James Hall, Dictionary of
Subjects and Symbols in Art, 2nd ed. (New York:
Harper & Row, 1979), p. viii.

If you want to quote from, say, an essay or an extract from a book
that has been reprinted in a book of essays, begin with the writer's name

(if you have not given it in your lead-in), then give the title of the essay or original book, then, if possible, the place where this material originally appeared (you can usually find this information on the acknowledgments page of the book in hand or on the first page of the reprinted material), then the name of the title of the book you have in hand, and then the editor, place of publication, publisher, date, and page. The monstrous but accurate footnote might run like this:

### For a reprinted essay in a book

12 Henry Louis Gates, Jr., "The Face and Voice of Blackness," in Facing History: The Black Image in American Art, 1710-1940, ed. Guy McElroy (San Francisco: Bedford Art, 1990); rpt. in Modern Art and Society, ed. Maurice Berger (New York: HarperCollins, 1994), p. 53.

You have read Gates's essay, "The Face and Voice of Blackness," which was originally published in a collection (*Facing History*) edited by McElroy, but you did not read the essay in McElroy's collection. Rather, you read it in Berger's collection of reprinted essays, *Modern Art and Society.* You learned the name of McElroy's collection and the original date and place of publication from Berger's book, so you give this information, but your page reference is of course to the book that you are holding in your hand, page 53 of Berger's book.

### FIRST REFERENCE TO A JOURNAL

Footnote 13 is for a journal (here, volume 29) paginated *consecutively* throughout the year; footnote 14, specifying the month, is for a journal that paginates each issue separately.

For a journal paginated *separately* (footnote 14) you must list the issue number or month or week or day as well as the year because if it is, for example, a monthly, there will be twelve page 10s in any given year.

Current practice favors omitting the volume number for popular weeklies (see footnote 15) and for newspapers, in which case the full date is given without parentheses.

### For journal articles

13 Anne H. van Buren, "Madame Cézanne's Fashions and the Dates of Her Portraits," Art Quarterly 29 (1966), 119.

14 Linda Nochlin, "Why Have There Been No Great Women Artists?" Art News 69 (January 1971), 38.

15 Henry Fairlie, "The Real Life of Women," New Republic Aug. 26, 1978, p. 18.

The author's name and the title of the article are given as they appear in the journal (*first name first*), the title of the article in quotation marks, and the title of the journal underlined (to indicate italics). Until recently the volume number, before the date, was given with capital roman numerals, but current practice uses arabic numerals for both the volume and the page or pages. Notice that when a volume number is given, as in notes 13 and 14, the page number is *not* preceded by "p." or "pp." The sample notes cite the specific page that the student is drawing on. If the article as a whole is being cited, instead of, say, page 119, we would get 117–22.

If a book review has a title, the review may be treated as an article. If, however, the title is merely that of the book reviewed, or even if the review has a title but for clarity you wish to indicate that it is a review, the following form is commonly used.

### For a Book Review

16 Pepe Karmel, review of Calvin Tomkins, <u>Off the Wall: Robert Rauschenberg and the Art World of Our Time</u> (Garden City, N.Y.: Doubleday, 1980), <u>New Republic</u>, June 21, 1980, p. 38.

### FIRST REFERENCE TO A NEWSPAPER

The first example is for a *signed article*, the second for an *unsigned one*.

### For Articles in a Newspaper

17 Bertha Brody, "Illegal Immigrant Sculptor Allowed to Stay," <u>New York Times</u>, July 4, 1994, Sec. B, p. 12, col. 2.

18 "Portraits Stolen Again," <u>Washington Post</u>, June 30, 1995, p. 7, col. 3.

### SECONDHAND REFERENCES

If you are quoting from, say, Frank Lloyd Wright, but you have not derived the quotation directly from Wright but from a book or article that quotes him, your footnote should indicate both the original source, if possible (i.e., not only Wright's name but his book, place of publication, etc.), and then full information about the place where you have found the material that you are using.

### For a Source Cited Indirectly

19 Frank Lloyd Wright, <u>The Solomon R. Guggenheim Museum</u> (New York: Museum of Modern Art, 1960), p. 20; quoted in William H. Jordy, <u>American Buildings and Their Architects</u> (Garden City, N.Y.: Anchor, 1976), IV, 348.

If Jordy had merely cited Wright's name, without any further bibliographic information, of course, you would be able to give only Wright's name and then the details about Jordy's book.

## SUBSEQUENT REFERENCES

If you quote a second or third or fourth time from the same work, use a short form in the subsequent footnotes. The most versatile short form is simply the author's last name and the page number, thus:

[20] Levey, p. 155.

You can even dispense with the author's name if you have mentioned it in the sentence to which the footnote is keyed. That is, if you have said "Panofsky goes on to say," the footnote need only be

[21] P. 108.

If, however, you have made reference to more than one work by the same author, you must indicate by a short title which work you are referring to, thus:

[22] Panofsky, Studies, p. 108.

Or if your sentence mentions that you are quoting Panofsky, the footnote may be

[23] Studies, p. 108.

If you have said something like "Panofsky, in *Studies in Iconology*," the reference may be merely

[24] P. 108.

In short, a subsequent reference should be as brief as clarity allows. The form "ibid." (for *ibidem,* "in the same place"), indicating that the material being footnoted comes from the same place as the material of the previous footnote, is no longer preferred for second references. "Op cit." (for *opere citato,* "in the work cited") and "loc. cit." (for *loco citato,* "in the place cited") have almost disappeared. Identification by author—or by author and short title, if necessary—is preferable.

## INTERVIEWS, LECTURES, AND LETTERS

[25] Interview with Malcolm Rogers, Director, Museum of Fine Arts, Boston, July 12, 1995.

26 Howard Saretta, "Masterpieces from Africa,"
Tufts University, May 13, 1995.

27 Information in a letter to the author, from
James Cahill, University of California, Berkeley,
March 17, 1995.

## BIBLIOGRAPHY

A bibliography is a list of the works cited or, less often, a list of all the relevant sources. (There is rarely much point in the second sort; if you haven't made use of a particular book or article, why list it?) Normally a bibliography is given only in a long manuscript such as a research paper or a book, but instructors may require a bibliography even for a short paper if they wish to see at a glance the material that the student has used. In this case a heading such as "Works Cited" is less pretentious than "Bibliography."

If the bibliography is extensive, it may be advisable to divide it into two parts, Primary Materials and Secondary Materials (see p. 196), or even into several parts, such as Theological Background, Iconographic Studies, Marxist Interpretations, Feminist Interpretations, and so forth.

### Bibliographic Style

Because a bibliography (or each part of a bibliography) is arranged alphabetically by author, the author's *last name is given first* in each entry. If a work is by more than one author, it is given under the first author's name; this author's last name is given first, but the other author's or authors' names follow the normal order of first name first. (See the entry under Rosenfield, p. 174.)

**Anonymous works** are sometimes grouped at the beginning, arranged alphabetically under the first word of the title (or the second word, if the first word is *A, An,* or *The*), but the recent tendency has been to list them at the appropriate alphabetical place, giving the initial article, if any, but alphabetizing under the next word. Thus an anonymous essay entitled "A View of Leonardo" would retain the "A" but would be alphabetized under V for "View."

In typing an entry, use double-spacing. Begin flush with the left-hand margin; if the entry runs over the line, indent the subsequent lines of the entry five spaces. Double-space between entries.

## REFERENCES TO BOOKS

### For a book by one author

Caviness, Madeline Harrison. The Early Stained Glass
     of Canterbury Cathedral. Princeton: Princeton
     University Press, 1977.

Note: Princeton needs no further identification, but if the city is obscure, or may be confused with another city of the same name (e.g., Cambridge, Massachusetts, and Cambridge, England), add the necessary additional information.

### For a book by more than one author

Rosenfield, John M., and Elizabeth ten Grotenhuis.
     Journey of the Three Jewels: Japanese Buddhist
     Paintings from Western Collections. New York:
     Asia Society, 1979.

Notice in this entry that although the book is alphabetized under the *last name* of the *first* author, the name of the second author is given in the ordinary way, first name first.

### For a collection or anthology

Goldwater, Robert, and Marco Treves, eds. Artists on
     Art. New York: Pantheon, 1945.

This entry lists the collection alphabetically under the first editor's last name. Notice that the second editor's name is given first name first. A collection may be entered either under the editor's name or under the first word of the title.

### For an Essay in a Collection or Anthology

Livingstone, Jane, and John Beardsley. "The Poetics
     and Politics of Hispanic Art: A New Perspec-
     tive." Exhibiting Cultures: The Poetics and
     Politics of Museum Display. Eds. Ivan Karp and
     Steven D. Lavine. Washington, D.C.: Smithson-
     ian, 1991. 104-20.

This entry lists an article by Livingstone and Beardsley (notice that the first author's name is given with the last name first, but the second au-

thor's name is given in the usual order) in a book called *Exhibiting Cultures*, edited by Karp and Lavine. The essay appears on pages 104–20.

### For Two or More Works by the Same Author

```
Cahill, James. Chinese Painting. Geneva: Skira, 1960.

---. Scholar Painters of Japan: The Nanga School.
    New York: Asia House, 1972.
```

The horizontal line (three hyphens, followed by a period and then two spaces) indicates that the author (in this case James Cahill) is the same as in the previous item. Note also that multiple titles by the same author are arranged alphabetically (*Chinese* precedes *Scholar*).

### For Encyclopedia Articles

```
"Baroque." The New Columbia Encyclopedia. 4th ed.

Jones, Henry Stuart. "Roman Art." Encyclopaedia Bri-
    tannica. 11th ed.

"Picasso, Pablo (Ruiz y)." Encyclopaedia Britannica:
    Micropaedia. 1978 ed.
```

The first and third of these three encyclopedia articles are unsigned, so the articles are listed under their titles. The second is signed, so it is listed under its author. Notice that an encyclopedia does not require volume or page, or place or date of publication; the edition, however, must be identified somehow, and usually the date is the best identification.

### For an Introduction to a Book by Another Author

```
Clark, Kenneth. Intro. to James Hall, Dictionary of
    Subjects and Symbols in Art. 2nd ed. New York:
    Harper & Row, 1979. vii-viii.
```

This entry suggests that the student made use of the introduction, rather than the main body, of the book; if the body of the book were used, the book would be alphabetized under *H* for Hall, and the title would be followed by: Intro. Kenneth Clark.

### For an Edited Book

```
Rossetti, Dante Gabriel. Letters of Dante Gabriel
    Rossetti. Ed. Oswald Doughty and J. R. Wahl. 4
    vols. Oxford: Clarendon, 1965.
```

## References to Periodicals

### For a Journal Article

Mitchell, Dolores. "The 'New Woman' as Prometheus:
 Women Artists Depict Women Smoking." <u>Woman's</u>
 <u>Art Journal</u> 12 (Spring/Summer 1991): 2-9.

Because this journal paginates each issue separately, the season or month must be given. For a journal that paginates issues continuously, give the year without the season or month.

### For a Newspaper Article

"Museum Discovers Fake." <u>New York Times</u> January 21,
 1980. Sec. D, p. 29, col. 2.

Romero, Maria. "New Sculpture Unveiled." <u>Washington</u>
 <u>Post</u> March 18, 1980, p. 6, col. 4.

Because the first of these newspaper articles is unsigned, it is alphabetized under the first word of the title; because the second is signed, it is alphabetized under the author's last name.

### For a Book Review

Gevisser, Mark, Rev. of <u>Art of the South African</u>
 <u>Townships</u> by Gavin Younger. <u>Art in America</u> 77
 (July 1989): 35-39.

This journal paginates each issue separately, so the month must be given as well as the year.

## SOME CONVENTIONS OF LANGUAGE USAGE

## The Apostrophe

1. To form the possessive of a name, the simplest (and perhaps the best) thing to do is to add *'s*, even if the name already ends with a sibilant (*-s, -cks, -x, -z*). Thus:

El Greco's colors
Rubens's models
Velázquez's subjects
Augustus John's sketches (his last name is *John*)
Jasper Johns's recent work (his last name is *Johns*)

But some authorities say that to make the possessive for names ending in a sibilant, only an apostrophe is added (without the additional *s*)—Velázquez would become Velázquez', and Moses would become Moses'—unless (1) the name is a monosyllable (e.g., Jasper Johns would still become Johns's) or (2) the sibilant is followed by a final *e* (Horace would still become Horace's). Note that despite the final *s* in Degas and the final *x* in Delacroix, these names do not end in a sibilant (the letters are not pronounced), and so the possessive must be made by adding *'s*.

2. Don't add *'s* to the title of a work to make a possessive; the addition can't be italicized (underlined), since it is not part of the title, and it looks odd attached to an italicized word. So, not "*The Sower*'s colors" and not "*The Sower's* colors"; rather, "the colors of *The Sower*."

3. Don't confuse *its* and *it's*. The first is a possessive pronoun ("Its colors have faded"); the second is a contraction of *it is* ("It's important to realize that most early landscapes were painted indoors"). You'll have no trouble if you remember that *its*, like other possessive pronouns such as *ours, his, hers, theirs*, does *not* use an apostrophe.

## Capitalization

Although some writers do not capitalize renaissance, middle ages, romanesque, and so on, most do, even when, for example, Renaissance is used as an adjective ("Most Renaissance portraits"). But do not capitalize medieval. Most writers do not capitalize classic and romantic—but even if you do capitalize Romantic when it refers to a movement ("Delacroix was a Romantic painter"), note that you should not capitalize it when it is used in other senses ("There is something romantic about ruined temples"). Many writers capitalize the chief events of the Bible, such as the Creation, the Fall, the Annunciation, and the Crucifixion, and also mythological events, such as the Rape of Ganymede and the Judgment of Paris. Again, be consistent.

On capitalization in titles, see pages 154–55 and 185.

## The Dash

Type a dash by typing two hyphens (--) without hitting the space bar before, between, or after. Do not confuse the dash with the hyphen. Here is an example of the dash:

```
        New York--not Paris--is the center of the art
    world today.
```

## Foreign Words and Quotations in Foreign Languages

1. **Underline (to indicate italics) foreign words that are not part of the English language.** Examples: *sfumato* (an Italian word for a "blurred outline"), *pai-miao* (Chinese for "fine-line work"). But such words as chiaroscuro and Ming are not italicized because, as their presence in English dictionaries indicates, they have been accepted into English vocabulary. Foreign names are discussed on page 179.

2. **Do not underline a quotation (whether in quotation marks or set off) in a foreign language.** A word about foreign quotations: If your paper is frankly aimed at specialists, you need not translate quotations from languages that your readers might be expected to know, but if it is aimed at a general audience, translate foreign quotations, either immediately below the original or in a footnote.

3. On **translating the titles of works of art,** and on **capitalizing the titles of foreign books,** see "Titles," page 185.

## The Hyphen

1. **Use a hyphen to divide a word at the end of a line.** Because words may be divided only as indicated by a dictionary, it is easier to end the line with the last complete word you can type than to keep reaching for a dictionary. But here are some principles governing the division of words at the end of a line:

- Never hyphenate words of one syllable, such as *called, wrote, doubt, through.*
- Never hyphenate so that a single letter stands alone: *a-lone, hair-y.*
- If a word already has a hyphen, divide it at the hyphen: *anti-intellectual.*
- Divide prefixes and suffixes from the root: *pro-vide; paint-ing.*
- Divide between syllables. If you aren't sure of the proper syllabification, check a dictionary.

Notice that when hyphenating, you do not hit the space bar before or after hitting the hyphen.

2. **Use a hyphen to compound adjectives into a single visual unit:** twentieth-century architects (but "She was born in the twentieth century").

## Names

1. Dutch *van,* as in Vincent van Gogh, is never capitalized by the Dutch except when it begins a sentence; in American usage, however, it is acceptable (but not necessary) to capitalize it when it appears without the first name, as in "The paintings of Van Gogh." But: "Vincent van Gogh's paintings." Names with *van* are commonly alphabetized under the last name, for example, under *G* for Gogh.

2. French *de* is not used (De Gaulle was an exception) when the first name is not given. Thus, the last name of Georges de La Tour is La Tour, *not* de La Tour. But when *de* is combined with the definite article, into *des* or *du,* it is given even without the first name. *La* and *Le* are used even when the first name is not given, as in Le Nain.

3. Spanish *de* is not used without the first name, but if it is combined with *el* into *del,* it is given even without the first name.

4. Names of deceased persons are never prefaced with Mr., Miss, Mrs., or Ms.—even in an attempt at humor.

5. Names of women are not prefaced by Miss, Ms., or Mrs.; treat them like men's names—that is, give them no title.

6. First names alone are used for many writers and artists of the Middle Ages and Renaissance (examples: Dante, for Dante Alighieri; Michelangelo, for Michelangelo Buonarroti; Piero, for Piero della Francesca; Rogier, for Rogier van der Wyeden), and usually these are even alphabetized under the first name. Leonardo da Vinci, born near the town of Vinci, is Leonardo, never da Vinci. But do not adopt a chatty familiarity with later people: Picasso, not Pablo. *Exception:* Because van Gogh often signed his pictures "Vincent," some writers call him Vincent.

## Avoiding Sexist Language

1. Traditionally, the male pronouns *he* and *his* have been used generically—that is, to refer to both men and women ("An architect should maintain his independence"). But this use of *he* and *his* offends many readers and is no longer acceptable. One common way to avoid this type of sexist language is to use *he or she, she or he, s/he, (s)he, he/she, she/he, his or her,* or *her or his.* Some writers shift from masculine to feminine forms in alternating sentences or alternating paragraphs, and a few writers regularly use *she* and *her* in place of the generic *he* and *his* in order to make a sociopolitical point. When such expressions are overused,

however, they call too much attention to themselves. Consider, for example, this grotesque sentence from an article in *Art History* (15:4 [1992] 545):

> What some music also does (and particularly Wagner) is draw the attentive listener into it, so that s/he finds him- or herself in a close dialectical engagement with something which seems like his- or herself in character but which is neither quite this, nor yet quite alien.

The writer is trying to say something about music, but his attempts to avoid sexist language by writing "s/he . . . him- or herself . . . his- or herself" are so awkward and so conspicuous that the reader notices only them, not the real point of the sentence.

There are other, more effective ways of avoiding sexist writing. Often you can substitute the plural form, as in "Architects should maintain *their* independence." Or you can recast the sentence to eliminate the possessive: "An architect should be independent."

2. Do not use *man* or *mankind* in such expressions as "man's art" or "the greatness of mankind"; consider using instead such words as *human being, person, people, humanity,* and *we.* (Examples: "Human beings need art," or "Humankind needs art," or "We need art," instead of "Man needs art.")

3. *Layman, craftsman,* and similar words should be replaced with such gender-neutral substitutes as *layperson* or *unspecialized people,* and (for *craftsman*) *craftsperson,* or, probably better, *artisan* or such a term as *fabric artist.*

4. Just as you would not describe van Gogh as "the male painter. . . " without good reason, you should not use such expressions as "woman painter" or "female sculptor" unless the context requires them.

## Avoiding Eurocentric Language

The art history that most Americans are likely to encounter has been written chiefly by persons of English or European origin. Until recently such writing saw things from a European point of view and tended to assume the preeminence of European culture. Certain English words that convey this assumption of European superiority, such as *primitive* applied to African or Oceanic art, now are widely recognized as naive. Some words, however, are less widely recognized as outdated and offensive. For instance, the people whom Caucasians long have called *Eskimo* prefer to be called *Inuit,* and there is no reason why we should not honor their preference.

**Asian; Oriental**    *Asian,* as a noun and as an adjective, is preferable. *Oriental* (from *oriens,* "rising sun," "east") is in disfavor because it implies a Eurocentric view (i.e., things "oriental" were east of the European colonial powers). Similarly, **Near East** (the countries of the eastern Mediterranean, Southwest Asia, the Arabian Peninsula, and sometimes northern Africa), **Middle East** (variously defined, but usually the area in Asia and Africa between and including Libya in the west, Pakistan in the east, Turkey in the north, and the Arabian Peninsula in the south), and **Far East** (China, Vietnam, North and South Korea, and Japan, or these and all other Asian lands east of Afghanistan) are terms based on a Eurocentric view. No brief substitutes have been agreed on for *Near East* and *Middle East,* but *East Asia* is now regarded as preferable to *Far East.*

**Eskimo; Inuit**    *Eskimo* (from the Algonquin for "eaters of raw meat") is a name given by the French to those native people of Canada who call themselves *Inuit* (singular: *Inuk*). The Inuit regard *Eskimo* as pejorative, and their preference is now officially recognized in Canada.

**Far East**    See *Asian.*

**Hispanic**    The word—derived from *Hispania,* the Latin name for Spain—is widely used to designate not only persons from Spain but also members of the various Spanish-speaking communities living in the United States—Puerto Ricans, Cuban Americans, and persons from South America and Central America (including Mexican Americans, sometimes called Chicanos). Some members of these communities, however, strongly object to the term, arguing that it overemphasizes their European heritage and ignores the Indian and African heritages of many of the people it claims to describe. (The same has been said of *Latina* and *Latino,* but these terms are more widely accepted within the communities, probably because the words are Spanish rather than English and therefore they do not imply assimilation to Anglo culture. Further, *Latina* and *Latino* denote only persons of Central and South American descent, whereas *Hispanic* includes persons from Spain.) Moreover, many people believe that the differences among Spanish-speaking groups from various countries are so great as to make *Hispanic* (like *Latino* and *Latina*) a reductive, almost meaningless label. Polls indicate that most persons in the

United States who trace their origin to a Spanish-speaking country prefer to identify themselves as *Cuban, Mexican* (or *Chicano*), *Peruvian, Puerto Rican,* and so on, rather than as *Hispanic.*

**Indian; Native American**   When Columbus encountered the Caribs in 1492, he thought he had reached India and therefore called them *Indios* (Indians). Later, efforts to distinguish the peoples of the Western Hemisphere produced the terms *American Indian, Amerindian,* and *Amerind.* More recently *Native American* has been used, but of course the people who met the European newcomers were themselves descended from persons who had immigrated in ancient times, and in any case *American* is a word derived from the name of an Italian. On the other hand, anyone born in America, regardless of ethnicity, is a Native American. Further, many Native Americans (in the new, restricted sense) continue to speak of themselves as Indians, thereby making the use of that word acceptable. Although *Indian* is acceptable, use the name of the specific group, such as Iroquois or Navaho, whenever possible. In Canada, however, the accepted terms now are *First Nations People* and *First Nations Canadians,* although some of these people call themselves Indians. One other point: All of the aboriginal peoples of Canada and Alaska can be called Native Americans, but some of them (e.g., the Inuit and the Aleut) cannot be called Indians.

**Inuit; Eskimo**   See *Eskimo.*

**Latina/Latino**   See *Hispanic.*

**Native American**   See *Indian.*

**New World; Western Hemisphere**   Because the half of the earth comprising North America, Mexico, Central America, and South America was, in the late sixteenth century and the seventeenth century, new to Europeans but not to the people who lived in this half of the world, the term *Western Hemisphere* is preferred to *New World.*

**Primitive**   Derived ultimately from the Latin *primus,* meaning "first," *primitive* was widely used by anthropologists in the late nineteenth and early twentieth centuries with reference to nonliterate, nonwhite societies, e.g., in Africa south of the Sahara, in

Oceania, and in pre-Columbian America. These societies were thought to be still in the first stages of an evolutionary process that culminates in "civilization," whose finest flowering was believed to be white industrial society. Today virtually all anthropologists agree that the word *primitive* is misleading, because it implies not only that the products of a "primitive" society (art, myths, and so on) are crude and simple, but also that such a society does not have a long history. *Tribal* is sometimes used as a substitute, but this word too contains condescending Eurocentric implications. (The journalists who in newspapers write of "tribal conflicts" in Africa would never speak of "tribal conflicts" in Europe.) *Aboriginal* and *non-Western* are sometimes used for what was once called "primitive art," but "aboriginal" gives off a condescending Eurocentric whiff, and non-Western inadvertently includes Asian art, for instance Ming porcelains. Expressions such as "primitive art," it has been argued, are Western constructs, inventions created by an imperialistic process that seeks to domesticate "the Other" by implying that the foreign culture is no longer vital. That is, an exhibition of "primitive art" of Africa, or of American Indian "tribal art," it is said, implies that the heirs to these cultures no longer produce significant art.

When speaking of individual cultures it probably is best simply to use their names (e.g., "Yoruba sculpture," "Benin bronzes"). No term has emerged that can usefully and inoffensively be applied when speaking across cultures—and many people would argue that this is a good thing, since any term would necessarily make false connections among diverse, independent cultures.

*Primitive* is used also in two other senses: (1) to refer to the early stages of a particular school of painters—especially the Netherlandish painters of the late fourteenth and fifteenth centuries, and the Italian painters between Giotto (born circa 1267) and Raphael (born 1483)—with the false assumption that these early artists were trying to achieve the illusionistic representation that their successors achieved; and (2) to refer to artists such as "Grandma Moses" (1860–1961), untrained in the formal academies, who were regarded as preserving a naive, uncorrupted, childlike, charming vision.

**Tribal**   See *primitive*.

## Spelling

If you are a weak speller, ask a friend to take a look at your paper. If you have written the paper on a word processor, use the spell checker if there is one, but remember that the spell checker tells you only if a word is not in its dictionary. It does *not* tell you that you erred in using *their* where *there* is called for.

Experience has shown that the following words are commonly misspelled in papers on art. If the spelling of one of these words strikes you as odd, memorize it.

| | | |
|---|---|---|
| altar (noun) | dominant | shepherd |
| alter (verb) | exaggerate | silhouette |
| background | independent | spatial |
| connoisseur | parallel | subtly |
| *contrapposto* | prominent | symmetry |
| Crucifixion | recede | vertical (*not* verticle) |
| deity (*not* diety) | referring | watercolor |
| dimension | separate | |

Be careful to distinguish the following:

**affect, effect**   *Affect* is usually a verb, meaning (1) "to influence, to produce an effect, to impress," as in "These pictures greatly affected the history of painting," or (2) "to pretend, to put on," as in "He affected to enjoy the exhibition." Psychologists use it as a noun for "feeling" ("The patient experienced no affect"), but leave this word to psychologists. *Effect,* as a verb, means "to bring about" ("The workers effected the rescue in less than an hour"). As a noun, *effect* means "result" ("The effect of his work was negligible").

**capital, capitol**   A *capital* is the uppermost member of a column or pilaster; it also refers to accumulated wealth, or to a city serving as a seat of government. A *capitol* is a building in which legislators meet, or a group of buildings in which the functions of government are performed.

**eminent, immanent, imminent**   *Eminent,* "noted, famous"; *immanent,* "remaining within, intrinsic"; *imminent,* "likely to occur soon, impending."

**its, it's**   *Its* is a possessive ("Its origin is unknown"); *it's* is short for *it is* ("It's an early portrait").

**lay, lie**   To *lay* means "to put, to set, to cause to rest" ("Lay the glass on the print"). To *lie* means "to recline" ("Venus lies on a couch").

**loose, lose**   *Loose* is an adjective ("The nails in the frame are loose"); *lose* is a verb ("Don't lose the nails").

**precede, proceed**   To *precede* is to come before in time; to *proceed* is to go onward.

**principal, principle**   *Principal* as an adjective means "leading," "chief"; as a noun it means a leader (and, in finance, wealth). *Principle* is only a noun, "a basic truth," "a rule," "an assumption."

## Titles

1. **On the form of the title** of a manuscript essay, see pages 154–55.
2. **On underlining titles** of works of art, see the next section, "Italics and Underlining."
3. Some works of art are regularly given with their **titles in foreign languages** (Goya's *Los Caprichos,* the Limbourg Brothers' *Les Très Riches Heures du Duc de Berry,* Picasso's *Les Demoiselles d'Avignon*), and some works are given in a curious mixture of tongues (Cézanne's *Mont Sainte-Victoire Seen from Bibémus Quarry*), but the vast majority are given with English titles: Picasso's *The Old Guitarist,* Cézanne's *Bathers,* Millet's *The Gleaners.* In most cases, then, it seems pretentious to use the original title.
4. **Capitalization in foreign languages** is not the same as in English.

*French:* If you give a title—of a book, essay, or work of art—in French, capitalize the first word and all proper nouns. If the first word is an article, capitalize also the first noun and any adjective that precedes it. Examples: *Le Dejeuner sur l'herbe; Les Très Riches Heures du Duc de Berry.*

*German:* Follow German usage; for example, capitalize the pronoun *Sie* ("you"), but do not capitalize words that are not normally capitalized in German.

*Italian:* Capitalize only the first word and the names of people and places.

## Italics and Underlining

1. **Use italics** (or underline to indicate italics) for **titles of works of art,** other than architecture: Michelangelo's *David,* van Gogh's *Sunflow-*

*ers*, but the Empire State Building, the Brooklyn Bridge, the Palazzo Vecchio.

2. **Italicize** (or underline) **titles of books** other than holy works: *Art and Illusion, The Odyssey*, but Genesis, the Bible, the New Testament, the Koran (or, now preferred, the Quran). (For further details about biblical citations, see p. 161.)

3. **Italicize** (or underline) **foreign words,** but use roman type for quotations from foreign languages (see p. 178).

# 8

# The Research Paper

## A NOTE ON ART-HISTORICAL RESEARCH AND ART CRITICISM

It is sometimes argued that there is a clear distinction between *scholarship* (or *art-historical research*) and *criticism* (or *appreciation*). In this view, scholarship gives us information about works of art and it uses works of art to enable us to understand the thought of a period; criticism gives us information about the critic's feelings, especially the critic's evaluation of the work of art. Art history, it has been said, is chiefly fact-finding, whereas art criticism is chiefly fault-finding. And there is some debate about which activity is the more worthwhile. The historical scholar may deprecate evaluative criticism as mere talk about feelings, and the art critic may deprecate scholarly art-historical writing as mere irrelevant information. But before we further consider the relationship between historical scholarship and criticism, we should think briefly about a third kind of activity, *connoisseurship*.

### Connoisseurship

The connoisseur identifies and evaluates works of art. Erwin Panofsky, in *Meaning in the Visual Arts* (1955), suggests that the connoisseur differs from the art historian not so much in principle as in emphasis; the connoisseur's opinions (e.g., "Rembrandt around 1650"), like the historian's, are verifiable. The difference (Panofsky says) is this: "The connoisseur might be defined as a laconic art historian, and the art historian as a loquacious connoisseur" (p. 20). But elsewhere in his book Panofsky distinguishes between art history on the one hand and, on the other, "aesthetics, criticism, connoisseurship, and 'appreciation'" (p. 322). Perhaps we can retain Panofsky's definition of the connoisseur as a "laconic art historian," and say that the connoisseur's specialty is a sensitivity to artistic traits. We can say, too, that the art historian possesses the knowledge of the connoisseur—a

knowledge of what is genuine and of when it was made—and then goes on (by analyzing forms and by relating them chronologically) to explain the changes that have occurred in the ways that artists have seen.

Connoisseurship today has been widely censured, especially by leftist historical scholars who sometimes characterize themselves as practitioners of the New Art History (see pp. 105–06). Chiefly concerned with art as a revelation of the social and political culture that produced it, these scholars see connoisseurship as an arid activity. In the eyes of the New Art History, connoisseurship concentrates on minutiae, evades confronting the social implications of art, fosters the elitist implications of art museums, bolsters the art market by authenticating works for art dealers and collectors, and asserts the validity of such mystical and elitist concepts as "taste" and "intuition" and "quality."

Even a new sort of connoisseurship, relying on scientific tests of pigments, paper, patination, and so forth, has been criticized along the same grounds. Scientific study is intended to clear matters up, but persons skeptical of connoisseurship argue that highly technical reports serve chiefly to enhance the mystique of art. On the other hand, many connoisseurs (they are found chiefly in museums rather than in colleges and universities) believe that art historians tend to be insufficiently concerned with works of art as things of inherent worth and overly concerned with art as material for the study of political or intellectual history. But let us now further consider the relationship between the art historian and the art critic.

## History and Criticism

The *art historian* is sometimes viewed as a sort of social scientist, reconstructing the conditions and attitudes of the past through documents. (The documents, of course, include works of art as well as writings.) In studying Cubism, for example, the supposedly dispassionate art historian does not prefer one work by Braque to another by Braque, or Picasso to Braque, or the other way around. The historian's job, according to this view, is to explain how and why Cubism came into being, and value judgments are considered irrelevant.

The *art critic*, on the other hand, is supposedly concerned not with verifiable facts but with value judgments. Sometimes these judgments can be reduced to statements such as "This work by Braque is better than that work by Picasso," or "Picasso's late works show a falling-off," and so on, but even when critics are not so crudely awarding As and Bs and Cs, acts of evaluation lie behind their choice of works to discuss. In-

trigued by a work, they usefully call our attention to qualities in it that evoke a response, helping us to see what the work has to offer us. As they do so, they are usually also calling our attention to the degree to which the work corresponds to certain standards or values—for instance, complexity or unity or sincerity or innovativeness or leftist or rightist politics. Consider the following passage, in which the architect Paul M. Rudolph talks about the Edgar J. Kaufmann House (1936–38), customarily called Falling Water or Fallingwater, designed by Frank Lloyd Wright at Bear Run, Pennsylvania:

> Fallingwater is that rare work which is composed of such delicate balancing of forces and counterforces, transformed into spaces thrusting horizontally, vertically and diagonally, that the whole achieves the serenity which marks all great works of art. This calmness, with its underlying tensions, forces and counterforces, permeates the whole, inside and

Frank Lloyd Wright, *Falling Water*, the Edgar J. Kaufmann House, 1936–38. Bear Run, Pennsylvania. (Western Pennsylvania Conservancy/Art Resource, NY)

out, including the furnishings and fittings. . . . The thrusts are under complete control, resulting in the paradox of a building full of movement: turning, twisting, quivering movement—which is, at the same time, calm, majestic and everlasting.

"Fallingwater," *Global Architecture* 2 (1970), unpaginated

Rudolph, in love with "underlying tensions, forces and counterforces," is barely concerned with how well Falling Water works as a house. Is it noisy? Damp and hard to heat? Rudolph does not care about how the house functions. In fact, he goes on to suggest that "the mark of an architect is how he handles those spaces that are not strictly functional." In short, Rudolph's values (at least in this essay) have to do chiefly with the resolution of forces, little to do with functionalism, and nothing to do with politics. Another critic might, for instance, object to the building as a toy designed for a multimillionaire.

## Criticism and Values

Criticism can be said essentially to be the setting forth of what the critic regards as true values and the rejection of false values. What makes a work of art good, or valuable? One criterion held that the more realistic the work—the closer it resembled what the eye saw—the better. Legend has it that two painters of the fourth century BC competed. Zeuxis painted a picture of a boy holding grapes that were so realistic that birds sought to peck at the grapes. Confident that he had won, Zeuxis asked the other contender, Parrhasius, to draw the curtain and reveal his painting. Parrhasius then pointed out that the curtain was the painting; Zeuxis had only deceived stupid birds, but Parrhasius had deceived a human being. Zeuxis conceded defeat.

Of course, there are other criteria. Whereas realism implies that the aim of art is to reproduce visible reality, some artists and critics say that the external world has no meaning and that the aim of art is for the artist to impose his or her vision—to make us see the world as the artist sees it. Still others speak of art for art's sake; the aim is to produce a work of art—something beautiful—that is independent of external reality, and that cannot be judged by resemblance to the external world, or by moral or religious values. Others hold other views. For instance, Marxist critics value art that accurately represents social and political conditions. Thus, Allan Sekula, a Marxist, finds inadequate the liberal sentiments usually associated with documentary photographers such as W. Eugene Smith:

> For all his good intentions, for example, Eugene Smith in *Minamata* provided more a representation of his compassion for mercury-poisoned

fisherfolk than one of their struggle for retribution against the corporate polluter. I will say it again: the subjective aspect of liberal aesthetics is compassion rather than collective struggle. Pity, mediated by an appreciation of "great art," supplants political understanding.

*Photography Against the Grain* (1984), p. 67

Sekula is very clear about the standards by which he evaluates a work of art: It is not enough for a picture to have formal beauty (let's say the "underlying tensions" that Paul Rudolph values in Falling Water) or for a picture to evoke compassion. It must also reveal and convey political understanding. "I am arguing, then," Sekula says, "for an art that documents monopoly capitalism's inability to deliver the conditions of a fully human life" (p. 74).

Other critics have other standards. *Modernist critics* (active chiefly from about 1950 to the mid-1970s, and primarily committed to abstract art and the apparently impersonal architecture of the International Style epitomized in the work of Mies van der Rohe) tended to assume that a work of art is self-sufficient, pure, and need not—indeed, should not—be seen as a reflection of the social context. It now seems evident that admirers of the International Style were espousing—whether they knew it or not—a capitalist celebration of business efficiency.) For the modernist, the significant artist was highly original, a member of the avantgarde, a genius who produced a unique work that marked an advance in the history of art—a sort of artistic Thomas Edison or Henry Ford. Not surprisingly, modernist critics tended to practice formal analysis.

One can easily understand why some philosophers doubt that objective evaluation is possible, and one can see why these philosophers say that such terms as "beautiful" and "ugly" are not really statements about artworks but are simply expressions of feelings. (As we have also seen, however, on pp. 17–18, some philosophers of art insist that the real existence of a work is not in its material makeup—paint on canvas, or a mass of bronze—but in the observer's response to it.)

A reaction to the modernist critics of the mid-twentieth century probably was inevitable, and it took the name of postmodernism. *Postmodernist* critics (active from about 1970 to the present) argue that the supposedly dispassionate old-style art historians are in fact, consciously or not, committed to the false elitist idea that there are universal aesthetic criteria. Here is the way Tom Gretton puts it:

> For most art historians "art" does not designate a set of types of object— all paintings, sculptures, prints and so forth—but a subset arrived at by a more or less openly acknowledged selection on the basis of aesthetic

criteria. But aesthetic criteria have no existence outside a specific historical situation; aesthetic values are falsely taken to be timeless.
"New Lamps for Old," in *The New Art History*, ed. A. L. Rees and
Frances Barzello (1988), p. 64

Behind a good deal of postmodern criticism stand the writings of the architects Robert Venturi and Denise Scott Browne, who see modernism, with its emphasis on formal beauty, as narcissistic. For these critics the artist is deeply implicated in society. Postmodern criticism therefore rejects formal analysis and tends to discuss artworks not as beautiful objects produced by a unique sensibility but as works that exemplify a society's culture, especially its politics.

But even when critics talk about artworks not as objects of beauty but as something else, probably the root of the criticism is a feeling, even a passion, which is then made acceptable by being set forth in a carefully reasoned account. But it must then be added that the root of much historical writing is also a feeling or intuition—a hunch perhaps that a stained-glass window in a medieval cathedral may be a late replacement, or that photography did not influence the paintings of Degas as greatly as is usually thought. The historian then follows up the hunch by scrutinizing the documents and by setting forth—like the critic—a reasoned account.

It is doubtful, then, that historical scholarship and aesthetic criticism are indeed two separate activities; or, to put it a little differently, we can ask if scholarship is really concerned exclusively with verifiable facts, or, on the other hand, if criticism is really concerned exclusively with unverifiable responses (i.e., only with opinions). If scholarship limited itself to verifiable facts, it would have little to deal with; the verifiable facts usually don't go far enough.

Suppose that a historian who is compiling a catalog of Rembrandt's work, or who is writing a history of Rembrandt's development, is confronted by a drawing attributed to Rembrandt. External documentation is lacking: No letter describes the drawing, gives a date, or tells us that the writer saw Rembrandt produce it. The historian must decide whether the drawing is by Rembrandt, by a member of Rembrandt's studio, by a pupil but with a few touches added by the master, or is perhaps an old copy or even a modern forgery. Scholarship (e.g., a knowledge of paper and ink) may reveal that the drawing is undoubtedly old, but questions still remain: Is it by the master or by the pupil or by both?

Even the most scrupulous historians must bring their critical sense into play, and offer conclusions that go beyond the verifiable facts—con-

clusions that are ultimately based on an evaluation of the work's quality, a feeling that the work is or is not by Rembrandt and—if the feeling is that the work *is* by Rembrandt—a sense of *where* it belongs in Rembrandt's chronology. Art historians try to work with scientific objectivity, but because the facts are often inconclusive, much in their writing is inevitably (and properly) an articulation of a response, a rational explanation of feeling that is based on a vast accumulation of experience. Another example: A historian's decision to include in a textbook a discussion of a given artist or school of art is probably a judgment based ultimately on the feeling that the matter is or is not worth discussing, is or is not something of importance or value. And the decision to give Vermeer more space than Casper Netscher is an aesthetic decision, for Netscher was, in his day, more influential than Vermeer. Indeed, art history has worked along these lines from its beginnings in *Lives of the Most Excellent Painters, Sculptors and Architects* by Giorgio Vasari (1511–74). Vasari says that he disdained to write a "mere catalog," and that he did not hesitate to "include [his] own opinion" everywhere and to distinguish among the good, the better, and the best.

On the other hand, even critics who claim that they are concerned only with evaluation, and who dismiss all other writing on art as sociology or psychology or gossip, bring some historical sense to their work. The exhibitions that they see have usually been organized by scholars, and the accompanying catalogs are often significant scholarly works; it is virtually impossible for a serious museum goer not to be influenced, perhaps unconsciously, by art historians. When, for example, critics praise the Cubists for continuing the explorations of Cézanne, and damn John Singer Sargent for contributing nothing to the development of art, they are doing much more than expressing opinions; they are drawing on their knowledge of art history, and they are echoing the fashionable view that a work of art is good if it marks an advance in the direction that art happens to have taken.

Probably it is best, then, not to insist on the distinction between scholarship and criticism, but to recognize that most writing about art is a blend of both. True, sometimes a piece of writing emphasizes the facts that surround the work (e.g., sources, or the demands of the market), showing us how to understand what people once thought or felt; and sometimes it emphasizes the reasons why the writer especially values a particular work, showing the work's beauty and significance for us. But on the whole the best writers on art do both things, and they often do them simultaneously.

Consider, as an example, Julius S. Held's article, "The Case against the Cardiff 'Rubens' Cartoons," published in the *Burlington Magazine*

(March 1983). Four full-scale cartoons (large drawings) for tapestries were acquired in 1979 by the National Museum of Wales as works by Rubens, but their attribution has been doubted. In the second paragraph of his article, Professor Held comments:

> When I first saw the photographs of the cartoons, and even more so after I had seen them in their setting in Cardiff (27th July 1980), I failed to notice anything that would justify the extraordinary claims made for them. That they were Flemish paintings of the seventeenth century no one could deny. They could also be of special interest as cartoons painted on paper, a category of works that must have existed in great quantity, though few have survived. Yet an attribution to Rubens, as the author of their design as well as the actual executant seemed to me highly questionable and certainly not at all self-evident. (p. 132)

Obviously Held is suggesting that the works do not look like works by Rubens, and in the words "the extraordinary claims made for them" we hear a strong implication that they are not good enough to be by Rubens. So we begin with evaluation, taste, perhaps subjective judgment, but judgment made by a trained eye.

Held goes on to buttress this judgment with other criteria, of a more objective kind. Technically, the cartoons are unprecedented in Ruben's oeuvre. They are done in watercolor on paper, a medium he never used on this scale; even in small drawings watercolor alone is rarely employed. The attribution, hence, of the disputed cartoons to Rubens is unlikely on this ground alone. Held proceeds to ask himself on what basis these cartoons were attributed to Rubens in the first place. The main argument in favor was based on the existence of two *modelli,* painted in oil and depicting actions similar to those of the two cartoons. These *modelli* are indeed by Rubens, but they cannot be used in support of the attribution of the cartoons. Why? Because in composition these *modelli* differ radically from the cartoons, whereas in all the instances in which we know Rubens's *modelli* for tapestry cartoons, the *modelli* and the cartoons agree with each other in all essential respects. In disengaging the *modelli* from the cartoons, Held also uses an iconographic argument: The cartoons depict incidents from the life of Aeneas, but the *modelli* illustrate scenes from the life of Romulus.

In short, during the course of his argument, Held introduces historical data in support of critical judgments. His final words (p. 136) make this clear: "The purpose of my paper is served . . . if it succeeds to remove Rubens's name from four paintings that are not worthy to carry it."

# WHAT RESEARCH IS

Because a research paper requires its writer to collect the available evidence—usually including the opinions of earlier investigators—one sometimes hears that a research paper, unlike a critical essay, is not the expression of personal opinion. But such a view is unjust both to criticism and to research. A critical essay is not a mere expression of personal opinion; to be any good it must offer evidence that supports the opinions, thus persuading the reader of their objective rightness. And a research paper is largely personal, because the author continuously uses his or her own judgment to evaluate the evidence, deciding what is relevant and convincing. A research paper is not merely an elaborately footnoted presentation of what a dozen scholars have already said about a topic; it is a thoughtful evaluation of the available evidence, and so it is, finally, an expression of what the author thinks the evidence adds up to.*

You may want to do some research even for a paper that is primarily critical. Consider the difference between a paper on the history of Rodin's reputation and a paper offering a formal analysis of a single work by Rodin. The first of these, necessarily a research paper, will require you to dig into books and magazines and newspapers to find out about the early response to his work; but even if you are writing a formal analysis of a single piece, you may want to do a little research into, for example, the source of the pose. The point is that writers must learn to use source material thoughtfully, whether they expect to work with few sources or with many.

Though research sometimes requires one to read tedious material, or material that, however interesting, proves to be irrelevant, those who engage in research feel, at least at times, an exhilaration, a sense of triumph at having studied a problem thoroughly and at having arrived at conclusions that at least for the moment seem objective and irrefutable. Later, perhaps, new evidence will turn up that will require a new conclusion, but until that time, one may reasonably feel that one knows *something.*

---

*Because footnotes may be useful or necessary in a piece of writing that is *not* a research paper (such as this chapter), and because I want to emphasize the fact that a thoughtful research paper requires more than footnotes, I have put the discussion of footnotes in Chapter 7 (pp. 165–76).

## PRIMARY AND SECONDARY MATERIALS

The materials of most research are conventionally divided into two sorts, primary and secondary. The *primary* materials or sources are the subject of study, the *secondary* materials are critical and historical accounts already written about these primary materials. For example, if you want to know whether Rodin was influenced by Michelangelo, you will look at works by both sculptors, and you will read what Rodin said about his work as a sculptor. In addition to studying these primary sources, you will also read secondary material such as modern books on Rodin. There is also material in a sort of middle ground: what Rodin's friends and assistants said about him. If these remarks are thought to be of compelling value, especially because they were made during Rodin's lifetime or soon after his death, they can probably be considered primary materials. And, of course, for a work such as Rodin's *Monument to Balzac* (1897), the novels of Balzac can be considered primary materials.

If possible, draw as heavily as you can on primary sources. If in a secondary source you encounter a quotation from Leonardo or Mary Cassatt or whomever—many artists wrote a good deal about their work—do not be satisfied with this quotation. Check the original source (it will probably be cited in the secondary source that quotes the passage) and study the quotation in its original context. You may learn, for instance, that the comment was made so many years after the artwork that its relevance is minimal.

## FROM SUBJECT TO THESIS

First, a subject. No subject is undesirable. As G. K. Chesterton said, "There is no such thing on earth as an uninteresting subject; the only thing that can exist is an uninterested person." Research can be done on almost anything that interests you, though you should keep in mind two limitations. First, materials for research on recent works may be extremely difficult to get hold of, since crucial documents may not yet be in print and you may not have access to the people involved. And, second, materials on some subjects may be unavailable to you because they are in languages you can't read or in publications that no nearby library has. So you probably won't try to work on the stuff of today's news—for example, the legal disposition of the works of a sculptor whose will is now being contested; and (because almost nothing in English has been written on it)

you won't try to work on the date of the introduction into Japan of the image of the Buddha at birth. But no subject is too trivial for study: Newton, according to legend, wondered why an apple fell to the ground.

You cannot, however, write a research paper on subjects as broad as Buddhist art, or Michelangelo, or the Asian influence on Western art. You have to focus on a much smaller area within such a subject. Let's talk about the Asian influence on Western art. You might narrow your topic, so that you concentrate on the influence of Japanese prints on van Gogh (or on Toulouse-Lautrec, or on Mary Cassatt), or on the influence of calligraphy on Mark Tobey, or on the influence of Buddhist sculpture on Jo Davidson. Your own interests will guide you to the topic—the part of the broad subject—that you wish to explore, and you won't know what you wish to explore until you start exploring. Picasso has a relevant comment: "To know what you want to draw, you have to begin drawing. If it turns out to be a man, I draw a man."

But, of course, even though you find you are developing an interest in an appropriately narrow topic, you don't know a great deal about it; that's one of the reasons you are going to do research on it. Let's say that you happen to have a Japanese print at home, and your instructor's brief reference to van Gogh's debt to Japanese prints has piqued your interest. You may want to study some pictures and do some reading now. As an art historian (at least for a few hours each day for the next few weeks), at this stage you think you want to understand why van Gogh turned to Japanese art (the explanation will probably include some relatively remote causes as well as what historians have called "releasers" or "triggers"), and what the effect of Japanese art was on his own work. Possibly your interest will shift to the influence of Japan on van Gogh's friend, Gauguin, or even to the influence of Japanese prints on David Hockney in the 1970s. That's all right; follow your interests. Exactly what you will focus on, and exactly what your *thesis,* or point of view, will be, you may not know until you do some more reading. But how do you find the relevant material?

## FINDING THE MATERIAL

You may already happen to know of some relevant material that you have been intending to read—perhaps titles listed on a bibliography distributed by your instructor—or you can find the titles of some of the chief books by looking at the bibliography in such texts as H. W. Janson's *History of Art* (1995) or Spiro Kostof's *History of Architecture* (1995), but if

these do not prove useful and you are at a loss about where to begin, consult the card or on-line catalog of your library, the appropriate guides to articles in journals, and certain reference books listed here subsequently.

## The Library Catalog: Card or Computerized

The card catalog has cards arranged alphabetically not only by author and title but also by subject. If your library has an on-line catalog, the principle is the same but alphabetization won't matter. The catalog won't have a heading for "The Influence of Japanese Prints on van Gogh," of course, but it will have one for "Art: Japanese" (this will then be broken down into periods), and there will also be a subject heading for "Prints, Japanese," after which will be a card (or an entry in the on-line catalog) for each title that is in the library's collection. And, of course, you will look up van Gogh (who, it will probably turn out in a card catalog, will be listed under Gogh), where you will find cards, or entries listing books by him (e.g., collections of his letters) and about him. Often it is useful and sometimes necessary, even for computerized catalogs where you search simply by typing keywords, to look up your subject in the *Library of Congress Subject Headings*, the three big red books that libraries keep near their catalogs.

## Scanning Encyclopedias, Books, and Book Reviews

Having checked the library catalog and written down the relevant data (author, title, call number), you can begin to scan the books, or you can postpone looking at the books until you have found some relevant articles in periodicals. For the moment, let's postpone the periodicals.

You can get an admirable introduction to almost any aspect of art by looking at a new thirty-four-volume work, *The Dictionary of Art*, edited by Jane Turner (1996). *The Dictionary* contains 41,000 articles, arranged alphabetically, on artists (including 3,700 entries for architects, 9,000 for painters, and 500 for photographers), forms, materials (e.g., amber, ivory, tortoise shell, and hundreds of other materials), movements, sites, theories, and so on. The articles, which range from a few hundred words to several thousand words (e.g., 8,500 on *abstract art*), include illustrations, cross-references to other articles in *The Dictionary*, and bibliographic references (some 300,000 such references). The index (670,000 entries) will guide you to appropriate articles on your subject.

Before *The Dictionary of Art* was made available, the usual starting place was *Encyclopedia of World Art*, originally a fifteen-volume work published by McGraw-Hill in 1959–68, but now with two supplementary volumes (1983 and 1987) updating the bibliographies. (Don't confuse this seventeen-volume work with *McGraw-Hill Dictionary of Art* [1969], a five-volume set containing about 15,000 entries, emphasizing biographies of artists.) *Encyclopedia of World Art* includes articles on nations, schools, artists, iconographic themes, genres, and techniques. It continues to be of some value, but for the most part it is superseded by *The Dictionary of Art.*

General encyclopedias, such as *Encyclopedia Americana* and *Encyclopaedia Britannica,* can be useful at the beginning. For certain topics, such as early Christian symbolism, *New Catholic Encyclopedia* (fifteen volumes) is especially valuable.

Let's assume that you have glanced at some entries in an encyclopedia, or perhaps have decided that you already know as much as would be included in such an introductory work, and you now want to investigate the subject more deeply. Put a bunch of books in front of you, and choose one as an introduction. How do you choose one from half a dozen? Partly by its size—choose a fairly thin one—and partly by its quality. Roughly speaking, it should be among the more recent publications, or you should have seen it referred to (perhaps in the textbook used in your course) as a standard work on the subject. The name of the publisher is at least a rough indication of quality: A book or catalog published by a major museum, or by a major university press, ought to be fairly good.

When you have found the book that you think may serve as your introductory study, read the preface to get an idea of the author's purpose and outlook, scan the table of contents to get an idea of the organization and the coverage, and scan the final chapter or, if the book is a catalog of an exhibition, the last few pages of the introduction, where you may be lucky enough to find a summary. The index, too, may let you know if the book will suit your purpose by showing you what topics are covered and how much coverage they get. If the book still seems suitable, scan it.

At this stage it is acceptable to trust one's hunches—you are only going to scan the book, not buy it or even read it—but you may want to look up some book reviews to assure yourself that the book has merit, and to be aware of other points of view. There are four especially useful indexes to book reviews:

*Book Review Digest* (published from 1905 onward)
*Book Review Index* (1965–)
*Art Index* (1929–)
*Humanities Index* (1974–)

**Book Review Digest** includes brief extracts from the reviews, chiefly in relatively popular (as opposed to scholarly) journals. Thus if an art book was reviewed in the *New York Times Book Review,* or in *Time* magazine, you will probably find something (listed under the author of the book) in *Book Review Digest.* Look in the volume for the year in which the book was published, or in the next year. But specialized books on art will probably be reviewed only in specialized journals on art, and these are not covered by *Book Review Digest.*

You can locate reviews by consulting **Book Review Index** (look under the name of the author of the book) or by consulting *Art Index.* (In the early volumes of **Art Index,** reviews were listed, alphabetically by the author of the review, throughout the volumes, but since 1973–74 reviews have been listed at the rear of each issue, alphabetically by the author of the book or by the title if the book has no author.) Scholarly reviews sometimes appear two or even three years after the publication of the book, so for a book published in 1985 you probably will want to consult issues of *Book Review Index* and *Art Index* for as late as 1988. **Humanities Index** works the same way as *Art Index* but indexes different journals for an interdisciplinary approach.

When you have located some reviews, read them and then decide whether you want to scan the book. Of course, you cannot assume that every review is fair, but a book that on the whole gets good reviews is probably at least good enough for a start.

By quickly reading such a book (take few or no notes at this stage), you will probably get an overview of your topic, and you will see exactly what part of the topic you wish to pursue.

## Indexes and Databases to Published Material

An enormous amount of material on art is published in books, magazines, and scholarly journals—too much for you to look at randomly as you begin a research project. But **indexes** and **databases** can help you sort through this vast material and locate books and articles relevant to your research topic. The most widely used indexes include these:

*Readers' Guide to Periodical Literature* (1900– )
*Art Index* (1929– )
*BHA: Bibliography of the History of Art* (1991– )
*Répertoire d'art et d'archéologie* (1910–90)
*RILA: International Repertory of the Literature of Art* (1973–89)
*ARTbibliographies MODERN* (1969– )
*Architectural Periodicals Index* (1973– )
*Avery Index to Architectural Periodicals* (1934– )

**Readers' Guide** indexes more than a hundred of the most familiar magazines—such as *Atlantic, Nation, Scientific American, Time.* Probably there won't be much for you in these magazines unless your topic is something like "Van Gogh's Reputation Today," or "Popular Attitudes toward Surrealism, 1930–40," or "Jackson Pollock as a Counter-Culture Hero of Fifties America," or some such thing that necessarily draws on relatively popular writing. *Readers' Guide* is also available (since 1984) through WILSONLINE and WILSONDISC (on CD-ROM).

*Art Index, Répertoire d'art, RILA,* and *ARTbibliographies MOD-ERN* are indexes to many scholarly periodicals—for example, periodicals published by learned societies—and to bulletins issued by museums.

**Art Index** lists material in about three hundred periodicals, bulletins, and yearbooks; it does not list books but it does list, at the rear, book reviews under the name of the author of the book. *Art Index* covers not only painting, drawing, sculpture, and architecture, but also photography, decorative arts, city planning, and interior design—in Africa and Asia as well as Western cultures. A computerized version of *Art Index* (since October 1984) is available through WILSONLINE, and, on CD-ROM, through WILSONDISC.

**BHA: Bibliography of the History of Art** represents a merger of the next two bibliographies that are discussed, *Répertoire d'art* and *RILA,* but you will still need to consult these two for material published before 1989. *BHA* covers visual arts in all media *but* it is limited to Western art from Late Antiquity to the present. Thus, it excludes not only ancient Western art, but also Asian, Indian, Islamic, African, and Oceanic art, and American art before the arrival of Europeans. In addition to including citations of books, periodical articles, exhibition catalogs, and doctoral dissertations, it includes abstracts (*not* evaluations) in English or French. *BHA* is available online from ORBIT/QUESTEL.

*Répertoire d'art* lists books as well as articles in some 1,750 periodicals (many of them European), but, like its successor *BHA*, it excludes non-Western art, and beginning with 1965, it excludes art before the early Christian period. It also excludes artists born after 1920.

**RILA: *International Repertory of the Literature of Art*** lists books as well as articles in some three hundred journals. It is especially useful because it includes abstracts, but it covers only post-Classical European art (which began with the fourth century) and post-Columbian American art. It thus excludes (again, like its successor *BHA*) prehistoric, ancient, Asian, Indian, Islamic, African, Oceanic, and Native American art. Several volumes of *RILA* can be searched at one time by using its *Cumulative Indexes*. It is available on DIALOG.

***ARTbibliographies MODERN*** used to cover art from 1800, but beginning in 1989 it limited its coverage to art from 1900. It now provides abstracts or brief annotations not only of periodical articles concerned with art of the twentieth century, but also of exhibition catalogs and books. Entries since 1974 can be searched through DIALOG. It is also available on CD-ROM.

***Architectural Periodicals Index*** indexes about five hundred journals. It is available online, as *The Architecture Database* (DIALOG), with files since 1978.

***Avery Index to Architectural Periodicals*** is available through DIALOG, as *On-line Avery Index to Architectural Periodicals Database*, with files since 1977, and as *Avery Index to Architectural Periodicals Database*, with files since 1977.

Major newspapers also cover art topics—for example, exhibitions and books. Some major newspapers have their own indexes; for instance, **The New York Times Index** (1851–) and **Times of London Index** (1790–). Many other indexes to newspapers are available on LEXIS/NEXIS.

Users of the Internet can access art-historical information from bibliographic and research databases of the Getty Art History Information Program (AHIP), thereby simultaneously searching *Avery Index, RILA,* and the *Provenance Index* (which gives details of ownership derived from sales catalogs).

Whichever indexes you use, begin with the most recent years and work your way back. If you collect titles of materials published in the last five years, you will probably have as much as you can read. These articles will probably incorporate the significant points of earlier writings. But, of course, it depends on the topic; you may have to—and want to—go back fifty or more years before you find a useful body of material.

Note, too, that if the museum that owns an object also issues publications, the object may be discussed in a publication issued about the time the object was acquired. Thus, if the Cleveland Museum of Art acquired an object in 1980 (the date of acquisition is given on the label next to the work), an issue of *The Bulletin of the Cleveland Museum of Art* in 1980 or 1981 may discuss it.

*Caution:* Indexes drastically abbreviate the titles of periodicals. Before you put the indexes back on the shelf, be sure to check the key to the abbreviations, so that you know the full titles of the periodicals you are looking for.

## Other Guides

There are a great many reference books—not only general dictionaries and encyclopedias, but also dictionaries of technical words (e.g., *Adeline's Art Dictionary,* reissued as *Adeline Art Dictionary* in 1966), and of motifs (James Hall's *Dictionary of Subjects and Symbols in Art,* 2nd ed. [1979]), and encyclopedias of special fields (*Encyclopedia of World Art*). *Adeline's Art Dictionary,* for example, defines terms used in painting, sculpture, architecture, etching, and engraving. Hall's *Dictionary* is devoted chiefly to classical and biblical themes in Western art: If you look up the Last Supper, you will find two detailed pages on the topic, explaining its significance and the various ways in which it has been depicted since the sixth century. For instance, in the earliest depictions Christ is at one end of the table, but later Christ is at the center. A dog may sit at the feet of Judas, or Judas may sit alone on one side of the table; if the disciples have haloes, Judas's halo may be black. Again, if in Hall's *Dictionary* you look up *cube,* you will find that in art it is "a symbol of stability on which Faith personified rests her foot;. . . Its shape contrasts with the unstable globe of Fortune."

Two other guides to symbolism—one by James Hall—may be mentioned here. Both include non-Western material, so the coverage is considerably broader than in Hall's *Dictionary of Subjects and Symbols,* but the coverage of Western material is somewhat thinner. The books are Hans Biedermann's *Dictionary of Symbolism* (1992), and James Hall's *Illustrated Dictionary of Symbols in Eastern and Western Art* (1994).

For definitions of chief terms and for brief biographies, see Peter and Linda Murray's little *Dictionary of Art and Artists* (1984), or *The Oxford Companion to Art,* (1970), edited by Harold Osborne. *The Larousse Dictionary of Painters* (1981) accompanies its biographies with

illustrations. For artists of the twentieth century, the best general reference works are *The Oxford Companion to Twentieth-Century Art* (1981), edited by Harold Osborne, and *Contemporary Artists* (1989). There are also subject bibliographies—books that are entirely devoted to listing (sometimes with comment) publications on specific topics. Thus, Yvonne M. L. Weisberg and Gabriel P. Weisberg's *Japonisme* (1987) lists and comments on almost seven hundred books, articles, exhibition catalogs, and unpublished dissertations concerning the Japanese influence on Western art from 1854 to 1910. Similarly, Nancy J. Parezo, Ruth M. Perry, and Rebecca S. Allen's *Southwest Native American Arts and Material Culture* (1991) lists more than eight thousand references, including books, journals, exhibition catalogs, and dissertations.

How do you find such reference books? The best single volume to turn to is

Lois Swan Jones, *Art Information: Research Methods and Resources,* 4th ed. (scheduled for 1996).

Among other useful guides to the numerous books on art are these:

Donald L. Ehresmann, *Fine Arts: A Bibliographic Guide to Basic Reference Works, Histories, and Handbooks,* 3rd ed. (1990).

Etta Arntzen and Robert Rainwater, *Guide to the Literature of Art History* (1980).

Arntzen and Rainwater covered material only to 1977; fortunately, a supplementary volume covering material from 1977 to 1996 is in preparation.

Max Marmor and Alex Ross, *Guide to the Literature of Art History,* volume 2 (scheduled for 1998).

It also includes updated material as well as chapters on such topics as design history, patronage and collecting, and aesthetics, criticism, and theory.

What about reference books in other fields? The best guides to reference books in all sorts of fields include these:

*Guide to Reference Books,* 10th ed., compiled by Eugene P. Sheehy and others (1986).

*Guide to Reference Books. Supplement to the Tenth Edition,* ed. Robert Balay (1992).

There are guides to all of these guides: *reference librarians.* If you don't know where to turn to find something, turn to the librarian.

# READING AND TAKING NOTES

As you read, you will, of course, find references to other publications, and you will jot these down so that you can look at them later. It may turn out, for example, that a major article was published twenty years ago and that the most recent writing about your topic is a series of footnotes to this piece. You will have to look at it, of course, even though common sense had initially suggested (incorrectly, it seems) that the article would be out of date.

In reading an article or a chapter of a book, read it through but do not take notes while reading it. By the time you reach the end, you may find it isn't noteworthy. Or you may find a useful summary near the end that will contain most of what you can get from the piece. Or you will find that, having a sense of the whole, you can now quickly reread the piece and take notes on the chief points.

When you take notes, use a word processor if possible. But if you don't use a word processor, use 4 × 6-inch cards, and write on one side only; material on the back of a card is usually neglected when you come to write the paper. If your notes from a source, on a particular point, run to more than one card (say to three), number each card thus: 1 of 3, 2 of 3, 3 of 3. Use 4 × 6 cards because the smaller cards (3 × 5) are too small for summaries of useful material, and the larger cards (5 × 7) invite you to put too much material on one card.

Here are some guidelines for note-taking:

1. **Write summaries rather than paraphrases;** write abridgments rather than restatements, because restatements may turn out to be as long as or longer than the original. There is rarely any point to paraphrasing; generally speaking, either quote exactly (and put the passage in quotation marks, with a notation of the source, including the page number or numbers) or summarize, reducing a page or even an entire article or chapter of a book to a single 4 × 6 card or to a few sentences. Even when you summarize, indicate your source (including the page numbers) on the card, so that you can give appropriate credit in your paper.

2. Of course, in your summary you will sometimes quote a phrase or a sentence—putting it in quotation marks—but **quote sparingly.** You are not doing stenography; rather, you are assimilating knowledge and you are thinking, and so for the most part your source should

be digested rather than engorged whole. Thinking now, while taking notes, will also help you later to avoid plagiarism. If, on the other hand, when you take notes you mindlessly copy material at length, later when you are writing the paper you may be tempted to copy it yet again, perhaps without giving credit. Similarly, if you photocopy pages from articles or books, and then merely underline some passages, you probably will not be thinking; you will just be underlining. But if you make a terse summary on the word processor or on a note card, you will be forced to think and to find your own words for the idea.

Most of the direct quotations that you copy should be effectively stated passages or crucial passages or both. In your finished paper these quotations will provide authority and emphasis. Be sure not to let your paper degenerate into a string of quotations.

3. If you quote but omit some material within the quotation, be sure to indicate the omission by an ellipsis, or three spaced periods (as explained on p. 160). **Check the quotation for accuracy,** and check the page number you have recorded on your card.

4. **Never copy a passage by changing an occasional word,** under the impression that you are thereby putting it into your own words. Notes of this sort may find their way into your paper, your reader will sense a style other than your own, and suspicions of plagiarism may follow. It is worth saying yet again that you should either quote exactly, and enclose the words within quotation marks, or summarize drastically. In both cases, be sure to give credit to your source. (For a detailed discussion of plagiarism, see pp. 161–65.)

5. Feel free to **jot down your own responses to the note.** For example, you may want to say, "Baker made same point 5 yr earlier"; but make certain that later you will be able to distinguish between these comments and the notes summarizing or quoting your source. A suggestion: Surround all comments recording your responses with double parentheses, thus: (( . . . )).

6. In the upper corner of each note card, **write a brief key**—for example, "van G's Portrait of Tanguy"—so that later you can tell at a glance what is on the card. See the accompanying sample note card. Things to notice are: a brief heading at the top identifies the subject of the card; the quotation is followed by the page citation; the writer's own response to the quotation is enclosed within double parentheses, so that it cannot be confused with the writer's notes summarizing the source.

> *van G's <u>Portrait of Tanguy</u>*
> *(1887–1888)*
>
> *Picture includes copies of Japanese prints but <u>not</u> in style of prints:*
>     *lacks characteristic contour lines of J. prints*
> *why?*
>     *Pollock and Orton claim V's interest is*
>        *in prints' <u>subject-matter</u>, not in their style:*
>        *"Attention is drawn to what they depict and*
>        *not to the stylistic character of the woodcuts" (p.41)*
>
>    *((seems to me van G is concerned with their style))*

## WRITING THE PAPER

There remains the difficult job of writing up your findings, usually in two thousand to three thousand words (or eight to twelve double-spaced typed pages). Here is some advice. (See also pp. 128–34 on writing with a computer.)

1. **Reread your notes,** sorting cards into packets by topic, or moving blocks if your notes are on a word processor. Put together what belongs together. If your notes are on a word processor, print them out, scissor them apart, and then arrange them into appropriate groups and sequences. Don't hesitate to reject material that—however interesting—now seems redundant or irrelevant. In doing your research you quite properly took many notes (as William Blake said, "You never know what is enough unless you know what is more than enough"), but now, in looking your material over, you see that some is unnecessary and so you reject it. Your finished paper should not sandbag the reader; keep in mind the Yiddish proverb, "Where there is too much, something is missing."

After sorting and resorting, you will have a kind of first draft without writing a draft. This business of settling on the structure of your work—the composition of your work, one might say—is often frustrating. Where to begin? Should this go before that? But remember that great artists have gone through greater struggles. If we look at a leaf from one of

Raphael's sketchbooks, we find him trying, and trying again, to work out the composition of, say, the Virgin and Child. Nicolas Poussin used a miniature stage, on which he arranged and rearranged the figures in his composition. An X-ray of Rembrandt's *The Syndics of the Cloth Drapers Guild* reveals that he placed the servant in no fewer than four positions (twice at the extreme right, once between the two syndics at the right, and finally in the center) before he found a satisfactory arrangement. You can hardly expect, at the outset, to have a better grasp of your material than Raphael, Poussin, and Rembrandt had of theirs. What Degas said of a picture is true of a research paper: "A good picture requires as much planning as a crime."

2. **From your packets of cards or your rearranged notes you can make a first outline.** In arranging the packets into a sequence, and then in sketching an outline (see pp. 83–85), you will be guided by your *thesis,* your point. Without a thesis you will have only a lot of notes, not an essay. This outline or map will indicate not only the major parts of the essay but also the subdivisions within these parts. Do not confuse this type of outline with a paragraph outline (i.e., with an outline made by jotting down the topic idea of each paragraph); when you come to write your essay, a single heading in your outline may require two or three or more paragraphs.

Don't scorn the commonest organization:

- Introduction of the works to be studied, and of the thesis
- Presentation of evidence, with interpretation relating it to the thesis
- Presentation of counterevidence, and rebuttal
- Conclusion

You may find that this organization doesn't suit your topic or you. Fine, but remember that your reader will need to be guided by some sort of organization that you will have to adopt and make clear.

3. **When you write your first draft, you may find it helpful to leave lots of space at the top and bottom of each page** so that you can add material, which will be circled and connected by arrows to the proper place. On reading your draft you may find that a quotation near the bottom of page 6 will be more appropriate if it is near the top of page 6. Circle it, and with an arrow indicate where it should go. If it should go on page 4, scissor it out and paste it on page 4. This process is a bit messy, but you will get a strong sense of what your paper sounds like only if you can read a draft with all of the material in the proper

place. When you move some material in your draft, also move your note cards containing the material, so that if for some reason you later have to doublecheck your notes, you can find your source easily. Of course, if you are using a word processor, you can move passages of text without cutting and pasting.

Your opening paragraph—in which you usually will define the problem and indicate your approach—may well be the last thing that you write, for you may not be able to enunciate these ideas clearly until you have learned something from drafting the rest of your essay. (On opening paragraphs, see pp. 151–52.)

4. **Write or type your quotations, even in the first draft, exactly as you want them to appear in the final version.** If you took notes on a word processor, just move the quotations from your notes into the paper. Short quotations (fewer than five lines of prose) are enclosed within quotation marks but are not otherwise set off. Long quotations are treated differently. Some instructors recommend that you triple space before and after the quotation, and single space the quotation. Other instructors recommend that you double space before and after the quotation, indent the entire quotation ten spaces, and double space it. In either case, do not enclose it within quotation marks.

(For more on quotations, see pp. 158–60.)

5. **Include, right in the body of the draft, all of the relevant citations** (later these will become footnotes or endnotes), so that when you come to revise, you won't have to start hunting through your notes to find who said what and where. If you are using a word-processing program, it will probably allow you to write the footnotes immediately after the quotations, and later it will print them at the bottom of the appropriate pages. Further, most word-processing programs let you add and delete notes while the computer automatically renumbers the notes in the final version. If, however, you are writing by hand, or on a typewriter, enclose these citations within diagonal lines, or within double parentheses—anything at all to remind you that they will be your footnotes.

6. Be sure to **identify works of art as precisely as possible.** Not "Rembrandt's *Self-Portrait*" (he did more than sixty), or even "Rembrandt's *Self-Portrait* in the Kunsthistorisches Museum, Vienna" (they own at least two), but "Rembrandt's *Self-Portrait of 1655*, in the Kunsthistorisches Museum, Vienna," or, more usually, "Rembrandt's *Self-Portrait* (1655, Kunsthistorisches Museum, Vienna)." If the exact date is unknown, preface the approximate date with ca., the abbreviation for *circa*, Latin for

"about." Example: ca. 1700. Be sure to identify all illustrations with a caption, giving, if possible, artist, title, date, medium, size, and present location. (See pp. 155–56 for more on captions and illustrations.)

7. **Beware of the compulsion to include all of your notes in your essay.** You have taken all these notes, and there is a strong temptation to use them all. But, truth to tell, in hindsight many are useless. Conversely, you will probably find as you write your draft that here and there you need to check a quotation or to collect additional examples. Probably it is best to continue writing your draft, if possible; but remember to insert the necessary material after you get it.

8. **As you revise your draft, make sure that you do not merely tell the reader "A says . . . B says . . . C says. . . ."** When you write a research paper, you are not merely setting the table with other people's dinnerware; you are cooking the meal. You must have a point, an opinion, a thesis; you are working toward a conclusion, and your readers should always feel they are moving toward that conclusion (by means of your thoughtful evaluation of the evidence), rather than reading an anthology of commentary on the topic.

Thus, because you have a focus, you should say such things as "There are three common views on. . . . The first two are represented by A and B; the third, and by far the most reasonable, is C's view that . . ." or "A argues . . . but . . ." or "Although the third view, C's, is not conclusive, still . . ." or "Moreover, C's point can be strengthened when we consider a piece of evidence that this author does not make use of." You cannot merely say, "A says . . . , B says . . . , C says . . . ," because your job is not to report what everyone says but to establish the truth of a thesis.

*When you introduce a quotation, then, try to let the reader see the use to which you are putting it.* "A says" is of little help; giving the quotation and then following it with "thus says A" is even worse. *You need a lead-in* such as "A concisely states the common view," "B calls attention to a fatal weakness," "Without offering any proof, C claims that," "D admits," "E rejects the idea that. . . ." In short, it is usually advisable to *let the reader know why you are quoting* or, to put it a little differently, how the quotation fits into your argument. After giving a quotation, you'll almost surely want to develop (or take issue with) the point made in the quotation.

It is almost always desirable in your lead-in to name the author of the quotation, rather than to say something like "One scholar has said . . ." or "Another critic claims that. . . ." In all probability the authors whom you are quoting are known in the field and your reader should not have to turn to the footnotes to find out whose words he or she has been reading.

Remember, too, that a summary of a writer's views may actually be preferable—briefer and more lively—than a long quotation. (You'll give credit to your source, of course, even though all of the words in the summary are your own.) You may have noticed while you were doing your research that the most interesting writers persuade the reader of the validity of their opinions in several ways:

- By letting the reader see that they know what of significance has been written on the topic.
- By letting the reader hear the best representatives of the chief current opinions, whom they correct or confirm.
- By advancing their opinions, and by offering generalizations supported by concrete details.

Adopt these techniques in your own writing.

Your overall argument, then, is fleshed out with careful summaries and with effective quotations and with judicious analyses of your own, so that by the end of the paper your readers not only have read a neatly typed paper, but they also are persuaded that under your guidance they have seen the evidence, heard the arguments justly summarized, and reached a sound conclusion. They may not become better persons but they are better informed.

Consider preparing a dual outline of the sort discussed and illustrated on pages 84–85, in which you indicate what each paragraph *says* and what each paragraph *does*. Thus, typical headings of the second sort will include "Introduces thesis," "Supports generalization," "Uses a quotation as support," "Takes account of an opposing view," and "Summarizes two chief views." Then look over your outline to see if each paragraph is doing worthwhile work, and doing it in the right place.

9. **Make sure that in your final version you state your thesis early,** perhaps even in the title (not "Van Gogh and Japanese Prints" but "Van Gogh's Indebtedness to Japanese Prints"), but if not in the title, almost certainly in your first paragraph.

10. When you have finished your paper **prepare a final copy that will be easy to read.** Type the paper (see pp. 154–55), or print a copy from the word processor, putting the footnotes into the forms given on pages 166–73.

A bibliography or list of works consulted (see pp. 173–76) is usually appended to the research paper, partly to add authority to your paper, partly to give credit to the writers who have helped you, and partly to enable readers to look further into the primary and secondary material if

they wish. But if you have done your job well, the reader will be content to leave things where you left them, grateful that you have set things straight.

*In brief:* After you have written a draft and have revised it at least once (better, twice or more), reread it with the following questions in mind. If possible, ask a friend also to read the draft, along with the questions, or with the peer review chart on page 126. If your answers or your friend's are unsatisfactory, revise.

- Exactly what topic are you examining, and exactly what thesis are you arguing?
- Does the paper fulfill all of the promises that it makes or implies?
- Are the early paragraphs interesting, and do they give the reader a fairly good idea of what will follow?
- Is evidence offered to support arguable assertions?
- Has all irrelevant material—however interesting—been deleted?
- Are quotations introduced with helpful lead-ins? Are all quotations instructive and are they no longer than they need to be? Might summaries of some long quotations be more effective?
- Is the organization clear, reasonable, and effective?
- Is the final paragraph merely an unnecessary restatement of what by now, at the end of the paper, is obvious? Or is it an effective rounding-off of the paper?
- Is the title interesting and informative? Does it also create a crucial first impression?

# 9

## Essay Examinations

### WHAT EXAMINATIONS ARE

The first two chapters of this book assume that writing an essay requires knowledge of the subject as well as skill with language. Here a few pages will be devoted to discussing the nature of examinations; perhaps one can write better essay answers when one knows what examinations are.

A well-constructed examination not only measures learning and thinking but also stimulates them. Even so humble an examination as a short-answer quiz is a sort of push designed to move students forward by coercing them to do the assigned looking or reading. Of course, internal motivation is far superior to external, but even such crude external motivation as a quiz can have a beneficial effect. Students know this; indeed, they often seek external compulsion, choosing a particular course "because I want to know something about . . . and I know that I won't do the work on my own." (Instructors often teach a new course for the same reason; we want to become knowledgeable about, say, the Symbolists, and we know that despite our lofty intentions we may not seriously confront the subject unless we are under the pressure of facing a class.)

In short, however ignoble it sounds, examinations force students to acquire knowledge and then to convert knowledge into thinking. Sometimes it is not until preparing for the final examination that students—returning to museums, studying photographs of works of art, rereading the chief texts and classroom notes—see what the course was really about; until this late stage the trees obscure the forest, but now, reviewing and sorting things out—*thinking* about the facts, the data, and the ideas of others—they see a pattern emerge. The experience of reviewing and then of writing an examination, though fretful, can be highly exciting, as connections are made and ideas take on life. Such discoveries about the whole subject matter of a course can almost never be made by writing critical essays on topics of one's own construction, for such topics rarely

require a view of the whole. Further, we are more likely to make imaginative leaps when trying to answer questions that other people pose to us than when trying to answer questions we pose to ourselves. (Again, every teacher knows that students in the classroom ask questions that stimulate the teacher to see things and to think thoughts that would otherwise have been neglected.) And although a teacher's questions might cause anxiety,

"I think you know everybody."

when students confront and respond to it on an examination they often make yet another discovery—a self-discovery, a sudden and satisfying awareness of powers they didn't know they had.

## WRITING ESSAY ANSWERS

Let's assume that before the examination you have read the assigned material, marked the margins of your books (but not of the library's books), made summaries of the longer readings and of the classroom comments, visited the museums, reviewed all this material, and had a decent night's sleep. Now you are facing the examination sheet.

Here are some obvious but important practical suggestions:

1. Take a moment to **jot down, as a sort of outline or source of further inspiration, a few ideas that strike you** after you have thought a little about the question. You may at the outset realize there are, say, three points you want to make, and unless you jot these down—three key words will do—you may spend all the allotted time on one point.

2. **Answer the question:** If you are asked to compare two pictures, compare them; don't write two paragraphs on the lives of each painter. Take seriously such words as *compare, summarize,* and especially *evaluate.*

3. **You can often get a good start if you turn the question into an affirmation**—for example, by turning "In what ways is the painting of Manet influenced by Goya?" into "Manet's painting is influenced by Goya in at least . . . ways."

4. **Don't waste time summarizing** at length what you have read unless asked to do so—but, of course, you may have to give a brief summary in order to support a point. The instructor wants to see that you can *use* your reading, not merely that you have done the reading.

5. **Budget your time.** Do not spend more time on a question than the allotted time.

6. **Be concrete.** Illustrate your argument with facts—names of painters or sculptors or architects, titles of works, dates, and brief but concrete descriptions.

7. **Leave space for last-minute additions.** Either skip a page between essays, or write only on the right-hand pages so that on rereading you can add material at the appropriate place on the left-hand pages.

Beyond these general suggestions, it is best to talk about essay examinations by looking at the most common sorts of questions:

- A work to analyze
- A historical question (e.g., "Trace the influence of Japanese art on two European painters of the later nineteenth century"; "Trace the development of Picasso's representations of the Minotaur")
- A critical quotation to be evaluated
- A comparison (e.g., "Compare the representation of space in the late works of van Gogh and Gauguin)

A few remarks on each of these types may be helpful.

1. **On analysis,** see Chapter 2. As a short rule, look carefully at subject matter, line, color (if any), composition, and medium.

2. A good essay on a **historical question,** like a good lawyer's argument, will offer a nice combination of argument and evidence; that is, the thesis will be supported by concrete details (names of painters and paintings, dates, possibly even brief quotations). A discussion cannot be convincing if it does not specify certain works as representative—or atypical—of certain years. Lawyerlike, you must demonstrate (not merely assert) your point.

3. If you are asked to evaluate a **critical quotation,** read the quotation carefully and in your answer take account of *all* of the quotation. If, for example, the critic has said, "Goya in his etchings always . . . but in his paintings rarely . . . ," you will have to write about etchings and paintings (unless, of course, the instructions on the examination ask you to take only as much of the quotation as you wish). Watch especially for such words as *always, for the most part, never;* that is, although the passage may on the whole approach the truth, you may feel that some important qualifications are needed. This is not being picky; true evaluation calls for making subtle distinctions, yielding assent only so far and no further. Another example of a quotation to evaluate: "Picasso's *Les Demoiselles d'Avignon* [illustrated in this book on p. 20] draws on several traditions, and the result is stylistic incoherence." A good answer not only will specify the traditions or sources (e.g., Cézanne's bathers, Rubens's *The Judgment of Paris,* Renaissance and Hellenistic nudes, pre-Christian Iberian sculptures, Egyptian painting, African art), calling attention to the passages in the painting where each is apparent, but also will evaluate the judgment that the work is incoherent. It might argue, for example, that the lack of traditional stylistic unity is entirely consistent with the newness of the treatment of figures and with the violent eroticism of the subject.

4. **On comparisons,** see Chapter 3. Because lucid comparisons are especially difficult to write, be sure to take a few moments to jot down a sort of outline so that you know where you will be going. You can often make a good start by beginning with the similarities of the two objects. As you jot these down, you will probably find that your perception of the *differences* will begin to be heightened.

In organizing a comparison of two pictures by van Gogh and two by Gauguin, you might devote the first and third paragraphs to van Gogh, the second and fourth to Gauguin. Or you might first treat one painter's two pictures and then turn to the second painter. Your essay will not break into two parts if you announce at the outset that you will treat one artist first, then the other, and if you remind your reader during your treatment of the first artist that certain points will be picked up when you get to the second, and, finally, if during your treatment of the second artist you occasionally glance back to the first.

## LAST WORDS

Chance favors the prepared mind.

Louis Pasteur

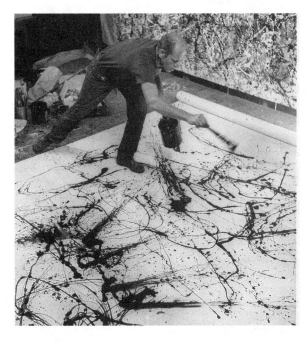

Hans Namuth, *Jackson
Pollock Painting*, 1950.
(© Estate of Hans
Namuth; courtesy of
the Pollock-Krasner
House and Study Center,
East Hampton, NY)

# Credits

"Millet's *The Gleaners*" (pp. 8–9) by Robert Herbert, reproduced from the exhibition catalogue *Man and His World: International Fine Arts Exhibition.* © The National Gallery of Canada for the Corporation of the National Museums of Canada. Reprinted by permission of The National Gallery of Canada and Robert L. Herbert.

Quotation and drawing (pp. 24–25) from Rudolf Arnheim, *Art and Visual Perception* (1974). Reprinted by permission of the University of California Press.

Quote by Eugene J. Johnson (pp. 54–55) in *International Handbook of Contemporary Developments in Architecture*, edited by Warren Sanderson. Copyright © 1981 by Warren Sanderson. Reprinted by permission of Greenwood Press, Westport, CT.

"Photography" (pp. 61–71) by Elizabeth Anne McCauley was written for this book and is used by permission of the author.

Excerpt from "The Assignment I'll Never Forget" (p. 66) by Dorothea Lange in *Popular Photography* 46:2 (February 1960), p. 43, reprinted by permission of *Popular Photography.*

"Two Low Relief Carvings from the Fifteenth Century" (pp. 93–95) © Oxford University Press 1964. Reprinted from *Relief Sculpture* by L. R. Rogers (1964) by permission of Oxford University Press.

"Mrs. Mann and Mrs. Goldthwait" (pp. 96–103) by Rebecca Bedell. Copyright © 1981 by Rebecca Bedell. Used by permission of the author.

"Gay and Lesbian Art Criticism" (pp. 111–13) by James M. Saslow was written for this book and is used by permission of the author.

Excerpt from "The Carvers of the Northeast" (p. 118–19) by John Pemberton III in *Yoruba: Nine Centuries of African Art and Thought,* edited by Allen Wardwell (New York: Center for African Art, 1989) p. 206, reprinted by permission of John Pemberton III.

"Guidelines on Writing with a Computer" (pp. 128–35) by Mark H. Beers and Stephen K. Urice was written for this book and is used by permission of the authors.

Excerpt from *Purposes of Art* (pp. 147–49) Third Edition, by Albert E. Elsen. Copyright © 1972 by Holt, Rinehart and Winston, Inc., by permission of the publisher.

# Index

219